The Digital Evolution

Also by A. D. Coleman:

CRITICAL SURVEYS:
The Grotesque in Photography (Ridge Press/Summit Books, 1977)

CRITICAL ESSAYS:
Light Readings: A Photography Critic's Writings, 1968–1978
(Oxford University Press, 1979; second edition,
University of New Mexico Press, 1998)
*Critical Focus: Photography in the
International Image Community* (Nazraeli Press, 1995)
*Tarnished Silver: After the Photo Boom,
Essays and Lectures 1979–1989* (Midmarch Arts Press, 1996)
*Depth of Field: Essays on Photography, Mass Media, and Lens Culture
(University of New Mexico Press, 1998)*

REFERENCE WORKS:
The Photography A-V Program Directory
(Photography Media Institute, 1981),
with Patricia Grantz and Douglas I. Sheer

FOR CHILDREN:
Looking at Photographs: Animals (Chronicle Books, 1995)

The Digital Evolution

Visual Communication in the Electronic Age:
Essays, Lectures and Interviews 1967–1998

by A. D. Coleman

Introduction by Hugh Kenner

Nazraeli Press

"It is the business of the future to be dangerous."

Alfred North Whitehead

"Science and technology multiply around us.
To an increasing extent they dictate the languages
in which we speak and think. Either we use those
languages, or we remain mute."

J. G. Ballard, quoted in Mark Dery,
Escape Velocity (Grove Press, 1996)

To the memory of Vilém Flusser (1920–1991).
His first words to me, spoken at a conference
in Vienna on the afternoon of June 22, 1980:
"You're not being theoretical enough!"

and

for Peter C. Guagenti, in friendship;

and

for Aaron Farr, wherever he is.

Contents

Acknowledgments

This book owes its existence to a suggestion from Peter C. Guagenti, whose supportive response to my technoskeptical meditations encouraged me to take a first look at them as a body of work in the fall of 1994, and who simultaneously persuaded me that the time had come to prepare for the twenty-first century by logging on to the Internet. Since then I've begun an active exploration of this new technology. What I write about it henceforth, however speculative, will be informed by praxis.[1] By making my plunge into all that as painless as possible, Peter did me a great service, for which I'm grateful.[2]

Putting this book together and tracking my relationship to these issues led me all the way back to the start of my life as a working professional. Jerome Agel, whom I met in a printing shop on the Lower East Side when I was still an undergraduate at Hunter College (Bronx) editing the school's bi-campus newspaper, gave me my first professional assignment (an article for his newsletter covering the book-publishing industry) in 1967. He also sent me a copy of the LP record of Marshall McLuhan's ideas he'd just co-produced with Quentin Fiore, and suggested I write a review of it and send it in to the *Village Voice*. I took his advice, making one of those "turns down some alley" of which Jack Kerouac wrote, after which nothing is ever the same. This book opens with that piece – because it belongs here, of course, but also in appreciation of Jerry's confidence in me early on.

These essays, lectures and interviews made their initial appearances in a wide variety of publications and forums. You'll find the specifics of their first publication and/or presentation in the endnotes or on the Credits page. My thanks to the various editors, interviewers, conference organizers and lecture

sponsors who provided the opportunities for arguments, predictions and hypotheses that must often have seemed (especially in the '70s and early '80s) recondite, eccentric and wildly unlikely. They include Carol Squiers at *American Photo*; Tina Potter at *ArtLook*; Eric Gibson at *ARTnews*; Manfred Willmann and Christine Frisinghelli at *Camera Austria*; Thom Harrop and Ana Jones at *Darkroom Photography/Camera & Darkroom*; James M. Trageser and Harlan Lewin at *A Critique of America*; Willard Clark at *Camera 35*; Andreas Müller-Pohle at *European Photography* (Germany); Jim Alinder, Richard Stevens and Charles Desmarais at *Exposure*; Barry Tanenbaum at *Lens' on Campus*; Bettina Edelstein at the *New York Observer*; Seymour Peck at the *New York Times*; Marc Silverman at *PHOTOpaper*; Stephen Perloff at *The Photo Review*; Jim "Flyboy" Stone at *The Polaroid Newsletter for Education*; Eli Bornstein at *The Structurist* (Canada); Robert Atkins at *TalkBack!*; Diane Fisher (who accepted this book's first essay, and asked for more) and Charles Whitin at *The Village Voice*; Rune Hassner of the European Society for the History of Photography; Helen Marcus of the American Society of Media Photographers; Marilyn McCray of the International Museum of Photography at the George Eastman House; Michael Recht of the Department of Art/Media Studies, Syracuse University; Steven J. Cromwell, organizer of the Society for Photographic Education National Conference 1978; and Anna Auer of the Sammlung Fotografis Länderbank-sponsored conferences on criticism in Vienna. They didn't know that they were helping me build a line of reasoning – nor did I. But this book results, in part, from their faith in my work, and in my working process.

Back in the early '80s, Aaron Farr – postal worker, amateur photographer, self-taught hacker – gave me my first hands-on encounter with the computer: a now-Jurassic Texas Instruments clunker. He was convinced I needed to have practical experience with this tool; I had my reservations. Aaron was right; without realizing it, he changed my life. I thank him for that, and remain in his debt.[3]

The immediate enthusiasm for this project of Chris Pichler, and his assurance that it made the ideal follow-up to *Critical Focus*, my first book with Nazraeli Press, convinced me that it held together as a group of texts. I knew that if it could sustain the interest of Chris, whom I count among the closest

of readers, it could attract and reward the attention of others as well. Working with Chris is always a pleasure, and our collaboration on this book has proved no exception to that rule.

The final editing of this book took place during the winter of 1996–97, as part of my stay at the Center for Creative Photography, University of Arizona, Tucson, as the Ansel and Virginia Adams Distinguished Scholar-in-Residence at that institution. My thanks to Terence Pitts, Director of the CCP – which now houses my archives – and his terrific staff, for providing such a supportive context for the furthering of this pet project of mine, among several others that also came to fruition there.

I also want to express my appreciation to Lucy Caswell of the Ohio State University Cartoon, Graphic and Photo Arts Library, and to Lisa Reddig and Tanya Murray, fact-checking assistance.

Finally, I'm deeply honored that Hugh Kenner consented to provide the introduction to this volume. I first read Dr. Kenner's provocative and influential literary criticism as an undergraduate, so his ideas began seeping into my consciousness almost four decades ago. References to that aspect of his work began cropping up in my own writings soon thereafter; you'll find several examples in this volume.

In 1968 – coincidentally, the year I began publishing critical essays on photography – Dr. Kenner issued one of the most remarkable of his many books, *The Counterfeiters: An Historical Comedy*.[4] This erudite, witty, melancholic and prophetic work – a meditation on computers, simulacra, and the transition from modernism to what would later come to be known as post-modernism – stands as one of the first serious attempts by a distinguished man of letters to engage with the cultural implications of digital technologies, especially in relation to creative activity in all media. Since then, he has become a regular commentator on computerization and its consequences.[5] Dr. Kenner exemplifies, among other things, the capacity of those of us raised in and enchanted by an analog world, with its literary and artistic traditions, to step boldly (if not fearlessly) into the digital universe next door. I am extremely gratified that he has elected to place my own considerations of those themes into context.

<div align="right">

A. D. C.

</div>

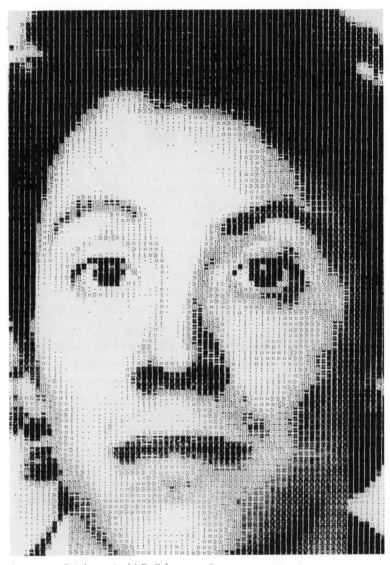

Anonymous, digital portrait of A.D. Coleman, 1978

Foreword

A young photographer and computer maven who began working with me as an assistant in the fall of 1994, Peter Guagenti, told me that some of the most useful writing of mine that he'd encountered during the process of our collaboration was what I'd had to say in recent years about electronic imaging and related issues. When I told him that I'd mulled those matters over for several decades, off and on, he suggested that I gather it all together, to see what it might look like as a whole.

At that time, my impression was that I'd addressed those questions only briefly and rarely, usually too little and too late. After following his suggestion, the experience of looking at everything I'd published and – in interviews, panel discussions and public lectures – said on this subject made it clear that at least I hadn't just stepped out for a beer during the early days of the digital evolution, and that both a development and a continuity of thought on these matters emerged from my recurrent ruminations, jeremiads and prophecies on this nexus of issues. This book is the result.

When I began writing about photography, in 1967, the battle over that medium's status as one in which art (whatever that might be) could be produced was still raging. Computers – large, noisy, mysterious machines with functions then limited almost exclusively to the mathematical – were a class of objects few lay people had laid eyes on, much less operated. The prophecy that they would transform our communications systems and pervade our everyday lives had been promulgated by only a few visionaries; to my knowledge, no one had hazarded a guess that anything anyone might ever consider as art would emerge from this technology.

A few pockets of resistance defended by diehard reactionaries aside, the battle for photography's recognition as a legitimate medium for the making of art – by which I mean a medium accessible to the mark of the mind and viable for the concerns of the poet – ended long ago. I'd estimate that it was widely understood as won at the height of the so-called "photo boom," circa 1975 – less than a decade after I first wrote down my thoughts about the emergent computer technology. Today, just shy of three decades from the point at which I joined that earlier struggle, photography stands permanently ensconced in the pantheon of the arts, while a multitude of works generated via computer and proposing themselves as art present themselves for our consideration; and, both appropriately and ironically, photography's shifting of the ground rules for acceptance into the territory of art serves as the most frequent analogue in the debate over the claims for the existence (actual or eventual) of "computer art."[6]

The writings, speeches and dialogic comments (extracts from a panel discussion and three interviews) collected here engage that argument, and, as the reader will soon see, pursue that analogy. However, just as the question of photography-as-art constituted only a subset of my more encompassing interest in the myriad ways that lens-based communications technologies reshaped the world, so my concern with computer art as such began as and remains subordinate to my concern with the fact that we have made the computer into what J. David Bolter calls a "defining technology"[7] of first-world culture. I find it intriguing that this manifests itself even more clearly in my writing on matters electronic than it does in my photography-specific texts. For many years, I have seen our cultural relationship to these two technologies as interrelated. I have also taken it for granted all along that efforts to gerrymander computer-generated work out of the territory of the arts would prove not only retrograde but futile, and certainly unworthy of prolonged attention.

The earliest public speculations I made on these subjects were published over thirty years ago, in September of 1967. They appeared in the very first essay I published in the *Village Voice*, the essay with which I began my career as a working writer – a review of a record by Marshall McLuhan with which this book's Prologue opens. I did not find occasion to return to the

subject until April of 1973, when I embedded some of my concerns in a short review of what we'd now call fax art by William Larson.[8] These were followed, a year later, by what now strike me as a handful of crudely formulated and elementary questions regarding so-called "generative systems" that arose in response to some work by Keith Smith and Sonia Sheridan I reviewed for the *New York Times* that summer.[9] Those, in turn, were succeeded by comments provoked by a controversy I'd observed within the Society for Photographic Education; drafted in late 1975, they appeared in an issue of *Camera 35* dated February–March, 1976, incorporated into an essay considering a proposed shift in emphasis for the S.P.E.[10]

Those concerns, and some others, were treated more expansively in "Remember: The Seduction of Narcissus was Visual," the essay from that same year that opens the main body of this collection and strikes its keynote. These problematic issues had begun to nag at me, as the reader will see. I came back to them in a 1977 book review. In 1978 I had the opportunity to address the Society for Photographic Education's membership as a whole, and used the occasion to synopsize my anticipation and anxiety concerning the emerging technologies, as well as to urge my colleagues' attention to them.[11] By then they'd become a cause for chronic meditation on my part, as this book reveals.

In 1978 I also had my first direct encounter with digital imaging: in a Times Square T-shirt emporium, I commissioned a full-face digital portrait of myself. It cost $5. It ended up as the front- and back-cover image for my first collection of essays[12] – making me, so I'm told, the only author in the history of the world's oldest university press to have his picture on the jacket of his book.

Meanwhile, I continued to poke at and pry into these matters, simply as a concerned citizen and an interested onlooker. I developed no theoretical expertise, nor, for the first decade-plus, had any revelatory hands-on experience (though, as recounted elsewhere in this volume,[13] I did begin to use the computer for my work as a writer, in mid-1987). The sources for my information were commonly available and anything but obscure: the mass media – TV, radio, daily papers and the popular press – and assorted books by Seymour Papert, Joseph Weizenbaum, Sherry Turkle and others, for the

most part written for non-specialists in the field. Just keeping my ear to the ground in this fashion made the future, in this regard, seem inescapable. In late 1986, even before I began working on a computer myself, I learned that *Lens' On Campus* – for which I then wrote a column – was on the verge of being purchased by another publisher; I persuaded editor-in-chief Barry Tanenbaum and the new owners that photo teachers and students, the magazine's primary readership, were thenceforth headed down the digital path, with no turning back, and that the periodical's new incarnation should speak to that transition and reflect it in its name. At my urging, they changed the periodical's title to *Imaging On Campus*, positioning it nicely to catch and ride the crest of that wave. (Unfortunately, that didn't prevent its demise for other reasons, just a year later.[14])

In the spring of 1988, Michael Recht of Syracuse University's Department of Art/Media Studies invited me to give a lecture to their students that he indicated would be a valedictory of sorts, and asked me to rethink and update that keynote address I'd delivered to the Society for Photographic Education just over a decade previously. Here's an excerpt from the resulting speech:

... Reviewing that talk and the ten years since it was delivered brought up quite a jumble – thoughts, emotions, memories, guesses. I'm going to present these to you as a kind of patchwork or collage, random thoughts in a dry time. If you'll accept a spoken version of the cubist idea that one way to apprehend something is to build up a montage of glimpses from different vantage points, perhaps we'll all find that some sense of the present and future emerges from these fragments.

Reviewing one's prophecies is always a sobering experience. The questions one asks are not only "When was I right?" and "When was I wrong?" but, perhaps most painfully, "Where did I miss the boat entirely?"

So I was grateful to discover that I hadn't made too much of a fool of myself. True, I'd projected that a popular, accessible form of holography (or some alternative three-dimensional imaging process) would be

introduced, with the result that 3-D imagery would swiftly begin to re-place the still-standard two-dimensional forms. As someone said during a symposium in which I took part recently, holography seems to be the ever-receding horizon of new photographic technology – always in sight, never within reach. At least not yet, in any case.

Conversely, I was perhaps too timid in my anticipation of the impact of electronic imaging and its pervasion of the field of visual communica-tion. While I cautioned photography teachers to prepare for students using electronic cameras, and projected a communications environment in which image manipulation increased rapidly, I'd no idea that a mere decade later the Scitex machine and other such devices would be accom-plished facts, and that photography education would have fallen almost hopelessly behind and be scrambling to catch up with the onslaught of these new technologies.[15]

If reviewing the prophecies in a single decade-old jeremiad sobers one, looking back over two decades' worth of auguries is daunting. Yet, on bal-ance, I'm not especially embarrassed, even by my mistakes. (Where is that digital equivalent of holography for which we're all presumably waiting breathlessly? Well, virtual reality seems a likely candidate for the job.) For every mark or two missed, there's an anticipation that proved out. Beyond that, many of the questions I asked seem to me to have headed in the right directions, even when my provisional answers turned out wrong.

Aside from some minor repairs and endnoting, I have left these essays unchanged; part of their value in their original form, I hope, is the way in which, separately and collectively, they capture my approach to worrying this particular complex of concerns across a sequence of given moments.[16] Because they appeared over a long span of time, in a wide range of publi-cations with diverse readerships, and were not written with the expectation of ever assembling them into a book, variations on certain key passages recur in several of them. I consider those integral to the specific argument of each essay, in most cases; beyond that, they indicate something about my own working method that I hope may prove useful. So I've chosen not to delete those reiterations, instead leaving the essays

largely as they were written and published. I beg the reader's indulgence for the consequent repetition.

The dates appended parenthetically to the ends of these essays, lectures and interviews are the dates not of their writing but of their initial publication or (in the case of lectures) the occasions of their original delivery and (with interviews) the dates on which they took place. Because the chronologically first of these essays – "Flowering Paradox: McLuhan/Newark," "Two Extremes," "Of Snapshots and Mechanizations" and "Begging the Issue" – broach the subject either fragmentarily or else within the comparatively narrow frameworks of, respectively, fax art, electrostatic artmaking, and photography education, I've chosen to identify them as constituting a "Prologue" to this collection; "Remember: The Seduction of Narcissus Was Visual," written some years later, strikes me as a broader, more appropriate opener. Nonetheless, the material herein is presented in strictly chronological order, according to the month and year in which (as indicated at each selection's end, and/or in the Publication Credits) the core version of each essay was first published, the lecture was presented, or the interview/panel discussion conducted. (In cases where a piece's publication history needs more elaboration, that's indicated in the Notes.)

This should make it clear that the "digital evolution" of the book's title refers not only to metamorphoses in the technology but to changes within me as well. What you'll find in these pages constitutes a modest, extremely personal and highly idiosyncratic contribution, from my decidedly lay perspective, to an ongoing public debate over issues that have already transformed our culture, and will continue to do so. At the same time, it reflects an internal argument with myself, between my conservative and radical aspects, my conflictual yearnings for both the comfort of the familiar and the adventure of the unknown. Neither of those forums, the public or the private, seems likely to achieve consensus in the foreseeable future. Apparently, in both cases, I like it that way.

A. D. Coleman
Staten Island, New York
June 1998

18

Introduction

I'll start with a grabber – "Computers – large noisy mysterious machines with functions then limited almost exclusively to the mathematical . . ." – that's our author on an early page, confronting us with the way things looked about 1967. The notion that computers were destined to "transform our communication systems and pervade our everyday lives" is something he recalls as tom-tomming from rare navel-gazers, so crazy it didn't even seem worth refuting.

And back in mid-1980, Coleman tells us, he and a man named Vilém Flusser shared time at a conference in Vienna. "His first words to me . . . 'You're not being theoretical enough.'" Meditation on those words has now prompted him to dedicate the present book to Flusser. Why? Well, for the good reason that "theory" simply entails a larger framework than, oh, "anecdotage," which is the normal stuff of scientific writing aimed at non-scientists. (Note how little of any biography of Einstein is devoted to the doings which merit a biography.) And it's only within that larger framework that our readers can be brought to perceive the dominant theme of the computer era: not some Grinch of a number-cruncher but a benign pervader and enabler of everyday lives.

Coleman saw to it that being "theoretical enough" should not entail drifting away from readability. For instance, his latest book, the one you're holding in your hands; open it anywhere at random and, lo, a perfectly readable paragraph. In part, that's because Coleman did not sit down late in the 1990s to contrive a (**Fireworks, Please!**) *overview*. What you're looking at is no such fabrication. It's a collection of essays he wrote over a span of

decades, each, line by line, responsive to some particularity. Always, as he wrote them, he held in the back of his mind the sense that something very large was developing: something that transcended the incidental, the anecdotal.

That is why the older chapters don't date, and the most recent ones can draw on them so calmly. By 1993 he's reporting some commemorative going-on in Rochester. "Cyberspace," a speaker is saying, "began right here [in Rochester], when Alexander Graham Bell and his assistant Thomas A. Watson had that first phone conversation at a point somewhere between two rooms." The speaker? He's John Perry Barlow, "Montana cattle rancher, lyricist for the Grateful Dead, co-founder of the Electronic Frontier Foundation and an ardent explorer/advocate of what is called cyberspace." Though that list of qualifications is positively cubist, Coleman isn't turning a hair. Montana-space, cyberspace: those do interpenetrate nowadays. Coleman murmurs in an endnote that "the first phone conversation" didn't happen in Rochester. And as for "Mr. Watson, come here, I want you" being the inauguration of awesome cyberspace: well, when a message is locating a medium its mere content needn't matter. Marshall McLuhan was telling us that decades ago.

Something else Barlow told that Rochester audience: "We are entering the virtual age. Everything you know is about to be wrong, and much of it already is. This is the biggest thing since fire." A.D. Coleman's take on such goings-on is instructive. He's not yet convinced, he says, by equations such as the one Barlow proceeds to draw, between True Democracy and Healthy Anarchy. Still, he think's it's worth noting that "these new forms are attracting people who are eminently quotable."

That is, perhaps, a more pertinent observation than anything on which the quotable folk can be quoted. When quotabilities abound, we have both (1) speakers and (2) an audience to absorb quotations of what they've said. It is such an audience that defines a new community; its existence is the real news. So the real news is what A.D. Coleman keeps bringing us. He's firm about limitations – "I don't feel any more empowered by a video installation programmed to start up when I enter the room than I do when I make eye contact with a silver-gelatin print that remains, as it were, permanently turned on regardless of whether or not I'm in the room." "We're still just bottom-

feeding on this idea of interactivity," said one of those Rochester speakers. "I'm glad," responds Coleman, "to hear I'm not the only one who thinks there must be more to this than this."

What's "more to it" isn't any specific event, any locatable metaphoric space. It's the continuum Coleman's sequence of essays was unique in reproducing, year by year. Years ago, as Coleman reminds us, I wrote, "There is no substitute for critical tradition: a continuum of understanding, early commenced." This volume, in its own modest way, offers the thirty-year growth of its author's understanding of these urgent digital issues as his contribution to the critical tradition of our electronic times.

Hugh Kenner
Athens, Georgia
May 1998

Prologue

Flowering Paradox: McLuhan/Newark

... On Sunday afternoon, he [James Rutledge, 19-year-old Negro] was inside a looted tavern with several other teenagers hiding from the fire of troopers and police. According to a witness, the troopers burst into the tavern shooting and yelling. "Come out you dirty fucks." James Rutledge agreed to come out from behind a cigarette machine. He was frisked against the wall. Then:

The two troopers ... looked at each other. Then one trooper who had a rifle shot Jimmy from about three feet away.... While Jimmy lay on the floor, the same trooper started to shoot Jimmy some more with the rifle. As he fired ... he yelled, "Die, you dirty bastard, die you dirty nigger, die, die ... " At this point a Newark policeman walked in and asked what happened. I saw the troopers look at each other and smile ...

The trooper who shot Jimmy remained ... took a knife out of his own pocket and put it in Jimmy's hand.

Shortly after three men came in with a stretcher. One said, "They really laid some lead on his ass." ... He asked the State Trooper what happened. The Trooper said, "He came at me with a knife."

Tom Hayden, "The Occupation of Newark,"
New York Review of Books, August 24, 1967.

The Digital Evolution

I.

Never before in the history of Western man have so many paradoxes simultaneously achieved such full and glorious bloom. There they nod, awaiting a Lefty, a Godot, a slice from the pie-in-the sky of Hegelian synthesis. None of these lurks in the wings; or if so, it has hopelessly muffed its cue. For now, in the most literate society on earth, words have lost their meaning; a plenitude of material goods has caused a decline in sensual refinement; the young of the middle and upper classes, out of boredom, turn on, drop acid and drop out into volunteer poverty, while the young of the lower class, out of despair, shoot heroin, unable to afford the electricity required for tuning in.

(Some do not. Some are driven to the wall; they fight and die.)

(It has been said that the most dangerous product of any society is someone with nothing to lose. That is half-true; equally dangerous, for opposite but analogous reasons, is someone who has nothing to gain.)

True to the spirit of the times, no one seems capable of piercing surfaces; like skater bugs on water, we glide the present, ignoring the depths beneath us in which the white whale circles the lost continent. Despite our efforts, those depths continue to exist.

There is an aspect of Marshall McLuhan which few people explore. The victim of those very phenomena which he was the first to codify, McLuhan became a household word before he had a definition. The result has been his misuse as a panacea. Invocation of the McLuhan pacifies priests from all sects of the one true intellectual establishment: the ecumenical spirit, rampant upon a field of transistors. Thus, unfortunately, a frequently astute and incisive observer of our contemporary malaise is taken too often at face value. (The assumption that things are as they appear to be is almost always wrong.)

McLuhan, the Henry Adams *manqué* of the 1960s, means what he means as well as what he says. "The medium is the message," one of his most quoted and most felicitous phrases, has an obvious implication which those who bandy his words about steadfastly refuse to recognize: namely, that any message, in any medium, must be analyzed, interpreted, and evaluated, in order for communication to take place. This is the polar opposite of justification

for so vapid, mindless, and (too often) hostile a "message" as present-day television; yet it is for precisely this purpose that McLuhan's statement is employed with vaguely eerie inaccuracy. Marshall McLuhan, I suspect, despises the media and the messages which, according to many, are on verge of replacing the sonnet, the symphony, the play, the dance, all the arbitrary and rigid and beautifully artificial forms into which man has compressed his creativity. (And wouldn't Sam Goldwyn spin in his crypt if he only knew that he'd been sending messages all along?)

Like Henry Adams, McLuhan is torn between his own virgin and his own dynamo. For McLuhan, it is ethical virginity on the one hand and pragmatic dynamism on the other; he is caught 'twixt the Scylla of intellectual snobbery and the Charybdis of mass-cult. Paradox in bloom. Ah, wilderness.

(With the Electric Circus here, can electric bread be far behind?)

. . . On Sunday afternoon, he [James Rutledge, 19-year-old Negro] was inside a looted tavern with several other teenagers hiding from the fire of troopers and police. According to a witness, the troopers burst into the tavern shooting and yelling. "Come out you dirty fucks." James Rutledge agreed to come out from behind a cigarette machine. He was frisked against the wall. Then:

II.

One of the basic assumptions on which rest the ideas expounded by McLuhan is this: "When two seemingly disparate elements are imaginatively poised, put in apposition in new and unique ways, startling discoveries often result." This notion is not wholly original; Kenneth Burke suggested the same theory several decades ago in his then-radical approach to literary criticism. (For McLuhan, as for Burke, the theory works nicely by itself but loses contact with reality at times, especially when practically applied. Thus: some magazine – *Forbes*, I believe – ran a full-page ad in the *New York Times* showing a long-haired, sideburned, granny-glassed male hippie above the caption, "The heir to General Motors." Snappy, yes? Clever, huh? Times

are changing, right? Makes you think, eh? Now picture the same caption beneath a photograph of Muhammed Ali.)

Some time ago, McLuhan, in collaboration with Quentin Fiore and Jerome Agel, combined this and other theories to produce what was perhaps the first deliberate and premeditated non-book, a primer on what has come to be called McLuhanism, titled *The Medium is the Massage*.[17] This volume is an outline of McLuhan's basic ideas, interspersed and intertwined with eye-opening typographic and pictorial demonstrations of the potential applications of McLuhan's vision. Now, under the same punning title and with the assistance of the same (albeit augmented) stunning cast, Columbia Records has issued an LP version of the book in mono and stereo,[18] billed in a Columbia news release as "the first spoken-arts record that can be danced to." (Despite that concluding proposition, it can't be.)

As a totality, judged on its own terms, the record is brilliant – witty, Joycean, contemporary (even avant-garde), erudite without a trace of coldness, educational but not didactic, serious with nary a hint of solemnity. Here, for the first time, techniques developed in electronic music and its forerunner, *musique concrète*, have been applied to a spoken narrative; the results are fascinating. The fragmentary, multi-faceted "message" of the record is alternately whispered and shouted through a rich, exciting texture; part sound effect, part humor, part advertisement, part music, and part lecture, *The Medium is the Massage* is the first recorded guided tour through the paradoxes, problems, and possibilities of the auditory media. It could – and no doubt will – serve as an excellent educational tool, ideal for explaining the electronic era to almost anyone of any age; and, through the radical innovations in teaching technique with which it is crammed, this record should have a noticeable influence on the computerized, programmed, videotaped "schools" of the very near future.

One may, of course, quibble with any number of the neat, humorous epigrams which are the lifeblood of this album. For example, as proof of the postulate that sequential thinking is being phased out of human verbal communication, the listener is told that "I don't follow you" has been replaced by "How does that grab you?" The logic of this might be acceptable to Nancy Sinatra; to my ears it is merely glib. These two phrases have no

connection with each other, and meet nowhere save in Professor McLuhan's metaphor. (Rarely, if ever, do the many people who fail to understand me turn a consequential and quizzical regard in my direction to inquire, "How does that grab you?"

Similarly, McLuhan – whose speaking voice, heard off and on throughout this album in readings from the book version, is distinguished and charming – suggests that "the medium of our time, electric circuitry, profoundly involves men with each other." While electric circuitry has, to my sometime dismay, involved me on occasion with such masseurs and masseusses as Joey Bishop, Joey Heatherton, Dean Martin, Alan Burke, Raquel Welch, Batman, William F. Buckley, Jr. (the leftists' rightist), Bob Hope, Jack Webb, and countless others, I would hesitate to call that involvement profound. To my mind, it is superficial. Frequency, contrary to current opinion, is not profundity; repetitiveness is not evidence of genius.

However, it is always simple to shoot someone full of holes, metaphorically as well as literally. With such minor criticisms as the above aside, I heartily recommend this record (the original soundtrack recording?) of Marshall McLuhan's *The Medium is the Massage*; it is vital to a full understanding of our times. That description, however, makes it sound pedantic, and it is not; far from it – it is exciting, comic, lucid, mind-blowing, often perceptive, always intelligent. On July 16, the day before it was released, the following occurred:

The two troopers . . . looked at each other. Then one trooper who had a rifle shot Jimmy from about three feet away. . . . While Jimmy lay on the floor, the same trooper started to shoot Jimmy some more with the rifle. As he fired . . . he yelled, "Die, you dirty bastard, die you dirty nigger, die, die . . . " At this point a Newark policeman walked in and asked what happened. I saw the troopers look at each other and smile . . .

How does that grab you?

(September 1967)

Two Extremes

If evidence of the potential diversity of non-"straight" photography were still needed, there could be none better than the exhibits of William Larson and Benno Friedman at the Light Gallery, since these two represent almost antithetical attitudinal polarities within this medium.

Friedman's work combines an overtly casual and accident-oriented method of making exposures with an approach to the printing process which involves extensive manipulations, The most frequently employed of these is chemical staining and discoloration of the images. This is one of the more traditional and widespread methods of post-exposure image manipulation – one can point to such diverse practitioners as Edmund Teske and Michael Martone, Van Deren Coke and Fredrich Cantor. Its most obvious effect is to manifest the maker's hand within the mechanical processes of photography, and the result is a unique, one-of-a-kind print. . . .

William Larson's "transmitted images" strike out in another direction. Friedman gives the last word to the maker's hand, Larson leaves it to the machine – which is not the camera in this case.

Larson has been working for some time now with the DEX Teleprinter, a device for transmitting material by telephone. Any form of graphic material is converted by the Teleprinter into sound signals on the sending end, and reconverted on the receiving end into light signals which are burned into sensitized paper for the print-out. Sound itself can also be transmitted in this fashion and converted into visual material; Larson's transmissions have included Rolling Stones songs, among other things.

Only a small portion of the total source material involved in these images is photographic in origin – there are also vertical strings of syllables, song patterns, rubber-stamp imprints, Larson's verbal descriptions of the items employed and annotations concerning the date, time and place of transmission. The reconstruction process gives a two-dimensionality to the various elements in these collages, and a uniformity which ties them all together.

It is possible, of course, to consider this process itself as photographic, in the literal sense of the word, since the reconstituted print-out is a drawing by light on sensitized paper. It seems to me that there is an inherent paradox

in employing what is intended to be a time-saving communication device for the purpose of transmitting ambiguous and ultimately undecipherable imagery, but the paradox has enough resonance to keep it intriguing. The images themselves are rather like messages stuffed into bottles and set adrift by some forlorn computer stranded on a desert isle.

The exhibit contains both the final print-out images and the "originals" (except for the music) employed in their making. Since the emphasis here, the real experiment, resides more in the process than the product, it might be more instructive – and certainly more exciting – to experience the transmission itself as well as its results. An account of such a demonstration is contained in an article on Larson by Alan Klotz in the October 1972 issue of *Afterimage*, which is available through the gallery. The account is enough to whet one's appetite, and beside it the contents of this show appear to be only the soup and nuts, with the main course left out.

(April 1973)

Of Snapshots and Mechanizations

To Peter Schjeldahl's comments[19] on the Sonia Sheridan-Keith Smith show which closes today at the Museum of Modern Art, I would like to add a few of my own. In darker moods, I am prone to think of "generative systems" – such as the 3M Color-in-Color process employed by Sheridan and Smith – as the inevitable result of the ultimate cultural merger.[20] To put it in appropriate terminology, origin-wise: Son of Post-Duchampian Theory Meets the Madison Avenue Mind.

I realize that distress over the mechanization of creativity is often a sign of creeping old-fogeyism. So, although I do not find such distress inconsistent with that paranoia which is my basic critical stance in regard to photography, at times like these I take myself with a grain of salt, and urge you to do likewise. Seasoned thusly, however, consider this:

Color-in-Color is a completely dry photo-mechanical process which allows the reproduction of originals, including three-dimensional objects, in color. The original is placed on the machine's scanning plate – a glass

plate similar to the glass platen on a conventional copying machine. With the press of a button the machine analyzes the original through optical filters which measure blue, green and red content, respectively. Color separations are made and are used to transfer yellow, magenta and cyan dyes in register to the copy paper. With the Color-in-Color System I, the result is a one-to-one reproduction of the original, produced in 30 seconds and in any quantity up to 15 automatically.

The Color-in-Color System II, developed two years after the System I, allowed the enlargement of color transparencies (8mm, 16mm, 35mm and 2x2 inch) by powers of 5.4, 7.4 or 11.2. In making the largest works in the Sheridan/Smith exhibition, originals produced on a System I machine were heat-transferred to transparent film, each sheet of which was cut up into 35mm transparencies. Each of these transparencies was then enlarged on a System II machine.

The process uses either normal paper which locks in the dry dyes for permanence or a special matrix material which holds the dyes in suspension until they are transferred by the application of heat to another material, such as transparent film, cloth, metal and other surfaces. Machine controls allow the operator to create variations of the original; even black-and-white originals may be reproduced in color. Further, color separations created in the process may be used in conventional printing.

What we have here, as this release from the museum indicates, is not merely a mechanical device for printing color images. Given a starting image and sufficient supplies, this 3M machinery is capable of filling a room (or, like Sherwin-Williams paint, "covering the earth") with infinite permutations and combinations. It is the imagistic equivalent of the proverbial monkey with eternity and a typewriter.

The perversity of such a device is that it achieves the triumphant merchandising coup of turning process itself into product, thereby converting the artist into a consumer. He/she may respond to this machine's output as a glutton or a gourmet, but the role it encourages is a passive one. Certainly it makes possible the manufacture of some impressive artifacts, such as the 47x11-foot cloth piece in this exhibit (a frontal body scan of a male nude).

But five hundred square feet of anything photographic and in color, no matter how banal, is impressive, as the Photo-Realists have realized to their benefit. With the 3M machine, you can "generate" so many things so quickly that you're bound to get something of at least passing interest.

Perhaps we need to begin making some distinctions between the tool and the servomechanism, because I'm not sure I understand the difference between the 3M Systems and those "Spin-Art" machines at carnivals which, by combining chance with centrifugal force, give you "your very own abstract painting in just seconds."

Debate on this issue – as on all others raised in this space – will be welcomed.

(July 1974)

Begging the Issue

Recent breakthroughs in the technology of photographic image reproduction and transmission indicate that we are approaching a visual consciousness-raising of the highest magnitude. The simultaneous appearance of large-screen video projection equipment and videodisc playback devices are auguries of a daily encounter with still and motion photography on a scale undreamed of in our philosophies, especially when coupled with the advent of holography. Dismissed recently by Hilton Kramer of the *New York Times*[21] – unable, as usual, to see the forest for the trees – holography represents the very first photographically credible illusion of three-dimensionality not restricted to the surface of some object (a photographic print, a hand-held viewer, a movie screen) that inherently undercuts its illusion.

The processes of holography are not particularly arcane or dangerous, though at present the places where the necessary skills can be acquired are few and far between, the cost of equipment not inconsiderable. The next step will most likely be the invention of holographic equivalents of Instamatics, sx-70s and Super-8s. They are already making holographic movies.

Add to that such developments as portable video equipment, closed-circuit and public access television and quadraphonic sound, and it is hardly daring to predict that by the turn of the century we will be able to flick on our

The Digital Evolution

portable holographic projectors and sit in the middle of real or fictional events, even to put on our own holographic vacation slides and home movies. The people of that era may well look back at our two-dimensional image systems the way we look back at silent movies.

A quantum jump is about to be made in the level of sophistication of our visual communications systems. That jump will land us, most probably, in a position triangulated by *1984*, *Brave New World* and *Fahrenheit 451*. The innovations will surely be exciting, but their implications are already frightening. There is little question that this change in technology will be accompanied by increasingly complex methods of thought manipulation on an even wider scale than presently exists. The heightened seductiveness of this right-lobe input will render us ever more prone to such manipulation, unless we are educated to perceive, interpret and respond to it as such. We will also be unable to utilize these new tools to their fullest potential if we lack training in their theory and practice.

The challenge of photography education at this juncture is that of preparing our culture for the imminent metamorphosis of its modes of visual communication. The crisis which looms alongside that change can force the recognition of the necessity and urgency of across-the-board photography education. So it was somewhat disconcerting to find that some members of the Society for Photographic Education, instead of grappling with that challenge, want to know "Who Put The E in S.P.E. and Is It Time To Take It Out?"

That was the topic of the main panel at the Midwest Regional S.P.E. conference, which this year [1975] was held in Iowa City in conjunction with the University of Iowa's biennial still/video/film festival, Refocus. The panel discussion took place at the same time as a demonstration of holographic methods a few rooms away, ironically enough; that coincidence pointed up the regressive nature of the questions quite clearly.

Neither of the questions got answered, regrettably. In part, this was due to the environment: Refocus (the largest student-run event of its kind in the country) is a sprawling, high-energy happening, not exactly conducive to the slow, painstaking analysis and evaluation those questions require. In part, however, the planning was at fault: two hours is hardly sufficient time

to raise these questions and their ramifications, much less to begin answering them.

Nathan Lyons attempted to answer the first question with his declaration, "I put the E in s.p.e., with the approval of its founding members, in 1963." He then attempted to place the question in perspective by providing a history of the organization's inception and evolution. As a founding member and past National Chairman, he was in a unique position to do so. It was clear that many people inside and outside of the s.p.e. lacked this background information. Unfortunately, Lyons's outline was never completed; chairperson Dru Shipman interrupted him early, insisting that the panel had to abide by the strict timetable she had unilaterally established for it. This deprived the panel – and the audience – of appropriate premises on which to consider the issue. Not unsurprisingly, though it ran (like Mussolini's trains) according to schedule, the meeting failed to resolve the issue, and the other panelists – Charles Gold, Lester Krauss, and Michael Simon – barely managed to address themselves to a few of its many implications.[22]

I hope that Lyons finds an opportunity – in print, ideally – to complete his history of the s.p.e. I also hope that the debate does not conclude with what I anticipate will be the chairperson's habitually exhaustive report[23] on what was essentially a non-event.

I found myself left wondering as to how the issue had arisen in the first place. There seemed to be two possible points of origin. One was a visible desire on the part of some members to disassociate the s.p.e. from what was referred to repeatedly as the "Visual Literacy" movement (a Kodak-sponsored project) and *Popular Photography*'s "Photography as a Fourth 'R'" campaign.

It is true that the concept of visual literacy has become a bandwagon.[24] It may also be true that Kodak and *Popular Photography* have jumped on board as a blatant, explicit tactic to legitimatize the merchandising of cameras to children. One may certainly question their motives and methods; their results should be scrutinized not only with care but with suspicion. But that doesn't make it any less important to teach photography to children. Do we stop teaching them to read and write because book publishers and pencil manufacturers stand to profit thereby?

The Digital Evolution

Taking the E out of s.p.e. is not the best way of disassociating that organization from those who would exploit the concept of photography education to increase their capital gains. That disassociation can better be accomplished through the difficult long-term process of providing superior alternative understandings of what photography education is about, and disseminating them as widely as possible. Taking the E out would instead disassociate the organization entirely from the issue itself. What would terminate would not be the relevance of that issue, but only the organization's obligation to address itself to it.

That, then, is the other impulse behind the desire to remove the E. It is clearly isolationist in essence. It would allow the organization's membership to concern itself exclusively with what Shipman calls "the teaching of photography on its own terms – not as a tool," whatever that may mean. The membership would thus be permitted to avoid the crisis generated by the surge of widespread, genuine interest in visual education and the imminent transmogrification of our visual communication systems.

This may meet the needs of some instructors – especially those for whom teaching is not a calling but a sinecure – who would like to have the burden of functioning as informed educators taken off their shoulders. That, of course, would decrease their responsibility to their students, and presumably leave them with more time for "their own work."

I hope that the membership of the s.p.e. – particularly the student membership – will take a close, hard look at the future. The s.p.e. is in a unique position at this moment. It is the only broad-based national organization dedicated to photography education. Its potential for shaping our culture's relationship to the medium of photography has barely been tapped. It is an invaluable tool to have at our disposal for the task ahead. Eliminate its function as such and it becomes only a fraternal order, a social club instead of a vanguard. I recommend that the membership of the s.p.e. seek in it "not peace, but a sword."

(February 1976)

Zestimonial.

my soap.

There's a film from my soap on the picture. It's a sticky film that doesn't even wash off. I won't use my soap anymore.

Zest.

Zest didn't leave a sticky film. I used Zest all week. It really lathered up. It made me feel very fresh and tingly. I'm going to stay with Zest.

Kay Bruner

The above sentences are excerpts taken from hidden camera interviews of Kay Bruner. At that time, we asked her to bathe pictures of herself, like the ones above, in her favorite soap and Zest.® We also asked her to try Zest at home. She found out Zest made her feel cleaner than her soap.

© 1976, The Procter & Gamble Company.

Try Zest. Like Kay Bruner, you'll find Zest makes you feel cleaner than soap.

Zest soap ad, print media version, 1976

The Digital Evolution

Remember:
The Seduction of Narcissus Was Visual

Do you remember The Singing Nun?

A phenomenon of the ecumenical 1960s, she called herself Sœur Sourire – Sister Smile – and, accompanying herself on acoustic guitar, ran a lilting little ersatz-folk ditty about St. Dominic into a Top-Ten single and an international hit album.[25]

It was a charming song; anyone over the age of twenty-five probably recalls the tune, and perhaps even the mellifluous French lyrics: "Dominique-nique-nique combattit les Albigeois . . ." (Little Dominic fought the Albigensians.)

Do you remember the Albigensians?

They were a medieval Christian sect in the south of France, believers in the Manichaean doctrine. Manichaeism held, among its tenets, that the existence of evil was necessary in order for human beings to recognize good – and that God therefore must have created evil as well as good. The hierarchy of the Catholic Church determined this complex and Eastern-influenced philosophical position to be heretical. It was decided that the Albigensian heresy had to be eliminated; Dominic was one of numerous individuals charged with that task.

The Albigensian heresy was eliminated by eliminating the Albigensians – man, woman, and child – in a prolonged bloodbath of a crusade so virulent that, according to *The Encyclopaedia Brittanica*, "[t]his implacable war . . . threw the whole of the nobility of the north of France against that of the south, and destroyed the brilliant Provençal civilization." For his role in this solution to that problem, among other accomplishments, Dominic was canonized.

So that song which we all remember with such pleasure celebrates the destruction by genocide of a dualistic conception of the universe. It is a charming song, though, isn't it? Or is it?

I'd suggest that it is not only naïve but potentially dangerous to respond to a song on a "purely musical" basis, without attempting to decipher the many messages that may be encoded therein. Another example, closer to home: Several years ago, a New York design company charged with the task of creating a space ad for a Chinese-American kosher restaurant in Brooklyn decided to "give it a Chinese look" by running a border of Chinese type around the cover. So they bought a Chinese newspaper, cut out a dozen or so lines, and pasted them up. Not until after it appeared in print did they discover the translation, roughly as follows: "Cheer for the glorious victory of the classless cultural revolution. The working class of every province, city and self-ruling district pledges to Chairman Mao. Be determined to criticize the followers of Lin and Confucius in depth. . . . "[27]

As that indicates, it is not only naïve but potentially dangerous to respond to a pictographic language form on a "purely visual" basis, without attempting to decipher its other messages. I would propose that photography is another pictographic language form, and that restricting our responses to photographic images to those perceptions that occur on "purely visual" terms narrows our function to that of visual idiot-savants. Formalism carried to that extreme is terminal, especially since formalism itself is a severely limited analytical tool. Its presumed strength – a purist insistence on considering exclusively "the thing itself" – is also its major weakness, since it severs a work from the individual life of its maker and from the context of his/her time and culture. Cut off an organism's roots like that and you deny its capacity to flower.

We live today in the most visually sophisticated culture in recorded history. Much of that sophistication is recent, and most of it is specifically attributable to photography – both directly (through what camera vision and photographs have taught us about visual perception and the appearance of the world) and indirectly (through the proliferation and repeatability of imagery that photography makes possible).

Consider, for instance, the two cartoons reproduced here. Not only were they both disseminated through photographically generated reproductions,

The Digital Evolution

Boy and Girl

Cartoon by John Henry Rouson. Copyright © 1972 by the
Los Angeles Times Syndicate. Reprinted by permission.

"I don't understand why I can't keep you in focus!"

Cartoon by Gahan Wilson. Reproduced by special permission
of *Playboy* magazine. Copyright © 1972 by Playboy.

but they are both *sight gags*, in more than one sense. They are meant to be
apprehended visually (Gahan Wilson's caption is essentially gratuitous, and
the humor of neither translates effectively into verbal form); and their sub-
ject matter – aside from the surreal improbability of Wilson's sitter and the
sexist silliness of Rouson's sitcom[28] – is human vision and its relation to cam-
era optics.

The implications of these two images are highly significant. Both appeared
in widely distributed periodicals: Wilson's in *Playboy*, Rouson's in hundreds
of newspapers to which it is syndicated. The demographics of *Playboy*'s read-
ership no doubt differ from those of Rouson's newspapers, but clearly both

these cartoonists assumed that the optical principles which are operative in these two jokes could be easily recognized by the average person in a matter of seconds. Yet three hundred and fifty years ago there would have been few

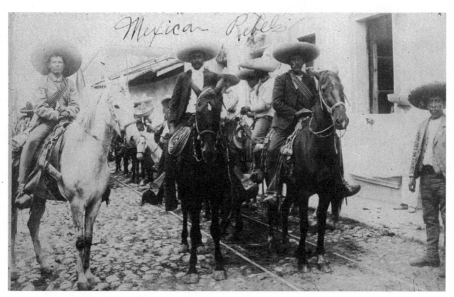

Anonymous. Collection of the author.

people in the world capable of interpreting these images in terms of the understandings of visual perception and lens optics implicit in them.

The perceptual evolution engendered by photography and epitomized in these two cartoons has been profound, but so rapid and pervasive that we have tended to take it for granted. Consider now the photographs reproduced here – macabre "before and after" souvenir postcards from a series about the Mexican Revolution.[29] These are communications of a kind that could not have existed prior to photography. The plethora of incidental detail that vivifies the events, the immediacy, the descriptive accuracy, and the sense of witnessing in these images (which are otherwise quite ordinary in their crafting) sets them apart from even such earlier masterpieces of visual reportage as Goya's "Disasters of War."

The Digital Evolution

In this instance the event has been trivialized, it seems; but that has more to do with the form of presentation – postcards being small, transient, casual, and ephemeral – than with the medium itself. There are certainly photo-

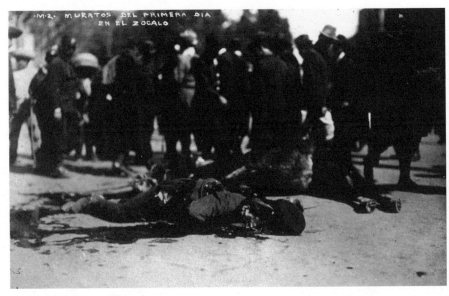

Anonymous. Collection of the author.

graphic forms in which these same images could be made to monumentalize what they describe. It is in the nature of every communicative medium that it can be used to reduce the meaning of experience as well as to distill it.

But imagine making these images, and turning them into postcards for sale. Imagine buying and sending them – an act of vicarious journalism. Imagine receiving them in your mailbox some morning. Consider what is assumed as given in each of those experiences, and you will be in a position to assess the gulf between a pre-photographic world and our own.

Photography has thrust us into an imagistic world. Perhaps that was inevitable; perhaps it is even for the better. This may have made possible at last the evolution of the intuitive, image-oriented right hemisphere of the brain, which would increase our potential for realizing at long last some

healthy balance between the right brain and the more rational, linear left hemisphere.

But, even if that is so, we are presently at a very early stage in that evolution, and a highly precarious one at that. Educators speak excitedly about tapping the creative potential of a generation raised predominantly on images, but that potential – if it does indeed exist – has barely begun to be realized. What is apparent, at the moment, as a manifestation of this hemispheric transition, is that verbal literacy is in a rapid and shocking state of decline, while visual literacy is still (although the level may be higher than ever before) in a basically passive stage of its development.

This is surely a cause for concern. Historically, the collapse of civilizations has almost always been preceded by the degradation of their language systems. If the solution in our case is projected to be the replacement of supposedly outmoded print-oriented verbal communication by visual communication, it obviously presupposes that the general populace will be as active a force in the shaping of visual language as it has been in the shaping of verbal language. At this point, however, that does not seem to be taking place.

Temporarily or not, we are presently a culture of visual communicatees, not communicators. Visual communication is experienced by many, but initiated and practiced by very few. The risks inherent in this imbalance are self-evident. As Stokely Carmichael said, "He who controls the definitions controls the structure of society."[30]

Since we have no way of knowing in advance the duration of this transition period or its aftermath, the prevalence of a receptive, non-initiatory relationship to visual communication is, at the very least, problematic. It leaves us open to visual manipulation *en masse*, considerably prior to our development of warning systems for same and effective methods for counteracting such mind control.

If, in fact, this passivity is endemic to or inherent in right-hemisphere behavior, then we have cause for alarm: the blinders of linear rationality are no worse than those of undiscriminating retinal response. The former reduced the Vietnam war to statistics; the latter converted it to home entertainment. I wish that this anxiety could be classed as purely speculative. Unfortunately, it cannot. The visual communications technology that buttresses the totali-

tarian futures predicted in George Orwell's *1984*, Aldous Huxley's *Brave New World*, and Ray Bradbury's *Fahrenheit 451* is with us today.

By now you have probably been to cinematic "feelies" like *Midway*, presented in Sensurround. You've seen 3-D movies, as well as still and motion holograms. You've encountered the Advent wall-size video screens, not to mention the whole range of home video equipment – Porta-Paks and such for generating your own video programs, Betamaxes and videodiscs for storage, retrieval, and playback. Surely you're familiar with instant color photographs. (You may even have witnessed the astounding Zest commercial in which photo-voodoo is practiced by washing SX-70 images of a woman with two different kinds of soap to demonstrate that Zest leaves no film; the woman herself is present in the ad, but the photographs, her surrogates, receive the cleaning. See the print version on p. 34.)

All of this stuff – the equipment, the processes and the exciting, accelerating rapidity and volume of image transmission they make possible – is of course fascinating. And seductive. And therefore dangerous. Such right-hemisphere playthings have a sinister side (pun intended). Add to the above list of innovations the small, inexpensive-to-manufacture, easy-to-install device that can turn any TV set into a video transmitter. Include sophisticated electronic equipment that makes visual and verbal eavesdropping a bagatelle. Throw in computer graphics – there are examples, nightly, on your TV set – whereby any still image can be converted into a videotape in which the subject of that static image can be made to perform any action realistically. Cap it with another computerized technique, now being used in police and espionage circles, that makes it possible to feed into a computer a very fuzzy or unfocused photograph and get back a much sharper and more defined version of the same image, generated through the application of the laws of statistical probability.

None of this is privy information. I don't have access to special sources; I just read the newspapers and the photo magazines. If this is what's visible on the surface of the current revolution in visual technology, imagine what exists that isn't being made public. Our visual hardware has already reached a point at which photographically credible still and kinetic imagery – some of it even three-dimensional – can be generated with little or no basis in

reality. I've touched on this subject before; I come back to it because the technology keeps growing more sophisticated, and we're not changing ourselves enough to keep up with it. We are hardly prepared to deal with this technology, even in its most benign manifestations. Its malignant capacities are awesome and self-evident.[31]

The only solution is cultural self-defense. We must take the tools into our own hands. Pay closer attention to what we see and what we are being shown than we ever have before. Consider, discuss, and argue with what is being communicated to us visually. Pick up the image-making machines and learn to control them. Teach our children well. And remember: the seduction of Narcissus was visual.

(November 1976)

No Future For You?
Speculations on the Next Decade
in Photography Education

...Let us consider the next decade through a series of speculations. These projections are based on actual events and current data, not on extrasensory perception. They are not prophecies; they are safe predictions.

The medium of photography is in the midst of a technological upheaval unmatched since the fruits of World War II military research were declassified and made available to the post-war public.

We are witnessing the rapid disappearance of silver as the primary vehicle for photographic imagery. The current generation of students is probably the last that will take the availability of silver-based materials for granted. Since much of the tradition of photography – in educational, historical, and critical terms – is based upon the silver negative and the silver print, extensive revision of our premises in these regards will be necessary, as will the development of comparable understandings of such likely replacements as magnetic and/or electronic films and papers.

Such a change will leave those involved with two-dimensional non-electronic or non-magnetic imagery even more at the mercy of the major photographic manufacturing corporations, which already are far too influential in determining which materials shall be made available to photographers. Thus it might be advisable for us to take steps towards creating a generation of students educated to be alert consumers of photographic materials, trained to make active and effective demands on the suppliers of those materials.

We are also on the verge of major breakthroughs in three-dimensional imagery, with holography by far the most likely candidate for the dominant process in that area. The introduction of holographic equipment and

materials that are economically and technically accessible to the popular market may well take place during this coming decade. I see no reason not to believe that such a process will replace two-dimensional imagery as the primary vernacular photographic medium as surely as color replaced black & white in that same field.

This will have the inevitable result of rapidly rendering two-dimensional imagery – especially in black & white, and most particularly in silver – obsolescent and archaic. In the minds of many, that will automatically make such imagery more "artistic," by rendering it non-functional in the everyday traffic of visual communication. It will certainly create a schism among photography students in their attempts to determine which of these major branchings merits their personal and/or professional commitment. It will probably create a similar schism among photography educators, and even those who manage to develop an educational methodology encompassing both forms had best be prepared for the divisiveness this evolution will generate.

There is another aspect of this technological upheaval that merits our serious attention. As I have noted previously, we have already entered an era in which the forgery of photographically credible imagery is eminently feasible. I am not speaking here of the expressively oriented work of such image-makers as Jerry Uelsmann or Clarence John Laughlin, though their techniques are readily adaptable to the production of imagery with other intentions. Rather, I am speaking of recent developments in the technology of image generation.

It is now possible, by a computerized process developed for police use, to reconstruct from even the blurriest film or still photograph a sharper, more focused image of anything depicted therein. This is achieved by the application of statistical probability factors to the various possible resolutions of such out-of-focus images. It is also possible, by another computerized technique, to take a still image of anything – including such an artificially resolved photograph as described above – and from it generate still or kinetic video images in which the subject of the original image can be made to perform any desired action realistically in convincingly dimensional space. What this means is that our visual communications hardware has reached

The Digital Evolution

the point where photographically credible imagery, both still and motion, can be manufactured with little or no recourse to actual photographs.

The existence of such technology within a culture which has been convinced for almost one hundred and fifty years of the scientific accuracy and evidentiary unimpeachability of photographs as documents should be cause for alarm. The visual technology for population surveillance and for the manipulation of news, fact, and history which buttresses the totalitarian futures projected in Aldous Huxley's *Brave New World*, Ray Bradbury's *Fahrenheit 451*, and George Orwell's *1984* are all in existence at this moment. Certainly as photography educators we must begin to work towards increasing the sophistication of the citizenry at large in the interpretation of photographic imagery and its manipulative potential; we must also work towards the establishment of professional codes of ethics, effective detection methods and legislative controls to counteract that potential. . . .

Surely these are not the only problems ahead for those involved with education in photography. No doubt there are others already visible, and still more which have yet to surface. But I believe that these will be among the central issues of the next decade for all of us.

I did not come here with ready-made solutions to these problems – this speech is not a test. But the decade ahead certainly is. The answers to it, right or wrong, lie within us and the courses of action we choose. I hope that what I have said here tonight provokes some discussion of these issues among us. And I hope that in 1988 I will be able to read over these words and discover that they were not entirely irrelevant to the decade they anticipate.

Thank you.

(March 1978)

Lies Like Truth:
Photographs as Evidence

Isn't it time to stop believing photographs?

As I've indicated previously in these pages [*Camera 35*], one of our culture's earliest and still-dominant responses to photographic imagery has been a blind faith that photographs can be trusted implicitly – that what we see in a photograph is "real." Our legal system accepts photographs as evidence admissible in court. Could this society demonstrate any greater confidence in the photograph's unimpeachability as a witnessing mechanism?

Yet a number of ostensibly unrelated phenomena, occurring simultaneously, suggest that we are on the verge of a major reassessment of photographs as evidence. This development is long overdue, given what we already know about the subjectivity of photographic image-making and the range of interpretations to which its results are open. It is also urgently necessary, due to the dangerous potential inherent in some of these phenomena.

Much of contemporary art, from photo-realist painting to so-called "conceptual" work, is explicitly concerned with one or another aspect of photographic verisimilitude. From the photo-realists' renderings in pigment of the effects of lenticular vision[32] to the conceptualists' photo-documentation of staged events,[33] the photographic re-presentation of reality is a central issue.

This inquiry into the nature of camera vision – this concern with the medium's infrastructure – is one that photographers of course have pursued also, as a central and unavoidable aspect of their work. Essentially, it's a philosophical debate over the relation of the photograph to the world it depicts. This debate can be traced back virtually to the medium's inception.

The Digital Evolution

One can track it from the controversy over Robinson and Rejlander's use of multiple negatives through the purist-pictorialist confrontations in *Camera Craft* magazine in the 1930s, into Weston's *Daybooks* and the writings of Wynn Bullock and others, right down to the present.

Indeed, photography currently is undergoing a massive formalist analysis by its practitioners. Much of this is coming from the relatively new academic sector, with results so dry and pedantic that they are often of interest to no one save other academics. In other instances the imagery itself and the ideas it embodies are provocative enough to merit a broad audience.

Three recently published works address the question of the photograph as evidence from very different vantage points. These are *Hitler Moves East: A Graphic Chronicle, 1941–43*, by David Levinthal and Garry Trudeau;[34] "Portraits of Violet and Al: A Photographic Fiction," by William DeLappa;[35] and *Evidence*, by Larry Sultan and Mike Mandel.[36]

Hitler Moves East is a collage of military photographs, maps, archival illustrative material, and excerpts from diaries, public announcements, and other written sources. This is a now-common format for books of contemporary history, and *Hitler Moves East* is a quite creditable – and credible – contribution to that field. There is only one catch: all the military photographs are fakes – created by one or another form of what used to be called "table-top" photography.

In a number of cases they are recognizable as such, and the book announces their origin on its jacket flap. Trudeau (who is also the creator of the cartoon strip *Doonesbury*) states in his introduction that Levinthal, the photographer, "has made no attempt to conceal the formal identity of his subjects. There is no intent to deceive." This may be disingenuous. But that's beside the point, for at least two-thirds of these images would probably pass most eyes with their authenticity unquestioned.[37]

Levinthal has used the sepia tonality of Kodalith paper and its high contrast, and a consistently shallow depth of field, along with painstakingly positioned miniatures and settings, to create images that by and large fulfill our assumptions as to what such photographs "look like." Blurred, fuzzy, grainy, overexposed, they are what we would expect of negatives and prints made, processed, and stored in the hazard and haste of wartime.

We have become habituated to such photographs, not only from their use in books of the kind this one parodies but in film and television "documentaries" constructed by sequencing and animating vintage imagery. We take their authenticity for granted so long as they conform to the established conventions of documentary photography's sign system. Paradoxically, it's that very sign system which makes falsification and forgery possible.

That possibility is the true subject of this unusual and well-conceived book. The book itself, as a piece of work, stands somewhere between the two poles. On one hand, it gives sufficient clues so as to disarm its own potency as a full-scale hoax; on the other, its overall effectiveness demonstrates how little additional subterfuge would be needed to make such a con almost foolproof.

DeLappa's "Portraits of Violet and Al" goes all the way. The work consists of a series of images that center around the two title characters. It purports to be their "family album," a composite of several dozen photographs made by different people over some three decades' time. Most of them are what used to be called "candid," though there's one that appears to be an I.D. picture made for some official purpose. Some, obviously made in urban shopping areas, were ostensibly purchased from photographers making instant portraits on the street; others seem to have been made by family members or by "Al" himself, who is absent from many of them.

The images describe a considerable span of time and events. Violet and Al meet and marry during his Army service in World War II. They make friends, visit relatives, celebrate Christmas, age, and remain childless. Hairstyles, clothing fashions, modes of interior decorating, automobile design, and architecture change.

DeLappa's directorial work has been painstaking in the extreme – there are no anachronisms or other internal inconsistencies to give his game away. Even the original prints (the work's first appearance was as an exhibition) appear to be the age they're supposed to be, showing the wear and tear of time as well as all the "flaws" that vernacular photography is heir to: tilted horizon lines, a TV antenna growing out of Al's head like rabbit ears, thumbprints on the surface of a Polaroid, and the like.

In short, it's a typical, even archetypal, white middle-class family album. By the time these images are translated into the form of reproductions (as

The Digital Evolution

Untitled, from *Hitler Moves East* © 1975 David Levinthal
Courtesy of the artist

in the issue of *Creative Camera* that was devoted to them), all clues to their
origin have disappeared. One would not think to question their authenticity;
their fidelity to another consensual photographic sign system certifies them.

The series is certainly a virtuoso display of self-effacing craft; DeLappa's
mastery of materials and processes is evident in his ability to duplicate a
remarkable range of vernacular imagery. The intent of the work, like that
of *Hitler Moves East*, is not just ironic but critical. Like any family album, it
encourages us to project our stereotypes, assumptions, and interpretations

onto a group of mute images of human beings, to impose a narrative framework on these fragments from people's lives. At the same time, it points up the fact that those story lines are all a form of fiction, born of our need for order, continuity, and logic, but "true" only by coincidence, if at all.

Evidence is another kettle of fish entirely. The book (for which there's also a traveling exhibit) is composed of fifty-nine anonymous photographs from the files of "government agencies, educational institutions and corporations," selected by Mike Mandel and Larry Sultan. It's a handsome, well-printed volume bearing the imprint of Clatworthy Colorvues, the aegis under which Mandel and Sultan pursue a variety of unique photographic enterprises. (They have collaborated on a series of distinctive billboard pieces, including "Ties" and "Oranges on Fire." As a solo act, Mandel is perhaps best known for his "Famous Photographers Baseball Cards," packaged complete with Topps bubble gum.)

The pictures appear to have been chosen with one eye cast ironically on the current state of "art" photography, since on one level the book functions as a "found" anthology of virtually every current style in the medium, from the snapshot aesthetic through minimalism to "new topographics." There's at least one image in this book that could be inserted into the next exhibitions of Ralph Gibson, Lee Friedlander, Garry Winogrand, Lewis Baltz, Mark Cohen, Robert D'Alessandro and a dozen other photographers and pass unnoticed. There's even a handful that could be insinuated into retrospectives by Minor White, Arnold Newman, Diane Arbus and Weegee without too much subterfuge being necessary.

Presented in those contexts, these images would no doubt evoke reams of formalist analysis and symbolic interpretation from viewers and critics – myself, I'm sure, among them. Part of the book's function is as a deadpan spoof of the seriousness with which we have invested such imagery when it's presented to us under the rubric of Art, and of our essentially bigoted refusal to take it seriously when it come from other sources.

Another of the book's functions might be termed an ecological one, in that it opens the door to the vast array of mysterious, ludicrous, and otherwise fascinating photographic imagery that already exists but is rarely if ever seen and appreciated. Given the existence of such a photographic midden

heap, do we really need any more? Perhaps we just need more and better editors.

But *Evidence* is not only a self-referential critique of contemporary creative photography, nor a random anthology of variously intriguing images. It's a precise statement with a specific point, which is this:

Here is a set of images made by professional photographers. The impulse behind their making is not aesthetic but functional; they're intended to convey specific situational information to experts in various fields. That's why they've been made, sorted, and preserved – because they're "evidence." But of what? They contain quite a bit of visual data, but in and of themselves they are not carriers of information in any meaningful sense of the word.

Granted, I'm a layman in all the fields to which these images pertain, and perhaps unqualified to interpret their particulars. But the general nature of these images, their essential ambiguity, is such that I can't imagine being able to lay one down in front of a specialist and receive an unequivocal interpretation of its message. Out of context – which means, essentially, without a written or spoken explanation of what they're supposed to show – they have no meaning. Or, to put it another way, they have so many possible meanings that to single out any one of them strictly on the basis of the photographic data would be almost impossible.

Yet this mute, fragmentary, utterly ambiguous imagery is treated as evidence by the institutional superstructure of this society – government agencies, educational institutions and corporations. Does that not raise some provocative questions about the relationship to fact, information, and truth – all aspects of the concept of "evidence" – that is maintained by this society and its superstructure?

Mandel and Sultan have refrained from providing any easy resolutions of those questions; the images are not captioned, nor are their individual sources even identified. We will never know what these images are meant to show – and that, I think, is the point.

Thinking about these three projects and their implications leads me back to a concern that is on the verge of becoming an obsession. Let me try to draw its outline in a paragraph.

On the formal level of law and the informal level of cultural consensus, the photographic image enjoys the status of evidence (both supportive and *prima facie*). As such, in most cases it is at best ambiguous and equivocal, as the Mandel-Sultan project demonstrates. Moreover, convincing yet spurious photographic "proof" can be manufactured relatively inexpensively and without recourse to unusual equipment or materials, as DeLappa and Levinthal-Trudeau show. Recent advances in the technology of image production, alteration, and dissemination – among them holography and the computerized generation of imagery – make it possible to produce even more credible photographic imagery, more credible because it can be three-dimensional, kinetic, or both. And all these tools, materials, and processes are at the disposal of the military, the police, the government, the C.I.A., the Weather Underground, the Not-Ready-For-Prime-Time Players . . . everyone.

Now just imagine for a moment that you lived, like me, in a culture that depended heavily on photographic imagery for information – a culture whose understanding of history and sense of reality were based more and more on that imagery. And imagine that you were subject to spells of paranoia: not the hard-core variety, just the periodic suspicion that people in high office and other positions of power (perhaps even the President himself!) lacked an unshakable commitment to truth. If, on top of that, you learned all the facts in that preceding paragraph, what kind of thoughts do you suppose might go through your head?

Consider the possibilities.

(October 1978)

Some Thoughts on Hairless Apes,
Limited Time, and Generative Systems

Much of our present-day debate over appropriate strategies for the meaningful interpretation of photographic images is a brave attempt – and perhaps a futile one – to resolve problems caused by our lack of a critical tradition in photography.

The significance of such a lack, in any medium, is clearly stated in this passage from Hugh Kenner's *The Pound Era*:

> There is no substitute for critical tradition: a continuum of understanding, early commenced.... Precisely because William Blake's contemporaries did not know what to make of him, we do not know either, though critic after critic appeases our sense of obligation to his genius by reinventing him.... In the 1920s, on the other hand, *something* was immediately made of *Ulysses* and *The Waste Land*, and our comfort with both works after 50 years, including our ease at allowing for their age, seems derivable from the fact that they have never been ignored.[38]

If the absence of such a "continuum of understanding" can be felt in photography generally, it is even more specifically noticeable in the critical literature on the technology loosely gathered under the umbrellas of "copy machines" and "generative systems" and the imagery collectively titled "electroworks" by this exhibit and symposium.[39] If the bibliography in the catalogue[40] is representative, then the critical literature addressing this technology and its consequences is scant and – at least in the case of my own contribution to it – utterly inadequate.

It was with considerable chagrin that I discovered my own critical effort in this area consisted of nothing more than a few occasional pieces, and that even the most substantial of those occupied only a page or so, raised but a few of the many essential questions and provided no answers at all, not even tentative ones.

This is especially distressing to me not only because it's a gaping hole in my critical work but because I've had hands-on experience with various forms of generative systems and copy machines. This personal history runs the gamut from being a teenage office gopher in charge of duplicating memoranda back in the 1950s to creating images myself on these machines in recent years: small editions of prints from collage matrices on the Xerox Color Copier, a body-scan self-portrait series done on the Haloid Xerox.[41] But even these direct and, to my mind, productive experiences with various aspects of the craft have left me little closer to the critical understandings I'd hope to evolve.

Still, I'll try to reformulate and sharpen some of the questions I asked five years ago; and I may be able to shed some light on the central source of the problems the critic faces in discussing work in this area.

What I feel the absence of most acutely in my critical attempts to grapple with electrostatic imagery and its modes of production is a set of lucid and cogent hermeneutic understandings: a written codification of those essential aspects of craft which inform and define the work, a dissection of its infrastructure. What are the particular attractions of generative systems as vehicles for image-making? What do they make possible that was impossible previously? What are the definitive limitations of the form – what *can't* be done, and why? In short, what are the aspects of process that must be understood in order to interpret and assess the work produced?

If this seems a request on my part that the artists do the critics' job, it's not. Exegetics – the analysis and explication of works – are the responsibility of the critic. But exegetics derive from and depend on the hermeneutics of performance, which are the practitioner's domain. And exegesis based on incoherent or shallow hermeneutics is likely to reflect the weakness of its foundation. As a critic, I've found very little writing in the field that points me toward a broad, integrated theory against which to gauge the practice.

The Digital Evolution

Therefore, let me take this occasion to make a formal request to the image-makers working in this form – a request not for more images but for more writing. You must provide a set of clear ground rules if you want an attentive and responsive audience.

When I last wrote about generative-systems art, in 1974, I analogized between this technology and the proverbial monkey who – given eternity and a typewriter – would in theory eventually produce every great work of literature already written, as well as all those to come.[42] In reality, we hairless apes have limited time, and I am becoming aware enough of that restriction that I can empathize with almost any attempt to create tools capable of faster response to the impulses of mind and spirit. My basic concern, then and now, is simply this: How, as a critic, can I go about the task of evaluating the achievement represented by a completed "electrowork?" If these are indeed collaborations – or, as Marilyn McCray puts it in her introduction to the catalogue, "closed partnership(s) between the artist and the machine"[43] – then how much of the success (or failure) of a given work should be attributed to each partner?

I am not such a Luddite that it disturbs me philosophically to give credit to a machine. Machines, after all, only embody and represent the sensibilities of those who devise them. Their inventors may be unaware of or perplexed by the uses to which their brainchildren are put, but they are nonetheless silent partners of and collaborators with those whose names are finally placed on the imagery. But how is the critic to give credit where credit is due? What percentage of the success of any "electrowork" belongs to the process and its inventors? Why are their names not on these images as well, if the artists truly accept them as collaborators?

I hope it doesn't make me seem (to quote Ms. McCray again) either an "old-line humanist" or an "art-for-art's-sake critic"[44] if I say that the two critical issues that still confuse me are, first, the question of authorship as just described and, second, the question of consumerism. Is there something inherent in generative systems as such that turns the artist into a consumer rather than a maker – into a person who simply selects from a range of available products rather than one who creates things that could not have existed otherwise? After all, if we're dealing with a technology

that not only facilitates the production of imagery but indeed *generates* imagery in an autonomous way, then the politics and aesthetics of that system are as much a critical concern as the politics and aesthetics of the artists who employ it.

I realize that raising these questions makes me sound antiquated. I also realize – with a full sense of the irony involved – that they're directly analogous to the questions (and objections) that were raised in relation to photography during the first decades after its invention. At the risk of appearing as someone whom generative systems have hurled back a century and a half in time, I'd like to point out that those questions were not inappropriate or foolish then, and are not inappropriate or foolish now. What those early commentators on photography were inquiring about were the hermeneutics. What, they were asking, were the imperatives and limitations of the photographic imaging system, and in what ways was it accessible to human manipulation and control? (Their signifier for that control was the mark of the hand; mine, today, would be the mark of the mind.) But it was not until camera workers formulated their structural understandings of the medium, and began to communicate them through written theories of photography, that the questions became unnecessary. I think we are in the same position today in relation to generative systems – and the critics will be forced to ask simplistic and obvious questions until the practitioners render those questions obsolete by educating the critics so that the critics in turn can educate the public.

Finally, at the risk of biting the hands of almost everyone present, I want to say that I'm disturbed by aspects of this exhibit and the events that surround it. In a number of quite blatant and highly symbolic ways, the artists represented in this exhibit were told last night that – in relation to the corporate structures that support this institution [the International Museum of Photography at the George Eastman House] – they are second-class citizens, to be segregated and discriminated against even as their work is being used. I found that both revealing and distasteful. It was mitigated, for me, only by the fact that my companion and I were automatically grouped with and treated exactly like the artists. I appreciate the tacit recognition of my fundamental allegiance in such situations.[45]

But to the artists I have something else to say: *You asked for it.* As this exhibit demonstrates clearly, you have taken a conglomeration of democratically accessible imaging systems intended for the production of inexpensive multiples, and have eagerly devoted your efforts to the creation of unique or limited-edition prints that are intended to be considered as precious objects in the art market. You have taken a technology geared for mass communication of ideas and converted it into a set of instruments for the exploration of private experience and personal sensibility. In that regard, this exhibit is your triumph – a clear demonstration that generative systems and copy machines are capable of producing museum-worthy and financially valuable capital-A Art.

However, the readiness with which this work succumbs to museumization – its absolute lack of defiance of the context in which we're viewing it today – suggests that economically, politically, aesthetically and conceptually, you and your work are committed to the hierarchical assumptions and cultural elitism represented by institutions such as this. To use this technology for the creation of high-priced artifacts aimed at museums, art galleries and wealthy collectors is to affirm the legitimacy of the very system responsible for offending you last night. Were you naïve enough to believe that you could escape that system's clutches, or that your support of it would exempt you?

The distinction that this exhibit's catalogue calls for – "Between the fine artist and the lay 'Key Operator'"[46] – has social and political ramifications you would do well to contemplate. The paradox involved is one that you, the artists, have the responsibility of resolving. Were you shafted last night? Unquestionably. But you were only hoist on your own petard. Perhaps this experience will prompt you to consider whether you are in fact being true to the underlying principles of the technology you've embraced, or are instead subverting its real potential. It may be time for a radical reconsideration of your medium – *radical* in the original sense of the word, which means to examine systems (including generative systems) by their roots.

(November 1979)

Fiche and Chips:
Technological Premonitions

In Mike Nichols's film "The Graduate," the older generation's sage coun-
sel for the future was summed up in a word: "Plastics." If an equivalent
torch were being passed to the younger generation today, I'd expect a dif-
ferent distillation: "Information."

We are presently undergoing an epochal transformation of our tech-
nology for the gathering, storage, retrieval and transmission of
information. Such advanced communications media as video, Super-8
film, and instant color photography already are publicly available and eco-
nomically accessible to a wide range of people. Public access to radio and
TV broadcasting facilities and channels is a tenuously established legal
right and, in some experimentally minded communities, an established fact.
Various other devices for the publication and dissemination of informa-
tion – including the offset press and the postal system – are at everyone's
disposal. (None of it is free – tools never are – but much of it is inexpen-
sive.)

Looming on the horizon, simultaneously, is the so-called "personal
computer" in combination with the "home entertainment center." These
devices, in some not-too-distant versions, are bound to include scanners
capable of reading (and printing out) virtually all the common forms of
encoded data: microform, videodisc, computer cards, and a host of others.
They will put the entire Library of Congress at the disposal of any member
of the citizenry who can afford these imminent successors to the standard
television set. In fact, it will become possible for the entire contents of the
Library of Congress to be stored in a few square yards of shelf space.

Because we are prone to thinking of *information* as written material, the common assumption is that this transformation will affect only our dealings with the written word. This is far from the case. Clif Garboden, writing on the subject of computer graphics for Polaroid's house organ, *Close-Up*, points this out:

> "In the documentation of the step-by-step construction of a complex missile system, for example, the ability of pictures to summarize is invaluable; alternatively, it is difficult to imagine the amount of written material which would be necessary to accomplish the same task. *Because of the benefits offered by the visual image, experts in the computer industry project that computer technology through the 1980s will emphasize picture processing in addition to word processing . . ."*[47] (Italics mine.)

M. Richard Kirstel has proposed that we might profitably contemplate photography as another form of information management.[48] In that light, I ask you to consider the following technological developments – all of them either presently existing or imminent – as interactive components in a rapidly evolving transcultural system for visual communication.

* Pentax has already produced and marketed a single-lens reflex camera in the 110 format – a camera system (complete with flash and interchangeable lenses) that can fit into a jacket pocket.
* Sony has just introduced the prototype Mavica, a camera system that encodes fifty photographs electronically on a magnetic videodisc. These images are instantly viewable on a TV screen, and can be transmitted over telephone wires. Sony expects to market this camera within the next two years, along with attachments permitting TV-screen viewing and the production of printed copies of images.
* The Bell System's TeleCopier has for a decade made possible the transmission of visual images via telephone.
* Biofuel, a California company, in collaboration with Ramtek (a manufacturer of computer-graphic display systems), has announced the inven-

tion of a "frame grabber" capable of making almost instant color prints up to 8×10 inches in size on plain paper from any video image. The system will be capable of reproducing over 50,000 hues, at a cost per copy of less than ten cents. This system will be marketed within two years.

* The Associated Press now works with a computer called an "electronic darkroom," which can store up to one hundred images at a time in digital form. An editor, sitting at a computer console, can call up any of these images on a TV screen. They can be cropped, enlarged, and treated with a variety of "image enhancement" techniques: lightened or darkened, either overall or in specific areas; intensified in contrast; even increased in sharpness. These images can then be printed out on receivers close at hand, or transmitted by wire anywhere in the world – or to outer space.

* Minolta has announced plans for the "home facsimile," a device based on fiber optics that can send and reproduce printed information over long distances in less than a minute. The system includes a "personal copier," a hand-held device slightly larger than a fountain pen that will optically scan information and store it. The copier can then be plugged into the home facsimile to reproduce the electronically stored data on paper. Production is projected during the 1980s.

* Through the existing technology of computer graphics, it is possible to take a still image of almost anything and from it generate still or kinetic video images in which the subject(s) of the original image can be made to perform any desired action realistically in convincingly dimensional space.

* Holography – a 3-D imaging process – is now in existence in both still and motion picture form. The introduction of economically accessible holographic equipment and materials into the amateur market will almost undoubtedly take place during this decade.

* Video pioneer Robert G. Thomas recently announced his invention of a 3-D television system that will work on any color TV set.

* The microfiche, about the size of a standard postcard, costs about 7 cents per copy to produce in large quantities (*i.e.*, in editions of several thousand), and can encode upwards of four hundred pages of image and/or text – thereby functioning as a new form of book or magazine.

* *Time* magazine is working with Microsonics, Inc. to perfect a technology whereby record grooves can be imprinted on a printed page. By passing a microphonograph across the page, the voice of a person being portrayed or quoted will be heard. A five-year period is projected for production.

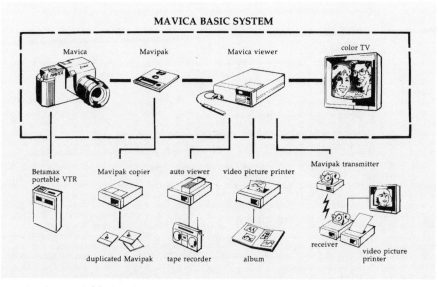

Reproduced courtesy of the Sony Corporation

I could go on, and on. We have been catapulted into the era of microform and silicon – the "fiche and chips" of my title. We now face the end of the era of silver, a precious metal, as the primary vehicle for photographic print-making. This is a symbolic dividing line, one that promises to create further separation between those concerned with capital-A Art and those concerned with communication, between those committed to the photograph as unique object and those committed to the photograph as dematerialized image and idea. Indeed, within the photography–education system and the professional realms of photography – including what we call "creative" or "art" photography – this transformation of the image-production technology will undoubtedly prove schismatic.

Fiche and Chips

Standing as we all do on this threshhold, it is essential for us to establish and maintain a set of consistent understandings to guide us through the maze ahead. Only experience can bring us answers, but to profit from our forthcoming encounter with this technology we must formulate appropriate questions. From the ways in which artists and photographers have responded already to the existing "generative systems" (a term loosely used to encompass all these devices and their interactions), we can see clearly that two contrary attitudes are already at work. I have discussed them at some length elsewhere;[49] I'd like now to revise and sharpen a crucial question which I posed at that time.

Is the challenge which now faces the image-maker that of taking commonplace means for the rapid production and dissemination of economically insignificant multiples and re-establishing hegemony over them by converting them into personalized vehicles for the creation of marketable artworks? Or is the challenge instead that of teacher-poets claiming for the citizenry a set of tools devised for the furtherance of the corporate/bureaucratic elite, humanizing those devices and revealing them to the polity as a birthright?

The assumptions underlying those two formulations are distinct and incompatible. The goal we set ourselves in regard to this technology – the purpose we establish for our relationship to it – will to a large extent determine our approach to its exploration. The prospect virtually demands that we rethink our fundamental assumptions. Sonia Sheridan, an eloquent theorist and artist who has pioneered in the exploration of generative systems at the School of the Art Institute of Chicago, has written at length on this subject. Here, in a set of quotes taken from several different statements, is her view of the situation:

"The artist as romantic recluse is no longer a viable conception in an age of accelerating dissemination of information and push-button imaging. As the number of participants in the image-making process expands, the number of experts grows larger. . . . From the day the art student enters school he enters the individualist's grind. Secrecy, mutual distrust and lack of appreciation for real insight seem to be the inevitable results of a system which promotes the individual at the expense of

The Digital Evolution

social needs. . . . The artist, who is supposed to be so free, appear[s] to me to be trapped in a tenuous thread of his own making. . . . The business of polishing up an image is a lot of crap. . . . I'm not searching for beauty – just to produce another 'aesthetic image' is a blind alley."[50]

(October 1981)

Digital Imaging and Photography Education:
A. D. Coleman interviewed by Thomas Gartside

Thomas Gartside: The topic for this year's [Society for Photographic Education national] conference is "Photography Within the New Technology: Defining a New Philosophy of Education." What are some of the things that led the board to adopt that topic?

A. D. Coleman: We're addressing that issue this year for several reasons. One is that the technology of image storage, retrieval, transmission, etcetera, is undergoing a drastic change at this point, primarily as a result of electronic imaging procedures and technologies that were unforeseen a decade ago.

How will this affect the traditional methods of photography education?

Photography education in the formal sense has traditionally revolved around the silver print. However, within a few years silver printing will probably not be the way in which most people encounter photography.

Do you see some advantages to the decline of the silver print?

Well, obviously, the new technology makes possible much more rapid and widespread dissemination of imagery, and may also help to move us away – at least within the photo-education system – from our addiction to the photograph as a precious object. The new technology de-emphasizes the photograph as object and re-emphasizes it as image and idea. Within the emerging systems of image storage and transmission, in most cases, imagery will be stored in some kind of video-encoded form. And it will only be in those circumstances when one wishes a hard copy of the image for some purpose – such as the physical formation of a family album, or to send to somebody as a gift or something – that one will actually produce a print of the work.

Are we still talking about the single image, or are we now starting to talk about running imagery?

By "running imagery," do you mean *kinetic*?

Yes. Like video, like TV?

I think that in some ways the distinction between the two is going to disappear, or at least to be emulsified considerably. For example, the Sony Mavica camera, which exists now in prototype form, and is due to be marketed in the next year or so, includes a camera that can be hooked up to a video-corder, and the camera will have both a still and a kinetic function. That is, you'll be able to make still frames or a running video documentary with the same camera, by flicking a switch. Those people – and we'll begin seeing them in photo education in a few years – those people who learn photography at home through such a system will arrive with the assumption that one aspect of image-making includes this ability to go from still to kinetic with the flick of a switch. That's a kind of student very different from the kinds of students we've encountered in photo education up until the present.

The perceptual activity of viewing a still is so vastly different than viewing a running image. I'm wondering if this is reflective of some larger cultural things.

Absolutely. What we are seeing is the increase of informational input and what they call "thruput" – and, as a consequence, the inevitable decrease in the amount of contemplative time that one is able to give to any specific piece. In essence, the image held in stasis – the still image, particularly the still photograph – is an icon, and its function can be contemplation. With the kinetic image, what is iconic, or what one contemplates, is not a single given image but the vehicle for that image. In television, in video, what one contemplates is the television set.

This development is disturbing to me, because I'm more inclined to the contemplative concept of what art can do; and I'm wondering if I'm old-fashioned, or if in fact there is something that's being lost.

There's something that's being lost, for sure, and my own inclination is toward the contemplative. At the same time, I think there's the possibility of something being gained – one thing being the ability to process

more information more rapidly, and therefore to possess a different, perhaps a broader grasp of what is happening around us. The risk, the problem, of course, is that what this is going to do, among other things, is to have drastic effects on the decision-making process. Because it forces the making of a decision on a more rapid basis, with less ability to think things through to their consequences, with less ability to hypothesize different potential consequences and direct a course of action. And it will tend, I think, to make us more reactive.

There seems to be a concentration on process and media in art education. In fact, the topic of this year's S.P.E. conference represents yet another step in that direction. Do you see any problems with this concentration on process rather than content?

Yes. It's a consequence of the new technology that one becomes so engulfed by the process of absorbing or trying to absorb all the information that one can encode with these new systems that one is distracted from the procedure of analysis and the application of critical/theoretical methodology to that material, because you simply become swamped by data.

Is there some awareness in the photography community of this problem – and, if so, what steps can be taken to combat it?

The first step in this is for the teachers of photography themselves to confront the fact that this drastic change is right around the corner, that we're going to start to see students who are habituated to this new technology in the next five or so years. That's something I think that most of us have tended to bury our heads in the sand with regard to, because it will require that most of us drastically re-educate ourselves. We'll also have to recognize as teachers that, in a sense, our function will continue to be one of countering a certain cultural tendency in relation to photography. We must direct students to pay more attention to the images they're making, rather than to give themselves up to the technology and surrender to its blandishments – direct them to make fewer and fewer images, and to think harder and harder about them.

(March 1983)

Lens, Culture, Art:
A. D. Coleman interviewed by Daniel Kazimierski

Daniel Kazimierski: . . . What changes in image-making, as well as in critical approach, do you foresee in the near future?

A. D. Coleman: Developments of the electronic technologies of information storage, transmission and retrieval that are emerging are going to drastically reshape the way we deal with both still and kinetic images, as well as the way we *think* about visual communication. I have a feeling that film – in the way we now think about film – is going to get lost in the shuffle, and we're going to end up with electronic imaging systems.

From the critical point of view, we're going to face another problem. Critics who are trapped in certain kinds of elitist or high-art definitions of photography – that is, critics who are emotionally committed to the fine print, gallery or museum presentation or expensive monograph as ideal vehicles for photographic activity – are going to have a very difficult time, because those forms are going to be outdated by the new technologies. Rapidly. Audiences for those forms will be very different from emerging audiences, who may be used to images generated out of transmission processes – images which, by their very nature, have a much more disposable quality. In that sense the electronic imagery, which will not have the aura of the unique hand-made object, may truly get us away from the object-fetishism of some forms of photography.

(February 1984)

Information, Please

In the communications environment of our time, the modes of still photography on which we most depend for reliable information about the social and political context in which we exist – those overlapping forms we loosely call "documentary" and "photojournalism" – are very much in flux. Both have changed drastically in the past quarter-century, as a result of complex interactions between such factors as the imperatives of practitioners, the editorial/distribution systems that deliver their work to the audience, the expectations and desires of that audience, and the emergent new technologies for visual communication. Yet we continue to talk about *documentary* and *photojournalism* as if those terms still meant what they were taken to mean forty years ago.

Originally, the function of these forms was informational and/or representational. It was the general purpose of those involved to *inform* – literally, *give form to* – what would otherwise be a welter of dissociated data; their intent was "to bring clearly before the mind" the events of their time – that being the primary definition of *representation.* This seems no longer to be the case. Or, to put it more precisely, while some people continue to work under that assumption, there is a great deal of photojournalism and documentary photography that does not conform to those definitions. I want to examine briefly these changes and their causes; out of that perhaps some new, more applicable understandings may emerge.

*

The Digital Evolution

Over the past several years, on several occasions and in locations as far-flung as San Francisco, Amherst, and Vienna, I've encountered a curious version of the history of the documentary impulse in photography. In summary, it goes something like this:

* Documentary was invented by Lewis Hine and Jacob Riis, the latter of whom is not to be given any credit due to character flaws and wrong politics.

* It was carried forward by August Sander, who was stopped by the Nazis in Germany; the members of the Photo League in New York, stopped by the right wing at home; and the Farm Security Administration team, whose work was perverted by the patriotism and subsequent corporate allegiances of its organizing mastermind, Roy Stryker.

* The only remaining documentary work of any significance being done by 1945 was that of Paul Strand, who unfortunately achieved nothing more than he already had (except that he "got old").

* There are no significant lessons to be learned from the work of the photojournalists and documentarians who were presented in mass-circulation magazines and books – David Douglas Duncan, Margaret Bourke-White, Henri Cartier-Bresson, Dorothea Lange, all the others.

* W. Eugene Smith – arguably the most influential, certainly the most controversial, and to my mind the most seminal and richly problematic of those workers – is to be mentioned only in passing, and only in order to be dismissed. The standard method for this is to decontextualize his work (something he resisted actively during his lifetime). This is accomplished by showing only the single image "Tomoko in her bath" from Eugene and Aileen Smith's *Minamata*, analogizing it to the "Pietà," and insinuating that the analogy somehow invalidates both. (A significant subtext to this devaluation of Smith is the omission of any mention that *Minamata* was a collaborative work: a collaboration between a Japanese and an American, between a man and a woman, between a husband and a wife. Since collaboration is a buzz-word among those who offer up this version of recent history, one can only assume that they find Smith guilty of what cartoonist Jules Feiffer once called "premature morality.")

* Thus, according to this account, by 1955 or so the documentary mode

had fallen into abuse and neglect, so much so that nothing of any note was achieved therein until – *mirabile dictu!* – it was "reinvented" in, of all places, San Diego, California, circa 1974. (Though its purported reinventors were variously friends, teachers, students, and colleagues of each other at the University of California, that fact is not considered essential knowledge, and goes unmentioned – as does the fact that several of the published and/or spoken versions of this history of recent documentary were authored by these reinventors themselves.)

* Characteristically, in these accounts the work of the San Diego reinventors of photography and of others accepted into their circle is described as "politically effective" when, in fact, it has had no demonstrable political effect whatsoever. Those involved in producing these works – and in generating the obligatory critical validations thereof – seem intent on deliberately confusing the term "political effectiveness" with the term "ideological correctness." One can understand their avoidance of the latter, with its totalitarian overtones, but that must be what they mean, since to speak of the political effectiveness of patently inconsequential work is to utter nonsense.[51]

There are far too many flaws, errors, and gaps in this eccentric (and, in several cases, egocentric) history for me to correct here. Let me indicate just a few:

First, the history of the documentary and photojournalistic modes is infinitely richer and more diversified than this presentation would admit – more so, indeed, than is perhaps known, since many earlier documentary projects are only now coming to light. The lessons to be learned from these works – the lessons of their failures as well as their successes – have yet to be adequately drawn.

Second, the period which this skewed history defines as a desert – the years from 1955 through the early 1970s – was, to the contrary, an extraordinarily fertile period for such work, particularly in its exploration of book form as a vehicle. To name just a few of the key works produced during that era, there were Henri Cartier-Bresson and Jean-Paul Sartre's *From One China to the Other*; Robert Frank's *The Americans*; Marion Palfi's *Suffer, Little Children*; Philip Jones Griffiths's *Vietnam, Inc.*; Paul Fusco's *La*

Causa; Michael Abramson's *Palante: Young Lords Party*; Jill Freedman's *Resurrection City*; Leonard Freed's *Black in White America* and *Made in Germany*; Herb Goro's *The Block*; Geoff Winningham's *Friday Night at the Coliseum*; W. Eugene and Aileen Smith's *Minamata*; Danny Lyon's *The Bikeriders* and *Conversations with the Dead* . . . This list could go on, and on; there were many others. Additionally, it should be noted that numerous long-term documentary projects – including those of Roy DeCarava, Marion Palfi, Milton Rogovin, Jerry Liebling, and Laura Gilpin – were underway during that time.

Third, the works mentioned above were all produced and intended for a very broad general audience, which its makers assumed was the appropriate audience for social and political debate. By contrast, the work of those claiming to reinvent documentary is directed, virtually without exception, to a constituency bounded by the museum, the art gallery, the art journal, and small-circulation "artists' books." Yet the makers of these works never seriously question their own elitist tendencies.

Fourth, the overall tenor of this reinvented documentary is unaffectionate, arch, ironic, hostile: hostile to the past, hostile to the present. I sense here the potential for the establishment of gulags of the spirit, aesthetic Stalinism.[52]

*

Let me suggest, very briefly, what I think is missed or misunderstood about the documentary work of the late 1950s through the 1960s.

As a result of policies that originated during World War II and were entrenched by the time that conflict ended, editorial control over text, captioning, and layout in mass magazines often restricted the freedom of writers and photographers to make their statements exactly as they wished. Sometimes this led to compromise, often to accommodation. (There is a noteworthy difference between the two.)

This made book form the preferred vehicle for those involved in image-text work of a primarily informational or representational nature. More control over and greater autonomy in relation to text, picture selection, design and other essential matters were available to those who worked in this

form. What was lost in immediacy – books take longer to produce than magazine issues – was compensated for by editorial freedom.

However, these were not thought of by their makers as "artists' books" – precious, limited-edition, expensive, self-expressive artifacts. Commercially published books such as those listed above were significant precisely because their makers found ways to create works about topical social and political issues that could be widely disseminated to the general public at low prices through existing distribution systems.

The restrictions inherent in book form have, however, been amplified over the past decade. Costs of paper and printing have skyrocketed; this has made publishers wary of projects whose topicality is too localized to guarantee extensive sales. With decisions made more cautiously, production time has increased. David Douglas Duncan's *I Protest!* – a highly editorial image-text account of the crucial Khe Sanh battle in Vietnam in February of 1968 – was rushed into print in a special paperback edition which hit the stands *less than two months after the battle.* It's hard to imagine any U.S. publisher undertaking such a project today.[53]

Therefore, book form is becoming a counterproductive system wherever rapid information dissemination is concerned. Also, the cultural attitude toward the book itself has begun to change. The book as an artifact is becoming archaized – and thus, as Marshall McLuhan and others have suggested, aestheticized – as a result.[54]

The emergent new forms of information technology – the computer and the electronically encoded image – seem to be the logical successors of the mass-circulation magazine and the mass-market book. Yet there has been surprisingly little exploration of these new vehicles by documentary photographers and photojournalists. Microfiche, videodisc, and various other innovations offer remarkable opportunities for image-text encoding, storage, retrieval, and dissemination.

The charmingly antiquated commitment to aestheticized forms of presentation – gallery/museum exhibits, artists' books, and the like – on the part of so many contemporary documentarians and even photojournalists necessarily restricts their work to a select and extremely limited audience. In effect, they commit themselves to preaching to the converted. Their insistence on re-

The Digital Evolution

A Bronx Family Album by Steve Hart
© 1997 SCT Communications

maining within the confines of contemporary art activity leaves an enormous vacuum at the center of the emergent communications environment. That vacuum may well be filled by corporate forces which will surely recognize the importance of these new forms, if documentarians and photojournalists persist in staring into their rear-view mirrors. The time for radical workers to engage experimentally with these technologies is now, at their birth.

I don't believe that technologies solve problems. Humans solve problems. Technologies are only problem-solving tools, tools that can generate problems as well. There are dozens of new technologies at the disposal of communicators today. How is it that our arguments over documentary photography and photojournalism are still centered around magazines, books, and gallery exhibits?

(March 1984)

Photography: Today/Tomorrow

The current condition of the field loosely called "creative photography" can be described as either confusion or ferment, depending on one's bias. It is a fluid, transitional phase. Previously operative paradigms have been exhausted, or so it seems. But the multiplicity of possible substitutes is such that aesthetic inquiry becomes an intellectual version of the shopping spree. The medium of photography itself – that is, the craft infrastructure which informs all production – is undergoing such massive, continuous transformation that the artist-as-producer has no time to consolidate a hermeneutics, which leaves the critics lacking the necessary foundation for their exegetics. Continuous innovation does not render analysis superfluous, but instead makes it impossible.

Not coincidentally, this is occurring at a time in which the visual communications technology which buttresses the totalitarian futures projected in Huxley's *Brave New World*, Bradbury's *Fahrenheit 451*, and Orwell's *1984* is all in existence – indeed, has in some cases already been obsolesced. The rapidity with which these inventions supersede each other renders them beyond the control of the populace at large, empowering instead a technocratic elite, corporate and multinational in its orientation. Such an elite is likely to coopt opposition from the art community by privileging those of its members who pound loudest on the doors.

Acceleration of visual communication necessarily encourages right-brain processing, bypassing the rational/linear left hemisphere. The potential for what the American C.I.A. calls "perception management" is enormous and imminent. Perhaps the strongest hope for the immediate future lies in the

The Digital Evolution

Melting Beds, Arkansas © 1995 Dan Burkholder
Courtesy of the artist

redefinition of photography education as the *media education* which Marshall McLuhan advocated. "Education," he wrote in 1965, "is ideally civil defense against media fallout. Yet Western man has had, so far, no education or equipment for meeting any of the new media on their own terms."[55]

(October–December 1985)

Photography: Today/Tomorrow

The Future of Photography:
A New World

A. D. Coleman: . . . Not to say that the individual doesn't matter, but I think that the impact of technologies on culture – the way cultures use the technologies that they evolve – shapes very much the way that individuals see those technologies.

If I were going to sum up what I think you should know or think about, it's that, from my standpoint, I've seen the future of visual communication and its name is electronic imaging. This is not to say that still photography in silver or aniline dyes is going to disappear completely. But I think that the thrust of the communication activities that take place in our society is going to be centered more and more around electronic imaging in the future.

And I see this as a two-edged sword. On the one hand, the emergence of these new technologies places the entire wealth, or an increasing proportion of the entire wealth, of the world's image resources, the material that's in archives and museums and all kinds of collections and so forth, at the disposal not only of specialists – picture editors and photographers and guys like Ron [Scott] who are a little bit of everything, and critics and historians – but even at the disposal of the average user. I think within the next five to ten years you're going to start seeing little kids with little-kid computers being able to hook into, let's say, the image data bank that the Library of Congress is building on videodisc – and being able to do that, probably, fairly inexpensively.

So, on the one hand, there's a kind of a democratic access to the world's image resources that's emerging out of this technology, and I think that's terrific. On the other hand, the hair on the back of my head rises – at the

The Digital Evolution

same time as I'm inspired by looking at the work that Ron is doing or the work that Raphaele is doing – because what's going on simultaneously is that, as these technologies make possible the manipulation of this imagery, what happens is that the credibility of the photograph as a vehicle for information and as, in some sense, a witnessing device – a vehicle in visual communication for what you might call the language of report – is going to inevitably deteriorate. And that's going to generate a major cultural shift in our relationship to photography as information.

. . . [W]e're an information-based society, we've been an information-based society since the great trading expeditions of the sixteenth century. We've been an increasingly information-based society since then. Any information-based society has, as a primary concern, the speed of transmission of information. And any system that lends itself to greater speed of information transmission is going to be the system of choice, ultimately, for the dominant activities of the society. Now, this does not mean that everything else disappears; but it does mean that it becomes more specialized, more rarified – in a certain sense more *archaized*, and in a certain sense more *aestheticized*.

I'd like to disagree a bit with a point that's been made by a couple of my other colleagues here. Tools are not "just" tools. Tools are *tools*; they make certain things possible, they make certain things easier, and in doing so they shape the way we think about our tasks. Changes in the technology of communication via words have produced changes in what we communicate *through* words.

. . . Back before the days of the halftone, back around 1870 or so when pictures, photographs, were being produced but they couldn't yet be reproduced as photographs, it was the custom in newspapers and magazines to derive from photographs line drawings or engravings or etchings which they would then reproduce. And they often in fact were not dissimilar in the fundamental strategy of image production from what we just saw on the screen [digitally manipulated photographs]. That is, they'd eliminate some elements that they thought didn't work so well, they'd add trees if someone thought it needed some trees. And it would always say underneath it, "from an origi-

The Future of Photography 77

nal photograph by Mathew Brady," or whatever. So there was an aura of photographic credibility that went with what were basically really fictions – not just serious interpretations, which all photographs are, idiosyncratic interpretations, but total fictions.

It seems to me that maybe the time has come for the ASMP [American Society of Media Photographers] to consider proposing some kind of legislation that might require, underneath photographic illustrations – as distinct from photographs – something that says, "Not from a single negative," or "Not from an original photograph," or "From original photographs by X, Y and Z." . . . Because the question becomes, how are we then to treat those images made with this technology, through these strategies, that are presented to us as informational – not simply as illustrational, but as informational? How then are we to deal with the information level of images that have the appearance of photographic credibility? I think there's going to be a major cultural problem. We've got a century and a half invested in the idea of the photograph having some kind of authentic transactional relationship to what's depicted.

. . . The Library of Congress has an enormous, multi-million-image bank of material that's been collected. All the Farm Security Administration material, for example, is there. All of that material is public domain. That was the deal with the FSA photographers. So it's available for anyone to use for a very small fee per picture use, $10 a picture for a print or $25 a picture for use. All of that stuff, stuff that's been donated to them, all of that stuff. Now they're putting all of that stuff onto videodisc. I don't know what they have at the moment in terms of regulations or systems for making that available, but once it's available on videodisc, all of those holdings are going to fit on this table. And there's got to be some system that's going to be able to make that available to scholars or whomever around the world, without their having to go to the Library of Congress and look through each videodisc.

But once they become available that way, the material becomes copyable. That's a fact. And that's not the only such archive. There are private corporations with picture archives who are putting them onto videodiscs.

I've got a former student working over at a place called the YIVO Institute on East 84th Street. They're putting together a seventeen-thousand-image videodisc project: images of Jewish life in Poland before World War II. They've got it broken down – they've worked out a whole program so that you can retrieve this material by any number of code words. You want to call up every image in there that somehow relates to home? You type in "home" and you get everything from a guy carrying a chicken *home* for Friday dinner to the *home* of the rabbi to people celebrating Passover at *home*, etcetera. It's all available.

And the problems of copyright and usage and so forth are going to become enormous, at the same time as the advantage of the availability of all this material is going to be there as a counterbalance – but not necessarily as a payback, not for the photographer – as a counterbalance for the culture, right? Now that probably doesn't make you any happier about the next twelve years.

. . . I think Doug [Sheer]'s point [from the audience] is very well taken. We haven't yet addressed here where we go as a culture when our images and words cease to be embodied in physical things that we can hold up and say, "See, here's a physical hard copy of *Time* magazine from 1945, and there it says *this,* and it's graven, it's stamped onto that paper in ink that can't be erased or smudged." What you're going to hold up instead is a floppy disk, and you'll say, "See, I have here a floppy disk of *Time* magazine from 1992 . . ." I don't doubt [the authenticity] of this as printed material, but [as a floppy-disk version] – somebody could have gotten in there.

. . . It seems to me that the direction of photography, the technological development of photography, has always been – there have always been several specific factors that we've evolved towards. One is an increasing capacity to encode a greater amount of information, and dimensionality is surely information. Another is reproducibility, and [yet] another is accessibility – both technical accessibility and economic accessibility. Now, it seems to me that if some version of three-dimensional imagery fulfills those – economic and technological accessibility and reproducibility – then we will have holography. And once we do, then just as color supplanted black &

white, just as the print on paper supplanted the daguerreotype, eventually three-dimensional imaging would supplant two-dimensional imaging. If those other factors are fulfilled.

When that's going to be? I've been prophesying the appearance of some version of this for years, and all I'm sure of at this point is that it'll happen "in the future."

... There are some other options [in the field of digital imaging, for young photographers], by the way. There are a number of places where you can study digital imaging systems – a number of schools of librarianship, interestingly, are coming to terms with the fact that librarianship in our time and into the future now means image librarianship as well. And so they're beginning to deal with training librarians towards the organization of [image] archives, image retrieval, etcetera. Not so much towards the issues that Ron and Raphaele are dealing with – that is, the manipulation of existing images or the creation of new images – but the handling of and interpretation and intelligent organization of old images. So I think there are a lot of options here.

My recommendation to students at this point are:

Number one, you cannot avoid these tools without defining yourself as archaic. Even if you don't use them, you have to understand what you're turning away from, I think. Even if you choose to work in the classic silver print. That would be number one. And the second would be to study what I like to refer to as "Photography and —." By that I don't just mean a good liberal-arts education, which I think is really fundamental. I mean some other discipline. If you want to go decipher and find ways of making images about the hidden black-box relationships that Len Stern was pointing out so eloquently, you've got to study some of the observational disciplines: sociology, anthropology, political science, economics. You're not going to know what you're seeing or what's there to be seen until you know what those hidden systems of relationships are, and that's the place to get that information.

(November 1987)

The Hand With Five Fingers:
or, Photography Made Uneasy

Several years ago, my son, my (then) wife, and I were discussing new technologies, when the conversation came around to the recent appearance of machines and appliances that talk to you. Inevitably, we got to the camera that, through the magic of the microchip, lets you know in no uncertain terms when – in its opinion – you're too close to your subject, are working in insufficient light, and so on.

Suddenly, Ed – who was then seventeen years old and who, having lived in the art-photography world *all* his life, views it with an eye even more jaundiced than mine – went into a spontaneous skit featuring an imaginary camera that could be programmed to take only a certain kind of picture, would offer a running critique of your seeing, and would refuse to register any negative that didn't meet its standards. For example, he improvised, you could have the NEA camera, guaranteed to produce a portfolio that would win a grant from the National Endowment for the Arts.

In a flash, Ed was bobbing and weaving around the room in a cutting parody of the avid small-camera user on the prowl – except that the invisible camera he held, having a mind of its own, kept pulling itself away from his eye to other, presumably better vantage points, all the while chastising him for his choice of shutter speed and aperture. He soon had Theresa and myself rolling on the floor.

Thinking about this afterwards, I realized that this conceit could be connected to what my colleague, the Baltimore Oriole, refers to as "cryogenic imagery." In an unpublished essay, the Oriole argues that, by now, photographers have established a sizable, steadily growing repertoire of archetypal

images, any variation of which is recognized by all and sundry as a "good shot." It's the Oriole's theory that *these images now come in the camera, cryogenically frozen*. The camera user needs only to scan the field of vision until the lens comes across a new instance of one of these archetypes; the frozen image is instantly awakened from its sleep and registered on the negative.

Now that would suggest that Howard Smith's theory was outdated. Smith, writing about the work of the midwestern studio photographer Michael Disfarmer in the *Village Voice* back in May of 1982, suggested that "the secret of taking a great portrait is actually quite simple to understand: the photographer just looks through the lens with intense magic until the person posing is transformed into a timeless work of art. At that exact moment the shutter is released."[56] Smith, obviously, is still committed to the antiquated notion that it's the photographer who makes the picture, not the camera.

I realize that you may be getting a little skeptical here, wondering if these folks don't have their tongues in their cheeks. You may even be questioning my sincerity. Let me assure you not only that my aim is true, but also that what I'm describing represents accurately the openly announced long-term agenda of the photographic industry – which, in a nutshell, is to get people out from behind their cameras so that they'll have more time available to be the subjects of photographs and to consume photographic prints.

You'll have to follow me closely on this one.

<center>*</center>

Up until 1888 – that is, for the first half-century of the medium's existence – anyone who wanted to make photographs had to practice photography. If you worked with the direct-positive processes (such as the daguerreotype or the tintype) you developed your exposed plates immediately. This was true also of the positive-negative processes that prevailed through the 1860s – the so-called wet-plate methods, which utilized glass sheets on which the emulsion had been freshly coated. Even the introduction of dry plates did not significantly reduce the photographer's involvement with the craft; it only provided some breathing room between exposure of the negative and pro-

The Digital Evolution

duction of the print. Short of hiring a personal assistant to handle dark-room work, the person who wanted to make photographs had no choice but to become knowledgeable in all areas of the craft, to think his/her work through from exposure to print.

George Eastman changed all that, permanently, when he introduced the first Kodak camera in 1888. "You press the button, we do the rest," read the slogan under which it was advertised. The camera user received the loaded camera, ready to go; after making 100 exposures s/he shipped the film, still in the camera, back to the company for processing and printing.

Not only did this make it unnecessary for the camera user to process his/her own film and make his/her own prints, it actually made that impossible, at least at first: the film for this camera initially was such that amateur processing was impracticable.

Historians of photography are prone to celebrating this as a triumph. I'd suggest that, in fact, it was in another sense a setback of major proportions. This was a time when a continually widening segment of the public was acquiring craft expertise in the first democratically accessible visual communications system. The Kodak No. 1 – by appealing to people's capacity for laziness – allowed the "luxury" of foregoing any study of that craft. In separating the act of negative exposure from development and printing, Eastman's system effectively undermined the impulse to learn the process of photography, by rendering such knowledge unnecessary.

A year later, Kodak introduced a new film, on a plastic base, which gave amateurs the option of either developing and printing their own images or letting Kodak "do the rest." But the die had already been cast. By permitting camera users to remain ignorant of the processes they were employing, this approach to photography remystified the medium – made of it a prototypical "black box" – right at the juncture when its demystification was underway among the population at large.

Why do I consider this a setback? Because the camera is, on at least two levels, an instrument for the control of perception. Not only does the user employ it to tame and organize visual perception, but through its structure the originators of the camera and their descendants – those who design the cameras, films, and papers of our time – dictate how we will see.

The only truly effective way to come to an understanding of the degree to which "the medium is the message" in photography is to study the medium itself – that is, the process of production. Only in that fashion can one discover the medium's inherent biases – the kinds of ideas and information whose transmission it facilitates, the kinds that it inhibits or obstructs. Only through the direct experience of craft can one encounter first-hand the limitations, the controls and the range of variables at the disposal of the practitioner. (While still photography is the model I'm using, the same obviously applies to the other lens-based media, video and film.)

Globally, there is now an enormous population of camera users, only a tiny fraction of which actually practices photography. The two functions, initially integral to each other, have been severed in what I can only suggest is the photographic equivalent of pre-frontal lobotomy. Social historians of the far future will find it astonishing that in a culture which produces billions of photographs annually much of the population still believed that cameras take pictures, that photographs don't lie, that seeing is believing. These are ideas of which photo students are effectively disabused by their second semester of coursework. They're ideas of which an entire culture could be disabused by a widespread emphasis on media education.

Unfortunately, what we get instead is an endless series of variations on the theme which, in the 1940s, was summed up in manuals and courses promising "Photography Made Easy." To counteract this, the late photojournalist W. Eugene Smith taught a course at the New School for Social Research in New York City that he titled "Photography Made Difficult." But the tide was against him then, brave dinosaur that he was, as it is now against anyone who would seek to make photography difficult, or even uneasy – anyone who would argue in favor of a more thoughtful, complex, problematic relationship to the creation of photographic images.

Certainly the photographic industry is not about to encourage such an approach among the citizenry. The relationship to photography that this industry promotes is one of rampant, even literal mindlessness. How else can one interpret the symbolism of the dreaded, disembodied "Hand with Five Fingers" that one camera company uses to promote its newest, most automated model?[57] How else can one explain the fact that at least two

major manufacturers are advertising their wares with slogans promising "decision-free photography"?[58]

Decision-free information? Decision-free perception? Decision-free self-expression? Decision-free communication? By their nature, such acts cannot be decision-free – at best, the decisions they involve can be deferred, left in the hands of others.

The phrase "at best" assumes, of course, that the avoidance of decision-making is a positive goal in life. If that is so (have no doubt that I hold an opposite opinion), when did it become so? When did the premise of our public discourse change so drastically that "freedom from decision" ceased to be a totalitarian threat? When did the ability to "slip effortlessly through life" which is offered to us by the makers of an instant camera lose its sting as an insulting description of the con artist or the uncommitted dilettante?

Media education, including the study of photography – in almost any form it takes in an environment whose keynote is sounded by the above slogans – is an oppositional force, an embrace of decision-making, difficulty, uneasiness. Let us keep that in mind as we proceed; after all, the real threat of "the hand with five fingers" comes not from without ourselves, but from within.

(January/February 1988)

Historianship and the New Technologies

... *Computerization may for a time* allow us to think that we have a handle on all this [various changes in the discipline of photography historianship], but that's an illusion. None of us will ever again be able to keep up with everything that's happening in the field. Increased specialization will be the inevitable result; and intensified collegial contact through electronic bulletin boards, periodicals and newsletters, professional organizations and gatherings such as this will be necessary if the field is not to become hopelessly balkanized.

... The field will feel particular pressure – but also face unusual opportunities – as a result of the emergence of visual information storage and retrieval systems. It is safe to predict that within the next half-century every significant image archive on the planet will be transferred to videodisc or its equivalent, thus becoming an accessible photographic database. This global disgorging of imagery on a virtually unimaginable scale will place enormous demands on our field; those who have evolved methodologies for the analysis, interpretation and organization of such imagery will surely have their work cut out for them.

We had better anticipate that situation and begin that work now....

Finally, I predict that we will awaken to the grave responsibilities inherent in the historianship of photography. Those who practice this craft are custodians of a vital cultural repository.... Those same electronic imaging technologies I mentioned earlier are already making possible the manipulation and alteration of photographs (the undetectable falsification of photographic evidence) and the creation of photographically credible images generated

entirely by computer-graphics programs. *Time*, *National Geographic*, and *TV Guide* are only a few of the U.S. publications that have already published falsified photographs. Forged "archival" material will surely begin to proliferate as soon as the traffic in archival imagery travels through electronic systems. Historians of photography are the culture's last line of defense in the battle against the counterfeiting of visual history; that battle is already upon us. . . .

(September 1989)

Back to the Future:
Photography in the '80s and '90s

Every generation wants to feel that it has made the world anew and set its own agenda. Yet this requires more than the mere declaration that the powers-that-be are old and in the way. It became clear in the '80s that many photographers felt constrained by the received version of modernism; the declaration of the advent of postmodernism was a bold stroke. But the nature of postmodernism itself is not yet clear.

Yet the very idea of it stimulated the already emergent debate over photography's role in the social construction of reality. This helped to establish an active critical dialogue about photography, some of which spilled out of the art world and into the culture at large – part of an insistent pluralism in both photography theory and praxis.

Other features of the decade included the expansion and solidification of our sense of the structure of photography's history; the sudden centrality of color imagery; the decentralization of sponsorial power, as more and more institutions became involved in collecting and presenting photography; and the rapidly increasing influence of state and corporate funding on all aspects of the medium.

For the '90s, I project a continuation of the above, with the following additional features:

* The further internationalization of the photo scene, especially in the areas of education, exhibition, publishing, criticism and historianship.
* The takeover of most informational functions of photography by electronic imaging, with a resultant diminution of the credibility of the pho-

tographic image in general. The new technology will also generate major legal battles over the issues of copyright and *droit morale*.

* The decrease in the production of photographs on paper, supplanted by video-screen display, and (a variant of everyone's favorite prophecy) some 3-D photographic imaging system viewable on the TV screen.

* The establishment in at least one major metropolis of a "photo-free zone," where people can appear in public without being photographed, and a compensating "auto-release zone" where photographers can make publishable images of street life without obtaining model releases.

(October–December 1989)

Who Owns the Facts?

Access to and control of information is a major concern of every culture. The dynamic tension between the centralization and the decentralization of information – between what is secret or privileged and what is commonly available – defines a culture in a most basic way. Recently, a new twist on this issue has been manifesting itself: the corporate world's proprietary relationship to information, the actual ownership of data (even, sometimes, data generated under government contract). It is a question that affects writers and photographers alike.

Anita R. and Herbert I. Schiller have termed this the "'privatization' of information." The Schillers, with overtones of dismay, express the view that "Information today is being treated as a commodity" and "Books are products."[59] I share their view, but not the naïve, simplistic quality of their disturbance. Information has been a commodity since at least the fifteenth century A.D.; books have been products for much longer; and I know too much history to find either of these facts startling. I worry about different aspects of the situation – including the all-too-common failure to distinguish between the concept of *freedom of information* and the notion that this somehow means that all information can or should be "free," meaning divorced from economic premises.

I come to this issue not only as a media critic concerned with communication systems and their cultural consequences, but also as a working professional writer. From the latter standpoint, it seems to me that the results of one's labors can be a product, a service, or some combination of the two. (The same would hold true for a professional photographer, whether in the

applied or fine-arts fields.) My labors as a critic have generated hundreds of newspaper and magazine articles, plus several books, all of which, to some extent, qualify as "information." My work as an editor on another project resulted in a compilation of basic data on extant photography-related A-V programming – unquestionably "information," intended as a resource and reference tool.[60]

Whether I choose to conceptualize my activity as the production of goods or the provision of services, I must market the results of that activity in order to make it effectual in the world, enable its continuance, and be recompensed for it. Certainly, therefore, this information – whether generated by me as a writer or compiled by me as an editor – constitutes a "commodity" and/or a "product." This is neither shocking nor shameful. As a worker, I've invested time, physical and mental effort, and money in its making. One of my purposes in doing so has been to get it into the hands of others; another has been to earn a living thereby.

The three principal forms of recompense available for such work are: 1) the economic support of public and/or private grant monies; 2) the indirect support of staff positions on publications or academic sinecures; and 3) the direct marketing of the work.

Though I have had some public grant support, and also teach part-time, I've never been a salaried staff writer. I've remained a free lance; at least 50 percent of my income for the past twenty-odd years has come from the licensing of various publication rights to my writings and (in a very few cases, back when I was young and ignorant) the outright transfer of copyright. Given that those "rentals" and occasional sales of my writings have been to publishers who transform them into the physical objects we call books, magazines, and newspapers – products whose creation and dissemination require the considerable economic investment of material, labor, and a merchandising system for distribution – there's no way not to think of my share in that process, on one level, as the manufacture of a product and a commodity.

The kicker, of course, is that "given." The fact is that, as a writer, I'm caught in a brief but highly problematic transition period in the evolution of communication systems. It's the *transitional* nature of this phase that must be emphasized.

At the moment, the dominant outlet for my work in the form in which I've chosen to cast it – the written word – is the publishing industry as we know it today, a dinosaur whose premises go back half a millenium and whose antiquatedness has been exhaustively demonstrated and annotated of late.

As it happens, I love books, magazines, newspapers – the feel of them as objects, the quality of their presence in my living space, their physical existence in multiples as social vehicles for thought and feeling. I hope that some version of book and periodical form remains viable during my lifetime, so that I can embody such of my work in it as seems appropriate.

But these forms are rapidly becoming slow, cumbersome, inefficient and expensive vehicles: the Cadillacs of the written word. And fond as I am of them, my commitment as a writer is to the dissemination of my work to the broadest possible audience – which means I want it to take as cheap and accessible a form as it possibly can.

Presently, that form – for writers, and photographers too – is the printed page. A decade or so hence, it'll be a network of electronic bulletin boards and/or a central information bank (administered, perhaps, by the Library of Congress), to which the nation's computers will be linked. These repositories will draw their materials from writers like me, photographers like many of this magazine's readers, and countless other sources. For some nominal per-word fee, we'll be able to copyright our writings and imagery as we generate them, enter them into such a bank, and have them automatically cross-indexed into various bibliographies, reading lists, and other references.[61]

Then people at their computers – at home, at work, at school, or at public terminals – can locate and call up that material. They'll read or view it on the screen and, if they wish, obtain a hard-copy version of all or part of it as a computer printout. The costs of this will be covered either by some tax-subsidized system or by the imposition of a nominal fee charged to users; in either case, a percentage of those revenues will be credited to the accounts of those who provide the specific material scrutinized and printed out. That way, we'll be subsidized by, and more directly accountable to, our readers and viewers. (A rudimentary version of this – lacking the technological elegance of my suggestion, but compensating authors and publishers for the photocopying of material – is already in place in the U.K., France, Germany

and Australia, through national organizations known generically as Reproduction Rights Organizations or RROs. The U.S. version of this, still in its infancy, is called the Copyright Clearance Center.)

That'll be a very different "given." My scenario may be inexact, but some version of it stares us in the face. The new electronic imaging systems – computers, scanners, laser discs and the like – surely foretell something parallel for those involved in the creation of photographs, especially those whose purpose is primarily informational. Perhaps this will force us to examine and accept the commodity/product nature of information-encoding and information-transmission systems other than the printed page. Perhaps it will allow writers, photographers, editors and others to conceptualize their output as disembodied ideas rather than tangible objects, as service rather than product.

But those ideas, that service, still won't be "free" – meaning without cost to produce and distribute – even though that system may provide even readier access to information than we now enjoy. Certainly it will not be conflict-free. We may simply exchange the familiar and tedious problems of the present-day publishing industry for novel and barely predictable ones. I would not put a damper on the legitimate alarm the Schillers and others are sounding in regard to ownership of and access to information. Without question, we will need a Freedom of Information Act to cover computerized data under government control, and should begin working for that now.

But I've stressed the transitional nature of the present situation. It is true that information – and, for that matter, information-processing equipment – is presently concentrated in corporate hands. However, some consideration must be given to the following matters, all of which will begin to have an increasingly visible impact on contemporary communication systems within the next few years:

The corporate state is actively encouraging the citizenry to acquire "personal computers," which within the decade may begin to become as ubiquitous as the standard TV set is today. This will create an enormously versatile and sophisticated nationwide grass-roots communication system at the disposal of the polity. In such a context, it will be difficult if not impossible to keep information hidden. Inevitably, there will be deliberate leaks. And accidental discoveries. And the results of sophisticated snooping.

Incidents along all three of those lines already abound. My own urban perambulations, combined with observation of my students and cohabitation with my son and his ethnically/politically/economically diversified social circle, indicates that we're rapidly breeding a sizable cadre of electronic whiz kids who thrive on a diet of what I've described elsewhere as "fiche and chips," and from whom I predict even the most elaborate and restricted information system will have few secrets. (There have already been a sufficient number of widely publicized and well-documented cases of system break-ins via youthful computer "hacking" to prove this point; the film *War Games* offered a fictionalized version of one such scenario.)[62]

Nor is this potential restricted to the highly-educated and well-to-do. The largest computers are indeed owned by and operated under the aegis of the military/governmental/corporate sectors, and can thus be thought of as controlled by the power elite; and most of the nation's 14 million personal home computers are owned by members of the middle and upper classes. *But computer programming as a skill and a profession is still largely in the hands of the working class.* Treated essentially as drone work, roughly on a par with stenography, the basic programming and running of computers has been widely promoted as an outlet for the upward-mobility ambitions of high-school graduates.

Consequently, the percentage of working-class computer operators and programmers is far greater than you'll find in the nation's executive suites. Assuming that enlightened self-interest will be demonstrated by these workers in this time of economic, social and political crisis, it would not be unreasonable to expect them to use the weapons at their disposal: sabotage, anonymous disclosure, theft, and the myriad other options available to the computer-literate person who chooses to "work late at the office."[63]

Indeed, the inability to keep any computerized data private may prove to be the real problem, instead of what the Schillers call "privatization." The day may not be too far off on which we'll look back with nostalgia at a time in which anyone was able to imagine that anything entered into a computer could be kept secret.

(August 1991)

Copyright – or Wrong?
Intellectual Property in the Electronic Age

My ruminations last month on the ownership and control of information now lead me inexorably to the matter of copyright. And I can think of no better jumping-off point for such a discussion than an essay by the late photographer and critic Derek Bennett, titled "A Speculation," that appeared in the elegant Belgian magazine *Clichés* awhile back.[64]

In the guise of a prophecy, this text was a frontal attack on what Bennett proposed was the "antiquated" concept of copyright, which he felt had ceased to serve any productive purpose (if it ever did) and now only stood in the way of progress. Ideas can't be owned, he argued, and treating them as property interferes with their free circulation. In short order, computerization and the digitization of imagery were going to undermine any practical exercise of copyright, and even the very concept of it, anyway; so we might as well have the grace to abandon it as a matter of choice before progress and/or technology stripped it from us.

My dispute with Bennett over this issue went deep. I found myself in profound disagreement not only with his conclusions but with some of his premises as well, so much so that I still feel impelled to formulate a reply. Therefore, with all due respect, let me see if I can defang and declaw Bennett's *bête noire*.

Everywhere in the world, people with an appetite or need for data and information – not only such researchers as journalists or scholars but also average citizens with their professional, personal and private concerns – struggle against forces that oppose the free flow of information. One, almost invariably, is the government; as discussed in my previous column, the other – at least in capitalist or social-democratic countries – is the corporate state.

Bennett saw copyright law as part of this problem, suggesting that copyright is now an archaic procedure serving only to stifle information exchange. But copyright does not prevent anyone from obtaining information; it should not be confused with a *trade secret*, which – like the recipe for Coca-Cola – can indeed be kept entirely private, forever if one so wishes.[65]

To register my copyright on something, I must deposit a copy of it in a public archive – here in the States, it's the Library of Congress – to which others have free access. So, if I had information that I wanted to keep secret, I'd put it under the mattress, or in a safe deposit box; the last thing I'd do is copyright it. To put it another way, short of searching through the Library of Congress's files for copyrighted but unpublished material, the only way to discover the existence of something that's been copyrighted is to come across a published version of it bearing the copyright notice – which means, by definition, that its contents have been made available to you for scrutiny.

Copyright thus bears direct comparison to the patenting process, which – in the U.S. – gives inventors (or their assigns) a fourteen-year monopoly on their device, formula or other discovery. Both patents and copyrights are granted to the originators of ideas embedded in specific forms, to compensate them for their investment of time, energy and labor in generating material that did not previously exist; that compensation merely guarantees them the exclusive right to sell or license their product for a fixed period of time. Thereafter, those products fall into the public domain, and may be freely used by all. Curiously, those who (like Bennett) proclaim the death of the author rarely acknowledge this parallel; you won't find them denying the existence of inventors, or proposing the dismantling of patent law and the elimination of its protection of those who devise physical things rather than concrete forms for thoughts and emotions.

Be that as it may, copyrighting clearly doesn't prohibit people from buying books, newspapers, magazines, records and videotapes, nor from borrowing those at libraries and archives or from friends and colleagues. It does not interfere with their hearing and seeing public presentations of a wider variety of what we might broadly call ideas and information — as embedded in music, films, plays, and talk shows offered on radio and TV, in movie houses and theaters – than the species has ever had available to it before.

Copyright law doesn't stop teachers from assigning readings to their students. It doesn't prevent anyone from handwriting or typing out a copy of any text for personal use, nor from quoting it (within certain size limits for a published quotation).

What copyright law prohibits (and not indefinitely, but for a limited time only) is the unauthorized duplication of those forms in which the information is embodied, and certain kinds of unauthorized public presentations thereof, especially when done for profit. While not very effective at stopping individuals from making single copies of things on photocopy machines, VCRs and home tape recorders, it's useful in forestalling and halting the increasingly common mass production and distribution of pirated versions.

To bolster his argument, Bennett painted a rosy but only partially accurate picture of the Middle Ages, replete with freethinking scholars cheerfully and unabashedly cannibalizing each other's work. There's some truth to that, but those times were much different from ours. Virtually all the writers of that age were subsidized — by the church, by the state, or by private patrons. And, even then, information was certainly commodified and controlled, not only by those who did the subsidizing but by those privileged institutions and individuals who owned or supervised collections of original manuscripts, or hand-copied versions thereof. (Those of you who read Umberto Eco's *The Name of the Rose*,[66] or saw the movie, will remember the elaborate labyrinth in the monastery's library expressly designed to restrict access to controversial texts.) Certainly censorship was rife; those were the days in which authors as well as books were burned.

As I pointed out in my earlier column, information has been recognized as a commodity for at least the past five hundred years; printed books and their manuscript predecessors have functioned as products for longer than that. As a result of electronic technology, the physical forms in which information is embodied, and the devices through which it is disseminated, are changing with breathtaking rapidity. Clearly, as Bennett himself observed, we're in a transitional state at the moment. I agree absolutely with that, but not with his conclusion that copyright will therefore become irrelevant in the digital epoch.

From my standpoint, it's wrongheaded to propose that anyone who supports the legal concept of copyright must believe that ideas can be possessed. I certainly don't conflate the two; such an argument ignores the difference between the uninhibited circulation of ideas and the unrecompensed production of specific embodiments of those ideas. The U.S. copyright law recognizes that distinction, and does not in fact allow the copyrighting of ideas; you cannot use it to safeguard the theme of an essay, or the conceptual premise for a suite of photographs. What the copyright law protects is what the philosopher Karl Popper calls "objective knowledge," by which he means *objectified* knowledge: thought that has been given specific, concrete form.[67]

What this means is that Georges Braque and Pablo Picasso could not have copyrighted the premise of cubism (which, simplistically stated, is that one can apprehend and describe something by building up a collage of glimpses of it from many different vantage points); Albert Einstein could not have copyrighted the formula $E=MC^2$, nor Edward Weston his conviction that the implacable forces of nature were revealed to the attentive eye in close scrutiny of animal, mineral and vegetable forms. But Braque's and Picasso's paintings, graphics and sculptures were protected by law from unauthorized replication, as was Einstein's essay disclosing and explaining his theory of relativity, as was Weston's "Pepper No. 30."

"To [secure] to each laborer the whole product of his labor, or as nearly as possible, is a most worthy object of any good government," said Abraham Lincoln in 1847.[68] Copyright enables me, as an independent contractor in the business of generating idiosyncratic configurations of words, to reap the fruits of my labors, providing me with an adequate if modest recompense for making the effort to transform my ideas into tangible, physical form. To inveigh against this is to suggest that writers – and photographers, and all other makers of embodied ideas – either must be willing to work for nothing or must find state, institutional, corporate or private patronage, for without copyright how else can their labor be subsidized?

But the protection afforded by copyright empowers me – and makes me accountable as well – in other ways, which I'll have to take up next month.

(September 1991)

The Digital Evolution

Marginalizing the Maker:
The Status of Authorship in the Digital Epoch

Will copyright become irrelevant in the electronic age?

Provoked by a polemic penned by the late critic and photographer Derek Bennett, I began considering this question in our last issue by examining the function of copyright in the economic life of those whose work involves embodying ideas and information in physical forms. I concluded by indicating that there was another way in which copyright empowered those writers, photographers, artists and others among us engaged in such labors.

In his germinal essay, "The Author as Producer," the German critic Walter Benjamin makes it clear that, as a *worker*, I have an ongoing, vested interest – not only economic but also political, and moral – in the material I generate as a writer. He argues that my job doesn't end with the final draft, but only begins there; in his view, it's incumbent upon me to exercise whatever control I can so as to ensure that, in the way it's edited and published, my work truly ends up serving my original purposes, furthering my commitments and goals rather than those beliefs to which I'm opposed.[69]

If I agree with Benjamin, and I do, how can I achieve such control over my work? After all, prior to publication, it passes through various editorial hands, in a process via which it could be subject to all kinds of alterations. Then, once off the press, my ideas are there on the printed page for any reader to absorb, reject, expand upon, revise; I can't (and wouldn't want to) dictate or overdetermine my readers' responses. By publishing, therefore, I've given those ideas to the world.

My *texts*, however, are not freely available for anyone's commercial or non-commercial use, because they are copyrighted. Significantly, this not

only protects my legitimate, continuing economic relation to my own work but also safeguards that work against unauthorized alteration and undesired recontextualization – that is, against misuses for which I cannot and should not be held responsible – both prior to publication and thereafter.

By extension, that reasoning applies to everyone who generates ideas embodied in tangible form – including artists and photographers. It was on that basis that Federal District Court Judge Charles S. Haight recently ruled in favor of professional photographer Art Rogers, who'd sued the artist Jeff Koons for exhibiting and selling "String of Puppies," a sculptural, polychromed-wood version of Rogers's black & white photograph titled "Puppies." The language of Judge Haight's decision is instructive. He opined that "Koons's sculpture does not criticize or comment upon Rogers's photograph. It simply appropriates it." (Koons had claimed that his use of the Rogers image had constituted *fair use*, examples of which would include criticism of or comment upon another work.) Having thus raised a specter to haunt every Madison Avenue art director with a Macintosh as well as every postmodern appropriationist in SoHo, the judge found for the plaintiff because the Copyright Act "confers upon the copyright owner the exclusive rights to do and authorize . . . 'the preparation of derivative works.'"[70]

This enlightened defense of the autonomy of photographers is precedent-setting here; undoubtedly it will undergo further challenge, testing and refinement in the courts. The French have already institutionalized a similarly expanded understanding of copyright in two farsighted laws. One of these is called the *droit de suite*, which translates roughly as "follow-up rights"; it guarantees artists a share in the future profits from all subsequent resales of their work. (California has adopted a version of this law, which mandates the payment of "resale royalties" to artists and photographers; similar laws are now under discussion in other states. How this will apply to the rapidly spreading practice of using scanned and digitized photos in desktop publishing and computer graphics is of course a particularly thorny question.)

The second of these pioneering French laws is called the *droit morale*, or "moral right"; it ensures that artists' works must always be properly attributed to them and cannot be altered without their consent after they are

sold. (European photojournalists are now demanding a variant of this rule that's specific to their profession; they're calling it the *droit de regard*, and it boils down to the kind of input into the editorial process for which W. Eugene Smith fought all his life.[71])

Versions of this model law have been passed, or are under consideration, in many countries now, including the United States, where Robert Rauschenberg, among others, has championed it. (Rather ironic, in light of Rauschenberg's "appropriation" of many images in his early silk-screen paintings.) Late last year, after six years' debate, Congress amended the Copyright Act by enacting the Visual Artists' Rights Act (VARA), which grants to some visual artists what a lawyer specializing in the arts – Barbara Hoffmann, Honorary Counsel to the College Art Association – calls "limited rights of attribution and integrity." (VARA applies only to paintings, drawings, prints, and sculptures that exist either in unique versions or in limited editions of up to 200 examples, which must be consecutively numbered and signed.)[72]

Such legislation cannot logically be supported without recognizing the clear parallels between it and the necessary assurances that copyright offers to writers; after all, that's why it's an amendment to the Copyright Act. To argue against copyright, therefore, is to dismiss out of hand the essential protection for artists and photographers that is represented by the *droit morale* and the *droit de suite*.

If everyone is free to do whatever they feel like with anyone else's work – re-edit it, change a line of reasoning or an aspect of style, alter its form, put words (or images) into its maker's mouth, publish or present it in contexts they find abhorrent – then surely any responsible maker of work will feel entitled, even obligated, to disclaim any such version of it as unauthorized, especially if it bears his or her name and thereby carries whatever credibility has accrued to them by reputation. Even with a strong copyright law, such abuses abound; tracking them and ensuring the publication of such disavowals is already not only undependable and after the fact of any damage done but also burdensome, tedious, and costly, as demonstrated by Art Rogers's experience. One doesn't need much imagination to foresee that, absent the copyright law, the instances would multiply exponentially and setting the record straight would become virtually impossible.

Parenthetically, I'd add that the elimination of copyright would let writers, photographers and artists off the hook, too easily, as perpetrators of political acts (for that is, among other things, how all verbal and visual statements made in public forums function). Copyright serves to keep us honest. It makes it less plausible and more difficult for us casually to disclaim our responsibilities to and for our works on the grounds that they were out of our control, that someone else operating without permission altered them or used them in contexts to which we stand opposed.

Fundamentally, what copyright does – like a signature on a document – is make one personally and professionally liable for one's actions. In my case, for example, it assures the reader that I've produced and given my consent to the statements he or she reads under my by-line, and have taken responsibility for their consequences; that I've considered and approved the presentational vehicle in which it's appearing; that (inasmuch as possible – there's always a gremlin) I've authenticated the integrity of that version of my text; and that I'm therefore the one who's due the credit and/or the blame for the life this example of my work leads in the world.

I insist on those as the conditions under which I publish; for, in the last analysis, if I can't be held morally and legally accountable by my fellow citizens for what I say in print, the context in which it appears, and the determinable effects of those choices, what possible weight can my words carry?

Whatever else it may bring, if the digital epoch encourages the diminution of that accountability, I won't consider it a change for the better. To reiterate what I said last month, ideas can't be possessed; but they can and should be properly attributed to those who originated and embodied them in whatever form is under discussion at a particular moment, and the integrity of that form can and should be maintained and respected. In my opinion, the makers of embodied ideas – among whom I include myself – should not be marginalized, either legally or conceptually, in their relation to their works. Quite the opposite: they deserve both the credit and the blame, the rewards and the punishments, that are due as a result of the impact their works have on their world.

Postscript

For years I followed Derek Bennett's critical work with interest and respect. A photographer as well as a writer, Bennett was born in 1944 in Buffalo, New York, so we were from the same state and about the same age. But he went to college in Canada and chose to spend his adult life in Europe, with Switzerland as his base of operations. Thus he brought a North American outlook to the European scene, and European experience to the U.S. scene.

Wherever his writing appeared – in *Clichés*, in *European Photography* out of West Germany, in *Creative Camera* from England, and in many other publications – it was usually cogent and dependably provocative. As a result, though I never met the man, the news of his premature death, which reached me in Sweden this past winter, came as a considerable shock – especially as I'd been carrying on the above argument with him in my head for almost two years, but had never managed to get more than a sketch of my position down on paper.

Bennett was not a man to take provocative positions casually, especially extreme ones whose realization would have a drastic effect on his own life and work. (Keep in mind that, as a writer and photographer, Bennett was putting his money where his mouth was; his own creative output was at legal and financial risk under the policy he was advocating.) For that reason alone, I wish I could have heard his counter-argument to my rebuttal; I know he'd have had one, and that it would have been tough-minded and well worth thinking about.

I'd assumed I had ample time in which to initiate an argument I hoped he'd rejoin, but fate has had it otherwise. Nonetheless, speaking as a critic, it doesn't seem an unfitting tribute to a valued colleague to take on one of his polemics posthumously; I hope someone will do the same for me some day. For any reader who wants to take up the cudgels on behalf of Bennett's deliberately extreme position, the pages of this magazine are as open as they would have been to Bennett's own efforts to carry this argument forward.

November 1991

CLBLEM.TIF, 1997 © Todd Walker
Courtesty of the artist

The Digital Evolution

Todd Walker:
Representation and Transformation

I came to photography with the desire to conquer this machine, the camera, and make it my slave. Instead, I have now a respect for it and for other machines as expanders of my awareness.[73]

Todd Walker

Back in the late 1950s, Todd Walker – who was already more than a decade into a highly successful career as a commercial photographer – took on an unusual assignment: that of making a series of militarily classified photographs of the computer at the Rand Corporation. Those were the days when a computer as powerful as the one on which I write this (the same size as the one which now sits on Walker's desk, and the one that's probably on the desk of the reader of this article) filled an entire room at the world-famous "think tank"; the days in which a mercifully forgotten IBM executive issued his famous opinion that "there will never be a demand for more than a dozen of these machines."

Walker thought differently; after studying and describing through the lens that massive, humming, clanking aggregate of wires and vacuum tubes, he predicted that "this tool would replace silver" in the working method of photographers. "It now appears to be happening,"[74] he notes with some satisfaction, though with typical modesty he does not propose himself to have been instrumental in that development.

Yet instrumental he has been, both directly and obliquely. Walker is a serious, mature, highly respected but hardly famous picture-maker; his eighteen-print show in New York at the Photography Center of the 92nd

Street Y in 1989 was his most extensive in many years. His penchant for exploring new territory has kept him ahead of all but a few highly dedicated trackers; but it's also made those who've lagged behind into followers, constantly coming across his footsteps as they catch up.

*

Writing, as a technology of communication, carried within itself the potential of social literacy – literacy shared by most if not all the members of a society. Not until the invention of the printing press, however, was this potential fulfilled. Similarly, photography placed the capability for visual description and interpretation of the physical world in the hands of the public at large, making the power to produce recognizable images of particularized objects into common property. Photography thus embodies the potential for a culture-wide visual equivalent of literacy, once the basic skills involved are widespread among the populace.

The computer – which, among its other functions, combines these two forms – represents the culmination of centuries of change in our culture's relationship between the senders and receivers of communication, including forms of communication that may be subsumed under the heading of art. So it's hardly coincidental that in 1981, after a half-century of immersion in a complex, synergistic relationship between photography, text, the printing press and art education, Todd Walker – evolving a typically idiosyncratic methodology – plunged into an involvement with digital imaging that synthesizes all his concerns. The most surprising aspect of that decision to introduce himself to what's generally thought to be a technology for which the young are particularly well-prepared is that he made it in his early sixties, at an age at which most people are anticipating their retirement. But to those who know his work, and especially those who've met him, that's no surprise at all.

By the time he made that commitment, Walker had long made a habit of taking roads less traveled by and making leaps of faith. Born in Salt Lake City, Utah in 1917, he was raised in Los Angeles, and began what might be called his life in art in 1934, shortly after graduating from Hoover High School: he became an apprentice painter in the Scenic Department of RKO

Film Studios in Hollywood, performing such tasks as marbling the fireplace for the set of Orson Welles's classic *Citizen Kane*. While on this job (which he held until 1942) he began studying commercial photography techniques at the Art Center School in L.A.; there one of his instructors, Eddie Kaminski, introduced him to cubism and surrealism, and planted the seed of the idea that photography could be an art as well as a craft.

Following a stint in the army, Walker embarked on a highly successful and lucrative career in commercial photography that lasted roughly twenty-five years. Those post-World War II years were a boom time for the profession in Southern California. Immersed in it, Walker developed a reputation as a versatile problem-solver; his pioneering, atmospheric ads for Chevrolet brought him national recognition in that field.

In the mid-1960s, his interest in all that began to wane. Alongside his commercial activities, he'd been exploring all the various modes of creative photography. "I am a photographer," he's written, "firmly grounded in the California tradition of photography,"[75] and among the ideas he'd absorbed were those stemming from the f.64 or "purist" approach then prevalent in that part of the country. But he'd found himself equally open to more technically radical attitudes. He'd also become absorbed in the study of what are now commonly called "alternative processes" in photography – the nineteenth- and early-twentieth-century techniques such as kallitype, gum dichromate, blueprinting, carbon printing and collotype that had fallen into general disuse during the heyday of the silver print and were considered antiquated.

During this time Walker initiated an inquiry into the supposed realism of the photographic image that has preoccupied him ever since. Referring to the dictionary, he makes a significant distinction between an *image* – "the optical counterpart of an object, produced by a lens" and a *picture*: "the representation of something in visible or symbolic form." "For me," he elaborates, "the image from the camera needs to be transformed into a picture. That transformation is an important part of my work. In addition to being involved with the image while using the camera, I must then concentrate on that image, with my reaction to the illusions that I have about my environment, and form a concrete picture that attempts to describe and delineate my illusion.

"When, from among the many inadequate or incomplete pictures that I have done, one seems to support the illusion that I had while using the camera, or now may have, this becomes the particular one from which I evolve my representation of that illusion. *Representation*: to present again," the photographer concludes.[76]

Such questioning led him to pursue in various ways the manipulation of the photographic processes. One of the first direct consequences of this search was his mastering of the Sabattier effect (more loosely called "solarization"), which results from briefly exposing prints or negatives to light during development. This causes a reversal of tones in areas of the print and, with practice, can be controlled with some precision. Walker had first encountered this phenomenon at the Art Center School; at that time, however, the dominant forces in the world of art photography – typified by historian Beaumont Newhall – considered this technique to be "an aberration," rather than an effect intrinsic and unique to photography.[77]

Disregarding that, Walker applied this technique to the then-standard silver-gelatin print and addressed a traditional form of art, the female nude (though, untraditionally, he photographed models whose bodies were far from stereotypically beautiful, as if anticipating the feminist critique of the female nude in art that would emerge a decade later). The ghostly female presences in these images of Walker's appear always to be on the verge of fully materializing – or dematerializing, as the case may be. Both these figures and the spaces they occupy seem to exist in the luminosity of some limbo that can only be glimpsed; the reversal of tones along the edges of their shapes casts them into a strange, indeterminate light, as if they were frozen at a moment of transition between spatial dimensions.

He also began working extensively with another traditional form of art, the landscape. Both these choices may bespeak a conservative streak in an otherwise revolutionary sensibility, but I'm more prone to surmise that this provision of well-known art-historical reference points reflects both a strategic wisdom and a certain old-fashioned courtesy toward his viewers. As Richard Kostelanetz has noted, "new contents are better handled with older forms, precisely because unfamiliar experiences are more easily understood and communicated in familiar formats. Conversely, if the [artist] wants to

The Digital Evolution

experiment with unprecedented forms, it might be wise to select a familiar subject."[78]

Around the same time, in 1964, Walker bought an old relief printing press and its accompanying type cases, and started to experiment with ink printing. He began by translating his solarized images into collotypes (the printing process used by Eadweard Muybridge for the original edition of his magnum opus from the 1870s, *Animal Locomotion*), a "hand method" which Walker says he "re-invented" in 1965,[79] and offset lithographic color prints, which he began making in 1966. Both conversions further heightened the eerie effect of his imagery because, not content with strictly reproducing his silver prints, he soon amplified their potential by introducing innovative aspects of process experimentation into the very act of printing.

Working with small presses he could control himself, Walker investigated such options as synthetic color and the integration of image and text. All this moved him further and further away from the then-prevalent notion of the photographic print as necessarily made in the darkroom on light-sensitive materials; it also allowed him to produce inexpensive multiples. A stream of limited-edition, hand-bound volumes – of the kind that would soon become known as *artists' books* or *bookworks* – began to flow from his studio, along with portfolios of unbound prints. These included homages to two of his favorite poets, William Shakespeare and John Donne – projects that could be considered posthumous collaborations, so intertwined are the components. (Most of these have long since become collectors' items, though new ones continue to appear.)

Eventually, when he found himself briefly without access to any press in 1970–71, Walker took up silk-screen printing as another means to those same ends, adding it to his repertoire. With silk-screening he produced the one work that most succinctly distills his philosophy. It is based on a close-up photograph of a leaf, which is reproduced twice in the print – once seamlessly, and once divided in half. Over these images appear the following words: "A photograph of a leaf is not the leaf. It may not even be a photograph."[80]

There were others expanding on the possibilities of these technologies as well during those days, of course; in retrospect, one must see Walker as a member of a notable generation of experimenters in photo-offset and photo-

mechanical reproduction that included Robert Rauschenberg, Scott Hyde, Sonia Sheridan and the late Syl Labrot, among others. Positioning Walker among his peers in this endeavor, historian Naomi Rosenblum wrote, "[P]hotolithography offers an opportunity to work in color without working with color film. . . . In working with silkscreen, photographers also avoid the problems of archival instability that bedevil dye-color films and prints, and at the same time produce images that proclaim their identity as artistic productions. Photolithography and silkscreen both enable Walker . . . to translate the infinite gradations of the silver print into disjunctured areas that are further formalized by the color and texture of the screen paint."[81]

*

By 1969, Walker had gradually but drastically curtailed his work as a commercial photographer. In the winter of that year, he gave it up for good. In January of 1970 he received an invitation to teach for a year at the University of Florida in Gainesville, where Jerry Uelsmann, another innovator with whom Walker had much in common, was already ensconced. Impelled to share what he'd been learning, Walker had done some part-time teaching in the Los Angeles area from 1966 on. With the move to Florida – where he stayed for seven years as Associate Professor of Art, Printmaking and Photography – he became a full-time teaching artist, and his influence on at least two generations of students was unleashed. As Julia K. Nelson has written, "While [Walker] was not completely alone in his efforts to repopularize alternative photographic processes, he certainly did most of the groundwork that led to [their] resurgence in art schools across the country in the 1970s."[82]

In 1977 he left Florida for the southwest, becoming Professor of Art at the University of Arizona, Tucson, a position from which he retired in 1985, by which time he'd become intrigued with the potential of digital imaging systems. Given his persistent concern with the permutative possibilities of the photograph, it seems a logical and small step for Walker to have inquired into computer-imaging techniques. Though he is a good bit older than most of those working with this technology, this artist is one for whom these new

The Digital Evolution

digital tools seem to have been designed, as they resolve (and even dissolve) technical problems with which he has been wrestling for years. As he himself says,

> The methods of graphic arts and photogrammetry were a photographic means of digitizing the information to emphasize or suppress qualities of the original image. The computer offers all this in an almost instantaneous form, while generations of film steps are necessary in the darkroom. I have learned much in the past few years of how this new tool deals with image information as numbers. All I learned to do chemically with images in the darkroom over those earlier years I can now accomplish sitting at a keyboard and critically watching the monitor.[83]

Walker began his computer experiments on an Apple II; a few of his successful efforts on that machine are included in the monograph *Todd Walker: Photographs*, published in 1985 by the Friends of Photography.[84] Then he switched to an IBM-compatible system. "In May of 1991 I acquired a Targa-16 board for my IBM clone and began to learn enough C language [for programming] to manipulate the grabbed information in the same manner that I have done with my photographic work for these years. I now have several hundred of these images on disk. There are several ways to make hard copy from these files, but Tucson is off the beaten track and my retirement budget does not allow me to explore such, so I have gone my own way," he writes.[85]

"Once I achieve on the monitor the digitized image I'm after," Walker explains, "I generate my color separations with the display on the screen. Then – still working on the computer – I change each of those to a negative. Next I shoot *those* as color separation negatives on Type 55 Polaroid P/N film. The Polaroid positive becomes a record of that separation; the Polaroid negative is an instant separation positive, which I take directly to the process camera.

"By shooting off the monitor to get my separations," he goes on, "I can make them very consistent without a lot of fiddling around on intermediate

steps. With the Polaroid film, if your exposure reading is accurate, the density on all your negatives will be identical. And I can work directly from those negatives to generate the collotype plates from which I print.

"The prints are small, less than 6" by 9", on Rives BFK [paper].... The editions, of course, are less than 20," Walker concludes.[86] He used a similar method to produce a recent diminutive (2-3/8" high by 3-7/16" wide!) bookwork, *Eighteen by Shakespeare and Walker*, in which he returned to the sonnets of one of his favorite poets:

> The illustrations are from my black & white photographs. Using a Targa+ board, these were enhanced with self-written routines. The monitor image from 4-color separation routines was then photographed to utilize the raster of the monitor as the halftone information to make collotype plates. These were printed by hand collotype on a Vandercook proofing press in lithographic ink on Curtis rag paper.[87]

The user of any technology absorbs the underlying assumptions embedded in that technology through the practical experience of hands-on encounter. Seymour Papert's experiments with children and computers at M.I.T. suggest that this process of internalization begins in early childhood. Children are being introduced to these devices at ever-younger ages; partly as a result, a generation of computer-literate young people is already making its presence felt in colleges and universities.

According to Papert, the typical child's eventual relation to computing is holistic, leading to polymathic thinking – that is, a versatile, problem-solving approach to computer activity.[88] There is no reason to believe that this would not hold also for the computer artist. From an art-historical standpoint, the polymath (with his/her diversity of interests and abilities) is unlikely to become single-tracked long enough to develop virtuosity in any one form; rather, s/he will be more prone to a restless, synthetic, eclectic sensibility. At the pole opposite the virtuoso one finds, typically, the seminal artist who, unconcerned with the polishing and perfecting of style, is more interested in seeding a multitude of ideas. Artists look to the virtuosi in their medium to set standards of performance; it is in the often rougher, less resolved work

The Digital Evolution

DEQPAM.TIF, 1997 © Todd Walker
Courtesty of the artist

of the seminal figures that they find guideposts to the territories still to be explored.

We might then predict that the new imaging technologies will tend to breed upcoming generations of polymathic artists. Yet the example of the obviously polymathic Walker, who took to these tools like a duck to water, raises a no less interesting speculation: What would other polymathic artists who were not born into this technology have made of it? Walker's creative journey suggests that there's a route leading somehow from Edward Weston's darkroom on Point Lobos and the commercial studios of L.A. in the '50s to the PC of a seventy-five-year-old artist in Tucson. Walker's results make me wonder what Guillaume Apollinaire, Kurt Schwitters, Hannah

Höch, Raoul Hausmann, László Moholy-Nagy and an assortment of early collagists and concrete poets would have done with these devices – because their appeal is clearly not limited by one's age or year of birth.

We do not yet have extended, long-term, exemplary bodies of work collectively constituting a widely accepted standard for what is loosely referred to as "computer art," much less a set of articulated premises for the criticism thereof. Yet there seems to be virtually no doubt in anyone's mind about the inevitable appearance of such bodies of work or our ability to develop methods and standards for analyzing, interpreting and evaluating them. And once such methods and standards appear, they will probably be applied to the work of those of Walker's students and fellow artists who, liberated by his example and his sharing of his experience, have engaged in the free play of imagery that's resulted in what I'd call an "open photography" – whose impact can be observed everywhere, from trendy SoHo galleries to MTV.

Which means that they'll also be applied to the body of work Walker has been evolving since 1981. I suspect it's too soon even to guess where that work will lead, or how it will resolve. But that it's part of the continuum of his inquiry is clear. In the new work he returns to negatives made thirty years ago, and incorporates more recent images from the terrain he now inhabits – just as he combines processes he learned or originated three decades past with new ones he's still in the midst of refining. This insistent representation and transformation of his own germinal ideas is one benchmark of his approach. The other is his faith that he will continue to learn from his chosen tools and processes, those "expanders of my awareness" which, as always, "are teaching me what else is latent in the negative that comes from the camera."[89]

(Fall 1992)

Postscript

Todd Walker died of cancer September 13, 1998. He worked until his last two weeks. At his request, his ashes repose in an 8-reel developing tank.

Walker's influence permeates comtemporary practice, with little recognition of its source. I hope this essay both commemorates him and provokes attention to his life, his work, and his generous example.

The Digital Evolution

Fotofutures:
Ten Possibilities in No Particular Order

The start of a new year turns one's thoughts to the future – and insofar as the future of photography is concerned, here are ten possible scenarios, in no particular order:

1. In 2173, in Auckland, New Zealand, the Global Conference on Criminal Sociology will include a session devoted to the disturbing planetwide rise of violations of "no photographing" laws in the long-established "photo-free zones" of all major cities: sections of these metropolises in which, by popular demand and general consent, photographing people in public places is prohibited. This rise will have taken place despite the availability of compensating "auto-release zones" wherein photographers can make publishable images of street life without obtaining model releases. Though unable to decipher a pattern or determine a cause, panelists will sound a warning, projecting a continuing increase in "antisocial photographic behavior" through the end of the twenty-second century.
The "photo-free" and "auto-release" zones were pioneered in France at the end of the twentieth century, subsequent to two celebrated 1992-93 court cases – separate but related – in which an elderly couple named Lavergne and, independently of them, a woman named Bournet claimed to be the lovers kissing in front of the Hotel de Ville in Paris in 1950 in Robert Doisneau's famous photograph. The concept of the distinct photo-related zones was originated in 1989 by the U.S. critic A. D. Coleman, who acknowledged a debt to French Marxist scholar Bernard Edelman, author of the classic text *Ownership of the Image*.[90]

2. FOTOARKIVO, the international consortium of public and private re-positories of photographic images, will declare in 2212 that cooperation among its 85,000 member institutions has resulted in the long-antici-pated acceptance of universal standards for encoding, transmitting and retrieving digitized imagery. As a result, some 280 billion images ("More being added each month," the ads will promise) will henceforth be acces-sible to anyone who will pay the equivalent of $50 for the initial hookup, plus $20 monthly for cable charges. Bonus for charter subscribers: a top-of-the-line home computer (retail value $200) for only $24.99. Twenty-four-hour, seven-days-a-week, 365-days-a-year free access to a hotline of-fering computerized assistance in constructing search-and-retrieve pro-grams will be included in the service.

3. Documents obtained in 2048 under the Freedom of Information Act in the U.S. will reveal that the Central Intelligence Agency's involvement in the world of photography during the Cold War went far beyond the agency's suborning of the Rochester Institute of Technology and the activities of such "ex"-Agency hirelings as a noted Washington, D.C. dealer. Indeed, it will be revealed that the much-ballyhooed "photo boom" of the 1970s was in fact a C.I.A.-orchestrated money-laundering scheme. The scions of the heads of a major oil company and a major insurance company, among others, will be implicated in the plot.

4. The simplicity of image piracy that electronic imaging makes possible will run headlong into massive lawsuits and whopping settlements in a number of celebrated cases. After much deliberation and contention, the North American Society of Media Photographers in 2015 will propose a system (akin to the library-usage fee in the U.K.) whereby, for a small fee, up to 25 percent of a published image can be "recontextualized" by digital photomonteurs on a fair-use basis – the fee to be paid back to the photography agencies and publishers registered with the system, and apportioned by them among the photographers they represent.

5. As copyright on various masterpieces of photography expires, we will begin to see colorized versions of classic monochrome images: Stieglitz's "Equivalents," Weston's "Pepper No. 30," Adams's "Moonrise over Hernandez," Lange's "Migrant Mother," etc. An aging Joel Meyerowitz[91]

will lead the widely-publicized protest over this practice that will erupt in 2021 when a colorized print of Diane Arbus's "Xmas tree in a living room in Levittown, L.I., 1963" is hung in the Oval Office at the request of newly-elected U.S. president Chelsea Clinton.

6. On March 17, 2046, a mile-square grid of helium-filled balloons will be floated over Prague, each balloon serving as a pixel in a simulation of a computer screen. Using laser light to project onto these, a computerized program will display the entire known *œuvre* of Josef Sudek to celebrate the master's one hundred and fiftieth birthday.

7. The physical dangers to photography on paper are light, heat, moisture and contaminated air. The physical dangers to photography in digitally encoded form are no less insidious, no less real: magnetism and static electricity. Walk into a photo archive fifty years from now with an electromagnet in an attaché case and you'll be able to erase a large chunk of the past with a flick of a switch. And who knows what an electrical storm over London might achieve? Beginning in the year 2069, hot on the heels of the terrorist wipe-out of the entire Library of Congress, myriad protective devices will be invented and sold; horror stories of other irretrievable losses will begin to proliferate.

8. Commencing shortly after the turn of the century, a mix of psychobiography, autobiography, historical research and muckraking investigative journalism from diverse sources will provide a steady stream of revelations both shocking and titillating concerning the professional/financial intrigues among, and the private/sexual shenanigans of, many noted and revered figures in the world of photography. Look for particularly juicy details on: a revered photo historian and his wife; the department of photography at an important New York City art museum from 1970–1999; the upper echelon of the 1980s executive crowd at one of the world's largest manufacturers of photo equipment and supplies; an Ivy League university's graduate photo program; Imogen Cunningham; and Ansel Adams. Contributing to this will be the long-awaited publication in 2050 of the full, unexpurgated version of Edward Weston's *Daybooks* – an uncensored microfilm copy of which will be discovered among the papers of Beaumont Newhall at the J. Paul Getty Museum on Brentwood Island, California.

9. As photographic works by artists with no grounding in photographic craft proliferate and begin rapidly deteriorating, the field of preservation and conservation of photographs will become prestigious and lucrative. In 2094 there will be widespread international dispute over a proposed million-dollar "restoration" of an early photocollage piece by the Starn Twins, two brothers who dabbled briefly in art in their youth before embarking on a successful career as E-mail evangelists.

10. In the largest "alternative processes" effort ever attempted, an acre of desert in the new nation of Palestine – a U.N. protectorate created in the fifty-fifth year of the *intifada*, and located on former nuclear-test-site territory in Nevada, donated to the cause by the U.S. government – will be sprayed with light-sensitive emulsion by a modified cloud-seeding plane. The same process will be repeated on an acre of terrain in the Palestinian territory on the recently colonized planet Venus. Both these events will take place on the first day of Ramadan in the year 2314. Developed by infusing morning dew with vinegar mist, the resulting images – viewable by overflying air- and space-craft and satellites – will be photograms of the previous day's activities in those two areas. They will be broadcast on all global and interstellar networks.

(July 1993)

Postscript

After I published the above version of these forecasts in *Camera & Darkroom*, a new peace initiative raised hopes for resolution of the Palestinian-Israeli crisis. Ever the optimist, I decided that my tenth prophecy seemed likely to become quickly outdated, and replaced it with another when I republished the piece in the *New York Observer*. Here's the substitute:

By 2025, the storage of a thousand digitized color images on a microchip no larger than the head of a pin will be commonplace; most people will carry inexpensive "picture pens" – digital cameras shaped like ballpoints – for everyday visual note-taking. The rage that fall season will be a new version marketed as "InSights": subcutaneously implanted

The Digital Evolution

microchips connected to the optic nerves and capable of recording anything registered on the retina via a thought-activated process. Downloading, transmitting, erasing and otherwise interacting with stored images will be accomplished via a small device connected to any home infotainment center. The implantation will be a simple operation performed on an outpatient basis. Demand will be enormous, leading to the establishment of an international chain of "InSights" clinics staffed largely by doctors and computer experts from the nation whose researchers devised this innovation, the new global leader in computer innovation: India.

(January 1994)

"Everything you know is about to be wrong": A Report on Montage 93

While I don't agree with a friend of mine who insists that "all change is for the worse," I'm not convinced that the pace of change was ever comfortable. Comfort, I suspect, is a function of stasis, not transition. But even if change once took place at a rate and quantity that the average person could accommodate and integrate, it surely no longer does.

Perhaps that's just my way of confessing that I'm not certain I'm able to keep up with it anymore. Nor am I sure I want to. And I'm afraid that, in any case, the choice isn't mine, or yours – fearful that there's no way off the hook, that we'll be dragged kicking and screaming into the future unless we come along willingly.

Certainly that was the underlying assumption of virtually everything exhibited, written, or uttered in lectures and symposia during an intensive confrontation with the present and immediate future of digital imaging that was held in Rochester, New York last summer. Montage 93, which subtitled itself the "international festival of the image," was an ambitious effort to grapple with and illuminate these early days of what the author William J. Mitchell has dubbed the "post-photographic era."[92] Seven years in the planning and making, this complex, multi-layered event – the brainchild of Nathan Lyons, founder and director of the Visual Studies Workshop – aspired to be nothing less than a watershed in the emerging dialogue on the subject of photography in the electronic age.

Partly as a consequence of those ambitions, the festival, which ran from July 11 to August 7, was orchestrated so elaborately, with so many parallel tracks, that deciphering its various and detailed promotional materials and

calendars was a visitor's first challenge. There were, among other offerings, sixteen exhibitions, including a "traveling exhibition" on the local Metro Bus system; a book fair; a high-tech digital-imaging trade show; an "arts and technology exposition"; a film festival; a video festival; a welter of panel discussions and lectures; an international student festival (in which I was a participant and lecturer); a set of digital-imaging workshops organized by the Center for Creative Imaging; a "pre-K-12 educational conference"; and concurrent meetings of such organizations as Oracle (the international association of directors and curators of photography collections and programs), the International Visual Sociology Association, and the Media Arts Teachers Association. These events interwove and overlapped with, illuminated and contradicted each other in valuable and provocative ways. Perhaps the best means of conveying the flavor of the event is, taking a cue from its title, to adopt a montage structure for this report.

*

On the morning of Monday, May 24, I head toward the International Center of Photography Midtown for a press conference on Montage 93. At the I.C.P., I drink coffee, munch on strawberries, listen to pep talks from Nathan Lyons and others, and wait my turn for a five-minute taste of virtual reality (or VR, as its enthusiasts refer to it), some version of which I've just been told will radically transform my future. Eventually I am strapped into an eight-foot-high gyroscope with what seem to be a modified motorcycle helmet with goggles on my head and modified Rubbermaid dishwashing gloves on my hands, and encouraged to shoot down the asteroids that zoom towards me in a cartoonish 3-D spatial illusion. I find 2-D video games to be somewhat less exciting than watching paint dry; adding a third or even a fourth dimension to them isn't likely to make a convert of me. I decide to reserve judgment. Maybe there are other applications for this technology; maybe I'll find out at Montage why this matters.

*

"Everything you know is about to be wrong"

Even before my arrival in Rochester, I discover that the official literature of the festival is voluminous, and daunting. Its brochures, schedules, and maps have in common only an impenetrable complexity. Despite this, in actual fact Montage 93 proves to be (once I get my hands on the local paper's user-friendly guide, which even includes photographs of the main sites) easy to get around. Aside from "New Arts/New Worlds," the student festival I've been invited to address, which is housed some 30 miles away on the campus of the State University of New York at Brockport, most of Montage's menu is served up in downtown Rochester, and – though this strikes Rochesterians, who all seem to own cars, as peculiar behavior – can be handled on foot by a practiced "walker in the city" from New York like yours truly. It's all pretty much in a line along a two-mile stretch. At the eastern end there's the International Museum of Photography at the George Eastman House; at the western terminus stands the Riverside Convention Center, which houses the book fair, the trade show, and the arts and technology expo. Roughly in the middle is the luxurious Eastman Theater, where the afternoon symposia and evening lectures are held. In between, on mostly tree-lined streets, are the various exhibition sites, along with a number of low-key, inexpensive restaurants, bars, shops, live-music clubs and cafés. It's a pleasant city for strolling – uncrowded, human-scale, clean and quiet – and the July weather is perfect for that purpose; by pacing myself, I take in what the festival has to offer in four afternoons, without breaking a sweat.

*

What's past is prologue: On the night of July 19, a group of a dozen mentally challenged people, out on a field trip with their nurse and an aide, stand transfixed before Canadian artist Wyn Gelense's installation in the former repair dock of Hallman's Chevrolet, a now-defunct auto dealership. By comparison with what's on view elsewhere in town, this piece is so low-tech as to be practically antique: merely a film loop rear-projected onto a shaped sheet of sand-blasted plexiglas that's suspended in the darkness of the bay. The film shows a close-up of a hand caressing, over and over again, a framed photo of a child sitting in a toy car. Seen in passing, from the street,

The Digital Evolution

it is at once riveting, meditative and melancholy. These spectators talk about it among themselves – I hear *Star Trek* mentioned several times – and then ask the docent (a local woman, a banker, one of a cadre of some 900 volunteers from the community) what it means. She turns the question back to them, and they propose possible interpretations as we continue to watch the huge, slowly moving hand obsessively touch the past.

<div align="center">*</div>

"We are entering the virtual age. Everything you know is about to be wrong, and much of it already is. This is the biggest thing since fire."

The speaker is John Perry Barlow – Montana cattle rancher, lyricist for the Grateful Dead, co-founder of the Electronic Frontier Foundation and an ardent explorer/advocate of what is called cyberspace. What exactly is cyberspace? It seems to be a hypothetical or imaginary location in which real events take place. Barlow, talking in the Eastman Theater, defines it operationally: "Cyberspace began right here [in Rochester], when Alexander Graham Bell and his assistant Thomas A. Watson had that first phone conversation at a point somewhere between two rooms."[93]

Barlow is leading off a week-long string of lectures addressing such issues as interactive telecommunications, virtual reality, and civil liberties in the computer age. He could be described as an electronic libertarian, whose E.F.F. was created to combat government intrusion into and corporate control of international computer networks and other cyberspace territories. "Our motto is: U.S. out of cyberspace," he announces. And, "In cyberspace, the First Amendment is a local ordinance." And, "The evidentiary nature of anything – thanks to events that started out in this town – is increasingly suspect."[94] And, "Much of what's wrong in America is the result of television being a one-way conversation." Like many of those on the outer edge of these technologies, he's hyped on something that's loosely referred to as *interactivity*, which they understand to be directly connected to true democracy and/or healthy anarchy. I am not yet convinced, but one thing is clear: these new forms are attracting people who are eminently quotable.

"We can understand the history of technology as changes in social interactions," artist/critic Joanna Frueh tells a rapt audience at the student festival, just before breaking into an *a cappella* version of "I Can't Help Falling in Love with You" in a rich, vibrant contralto. It's just one of many surprises and challenges they'll be offered during the week.

"New Arts/New Worlds," the student festival, is severely under-attended. Montage's staff had expected a minimum of one hundred and twenty, were prepared for quite a few more, but end up with only three dozen – and only one of them, a Texan, from the U.S. This is surprising and inexplicable, given the richness of the program, the relative inexpensiveness of its fees, and the extensive mailings. To their credit, everyone involved – from chairperson Elaine O'Neil of the Rochester Institute of Technology, William Johnson of Eastman House, and site coordinator Pat Epstein to the patient and indefatigable young volunteers who solve every conceivable logistical problem with humor and good will – puts as much wholehearted effort into it as they would have for an overflow crowd. As a result, the registrants – some of whom are photo students and some photo teachers, and who have flown in from Finland, Spain, Australia, Brazil, South Africa and other distant points on the compass – get a remarkable bang for their buck: morning symposia with people like Frueh, Brian Wallis of *Art in America*, and picture-makers like Evergon, Carrie Mae Weems, Esther Parada and Paul Berger; discussion groups; portfolio reviews; informal encounters with assorted photo-notables; and passes to all the festival's other lectures and events.

Some of what they come up against leaves them understandably befuddled – such as Peter Weibel's extraordinary impersonation of the stereotypical mad Teutonic professor offering a totally incomprehensible lecture, at which the overly polite Rochester audience steadfastly refuses to laugh despite the many clues to its parodic purpose. Much of what these students and teachers are seeing and hearing is brand-new to them – including not only the new image technologies but also the debates over critical and theoretical issues that are now standard fare in photography education here in the States.

Most of them have had, or are presently undergoing, a traditional education in photography, grounded in silver and aniline dyes. Only the Finns, who are from the Nykarleby School of Arts, appear to have much familiarity with digital imaging; they come bearing gifts, in the form of a limited-edition book they produced for the occasion via desktop publishing, a lovely little image-text fictional-mythological work (based on manipulated Edward S. Curtis photos) whose production was funded by the Finnish government.[95] They give copies of it to some of us as a way of saying thanks, but clearly they – and the other participants as well – feel that they've received something of great value during their stay: they're exhausted, their circuits have obviously been overloaded, but they're energized and enthused about the future of the medium they've chosen, even with its ground rules changing before their eyes.

<div align="center">*</div>

"Interactivity" is the buzzword of the hour, but no one seems willing to define it – beyond asserting that it's brand-new, unprecedented and good for us. The implication is that none of the preceding media have been interactive, and that our relation to all those older forms – paintings, photographs, books, movies, television as we've known it – therefore was and is passive, absorptive, disempowering: they talk, we listen.

I'm having trouble with this, because I'm convinced that when I'm sitting in the Thalia with tears pouring down my cheeks as Bette Davis's face goes out of focus at the end of *Dark Victory*, or making my argumentative marginal notes in John Berger's *Another Way of Telling*, or listening to my friend Charles Catlett read his latest poem-in-progress, or yelling back at William F. Buckley's snotty nonsense on the tube, or spending half an hour studying a Susan Meiselas photograph, I'm interacting. I'm not an empty vessel into which someone else's ideas are being poured; I am, as the late I. A. Richards (among others) would have argued, making meaning from what's been presented to my perceptual system.

I make no claim to expertise on matters computer-related, nor have I experienced widely any area that could be considered state-of-the-art. Still,

very little of what I see in the exhibits or at the trade fair, and hear described in such glowing terms by speakers and panelists, seems to me like anything I'd consider a major breakthrough. Mostly it's bells and whistles and buttons to push, lots of buttons to push: everything here hums and clanks and flickers and turns on and off.

Somehow I don't feel any more empowered by a video installation programmed to start up when I enter its space than I do when I make eye contact with a silver-gelatin print that remains, as it were, permanently turned on regardless of whether or not I'm in the room. "There's a tremendous breakthrough awaiting us in this decade. We're still just bottom-feeding on this idea of interactivity," admits the entrancing Brenda Laurel (who gave us the home version of Pac-Man, surely a dubious blessing at best) at her lecture; I'm glad to hear I'm not the only one who thinks there must be more to it than this.

The most convincing demonstration of the possibilities in store, for me at least, is a videotape that Jaron Lanier runs during his lecture. Billed as "the founder and recently deposed CEO of VPL Research, . . . the first vendor of complete VR systems," Lanier looks like a large, plump troll with waist-length blond hair in cornrows; he has the body language of a flower child, the spacey speech patterns of a benign acid-head, a collagist's way of thinking and distinct flashes of genius. In addition to being a computer whiz and an inventor, he's also a musician and composer who's devised, for his own pleasure and use, a virtual-reality environment in which various instruments float: something vaguely saxophonish, a synthesizer keyboard, and a kind of tambourine. The tape shows him in performance, sitting on a stage, wearing virtual reality's trademark gloves and helmet, improvising – as, on a video screen above him, a 2-D video projection shows the audience what he's seeing: the virtual-reality versions of his own disembodied hands playing these instruments to make the music they're hearing. As an amateur musician myself, I'm fascinated; video games may not tempt me, but this looks like an *adventure*.

*

The Digital Evolution

Interactive artworks confront audiences and presentational venues with a number of new challenges. Scheduling, for example. A dozen people can look at length and simultaneously at one of Ansel Adams's larger prints of "Moonrise over Hernandez." But only one can be strapped into a VR device at any given moment. So people start lining up at 8 A.M. outside the Strong Museum – which won't even open until 10 – to register for five minutes on the VR device that's part of the group show there, ponderously titled "Perspectives, Proximities, Perceptions: Expressions in Three-Dimensional Graphic and Electronic Media." By 10:30, it's booked for the day, every day. The same thing happens with the VR device made available at the trade show by New York's CyberEvent Group. (VR is the cutting-edge technology of the moment; Jaron Lanier was also the hottest ticket among the evening lecturers.)

Moreover, these and numerous other works at the various exhibits require time – time to learn how they work, as well as time to absorb their content. Most are determinedly innovative and idiosyncratic in their operation. Many of them have a fixed and not inconsiderable duration: Alan Rath's electronic sculpture, a meditation on the Challenger spacecraft explosion, for example, runs about twenty-five minutes. Those with audio components take it for granted that one will be able to listen to their soundtracks without interruption from other sound sources. Quite a few – such as Daniel Reeves's storefront installation "Eingang/The Way In" – are predicated on the viewer establishing a slow, continuous, meditative and even solitary relationship to them.

Which is to say that they don't do particularly well in the *Max Headroom*/video-arcade atmosphere of the group show, where they compete with, distract from, and sometimes drown out each other, and where one feels impolite if one spends more than a few minutes of exploratory time on anything when other people are lined up for their turns. Nor do they thrive on crowds. The installation displaying Grahame Weinbren's film, *Sonata*, uses laser-disk players and infrared sensors; it is activated by the viewer pointing to different sections of the video screen, which generates shifts in the point of view from which the narrative is seen and told. This is intriguing and, in fact, truly interactive. But it takes at least one viewing just to get the hang of the system, and another to put what you've learned into practice, which is

© 1992 Steve DePaola
Courtesy of the artist

impossible under the circumstances; and it would help if its soundtrack were not constantly overwhelmed by the noises from the six other devices elsewhere in the same room at the Memorial Art Gallery's show, "Iterations: The New Image," a traveling exhibit co-curated by Timothy Druckrey and Charles Stainback.

This is only one of eight group shows included in the festival, all of which – even those that fail – merit individual discussion that space does not permit. Of these, "Iterations," which concentrates on digital imaging, is the most clangorous; in addition to the projects of Rath and Weinbren, it includes works by Esther Parada, George Legrady, Keith Piper, Jim Pomeroy, Carol Flax and quite a few others, fifteen artists in all.[96]

To provide, much too quickly, a sense of what the exhibits encompassed, here are some brief synopses:

* "Interior Dialogues," at the Pyramid Arts Center: a juried show of work by twenty-four recent graduates of M.F.A. programs, all but four from

The Digital Evolution

schools here in the States. A cross-section of typical current student work. Most interesting: Kristin Anderson's intelligently seen small-camera black & white images of boys; Young Kim's melancholy assemblages on the loss of her identity as an expatriate Korean; Chuck Samuels's stylistically accurate, biting, parodic reenactments of iconic images by Ralph Gibson, Man Ray, Edward Weston, E. J. Bellocq and others, with himself in the female roles. Worth noting: four of those chosen by the jury got their degrees from the School of Visual Arts in New York. The show's "sponsor and organizer" is the M.F.A. photo program at that school; the show's "director" (though not a juror) is Charles Traub, who heads that program; and its two curators are graduates of that program.

Also in the same space: an eerie, grim installation by Sherwin Mark, "Remembering Forgetting," centering around a photograph of the 1911 lynching of a Black man, Zachariah Walker, by a mob of steelworkers in East Fallowfield, Pennsylvania – the crowd of murderous men all posing proudly for the camera.

* "Copigraphic Interconnections," at the Visual Studies Workshop: a loose survey of "copy art" – works produced on assorted electrostatic reproduction systems – by 18 artists from many countries presently living in Toronto. Curated by Monique Brunet-Weinmann. My favorites: Franziska Megert's video installation, "Arachne-Vanitas," in which the silhouettes of spiders crawling on the screen transform a nude young woman into an old one (its relation to copy art is marginal); Boris Nieslony's disassembled Xerox copier, spread out like a dissected cadaver on the floor.

* "Perspectives, Proximities, Perceptions," previously mentioned: a reasonably comprehensive survey of work produced with current 3-D imaging systems, curated by Lance Speer and Louis M. Brill. Worth noting: Rebecca Deem's "Leap of Faith," a small installation I'd seen a few years back at the now-defunct Museum of Holography in New York; the late Jim Pomeroy's modified View-Master images; curator Speer's stereopticon made from a human skull, constructed so that one looks out at the image through the skeleton's eye sockets. The exhibit includes a most instructive and useful timeline recounting the evolution of 3-D still photography and film, with examples of the consumer-market cameras and their results.

It also offers a useful handout lucidly describing the various processes, from anaglyphic imagery to assorted forms of holography.

* "The New Images," at the International Museum of Photography: a shapeless, sprawling smorgasbord curated by Ginette Major and Hervé Fischer. Ninety-six works by twenty-six artists and/or organizations from five different countries. Holograms, 3-D television, computer animation, stereo images, 3-D and 2-D computer images, and lots more. Much kitsch. Best in show, hands down: Evergon's 1989 triptych of enormous transmission holograms, directorial images representing a river god at three stages of his life.

* "Electronic/Mail Art," at the Damon City Center: no less amorphous, but in this case on purpose. An open invitational exhibit, organized by Kathleen Farrell and George Campbell McDade, who – so far as I could tell – put up everything they received from what seem to be hundreds of folks from all around the world. Since "mail art" (which now includes faxes, E-mail, and other newer forms) is inherently antagonistic to institutionalized aesthetic standards and curatorship, their hands-off no-editing policy is appropriate. The results are, to say the least, uneven; but taken as a whole, the show makes it clear that creative energy flows everywhere, through all of us, and it doesn't take anything more technologically complex than imagination and a postage stamp to unleash it. In the context of Montage 93, it's a much-needed antidote.

* So, in a somewhat different way, is "Retratos y Sueños/Portraits and Dreams: Photographs by Mexican Children," at the International Museum of Photography. Curated by Arthur Ollman and Wendy Ewald, this show documents one of MacArthur Foundation fellow Ewald's most recent projects. The children of San Cristobal de las Casas, a small village in Chiapas, Mexico's southernmost state, were taught photography by Ewald and turned loose in their own context. They photographed their friends and family, their pets, their homes, the things they loved – and their dreams and imaginings. Then they wrote about their pictures. Presenting this work in the form of large, exhibition-quality silver prints may distort it somewhat, but what pulses through is the exuberant spontaneity of young people given their first opportunity for the visual interpretation of their own

The Digital Evolution

© Michael Brodsky
Courtesy of the artist

lives. For anyone worried that, in the digital era, what we once thought of as photography has no function in the world anymore, this show provides not only a respite but a cause for optimism – and rejoicing.

* "Projects: Within Memory," at the Midtown Plaza Mall. Curated by James Sheldon of the Addison Gallery of American Art, this was the most tightly edited and thematically coherent survey show of the festival. Those represented were (with few exceptions) addressing the issue of individual or collective memory via photography. Notable among them: Joachim Schmid's typologies based on "found" photographic imagery; Pedro Meyer's family-album CD-ROM project, *I Photograph to Remember*; Patti Ambrogi's understated, angry anti-rape piece, "Not Seriously Injured"; Yasumasa Morimura's "The Death of Father," a parodic reinterpretation of a classic example of Western painting; and Joan Fontcuberta's send-up of archaeology, a pseudo-report on the primitive people of Retseh-Cor (Rochester spelled backwards) from the fictitious "Rochester Institute of Prospective Anthropology."

"Everything you know is about to be wrong"

In the student festival's handbook, approximate viewing times are proposed for all the exhibits; none is longer than an hour, and few attendees will actually devote that much attention to any one show. Yet in fact, whether they reward it or not, most of the shows – indeed, many of the individual works on view – demand far more time than that. What these group shows are, then, are occasions for "grazing," not unlike the skimming through channels that remote controls make possible on our TV sets. Who is at home with all this? So far as I can tell, only the young (by which I mean those under twenty-five), who are present in droves, and who dart and flit from one device to another like shoppers at the mall. At one of the afternoon symposia, Maricia Battle, Assistant Curator at the National Museum of American Art in Washington, D.C., asked, not sarcastically, "How do you attract an audience with an attention span of three seconds?" The answer would seem to be, "With aggressive, rackety, complicated artifacts that encourage a hands-on relationship." But a parallel question is, "What audience will these strategies drive away?" I posed this to the panel, but no one wanted to touch it.

All the festival's solo shows are multi-media installations; these range from the Gelense projection to such elaborate fabrications as Mary Lucier's "Oblique House (Valdez)," Francesc Torres's "Too Late for Goya," and Dawn Adair Dedeaux's "Soul Shadows: Urban Warrior Myths," the last of which occupies an entire warehouse. They exemplify what Joseph Marshall recently referred to as "the fact of the transformation of 'photographic art' into an art of montage in response to mass media."[97] Lucier's work is comprised of video interviews with residents of Valdez, Alaska, who lived through both a major earthquake and the more recent oil-spill disaster; these are activated and orchestrated by the viewer's movement through the structure housing the monitors. The Torres work projects along one wall, in extreme slow motion, film footage from six major twentieth-century events, ranging from the Russian revolution of 1917 to Gorbachev's 1985 ascent to power. (Just outside the space in which it was installed at the Memorial Art Gallery, coincidentally, is an example of the historic origin of the pixellated image: a Roman mosaic.) And Dedeaux's raw, powerful scrutiny of urban gang

warfare, which grew out of a collaboration with inmates in the Orleans Parish Prison, incorporates videotapes, audiotapes, enormous hand-colored still photographs, bookworks and other material into a gritty, raucous bottom-up vision of street and prison life (and death) in the African-American communities of New Orleans. Groups of young people from Rochester and the surrounding region have already made arrangements to attend *en masse*.

*

With all this whirling in my head, it's something of a relief to discover that the transition into this new imagistic universe is going to be gradual. Much of the work on view in the exhibitions has been produced with comparatively traditional tools and materials. At the trade show, I learn to my delight that Henry Wilhelm – who still owes me a print washer from his East Street Gallery days – has at long last completed and published his definitive study, *The Permanence and Care of Color Photographs: Photographic and Digital Color Prints, Color Negatives, Slides, and Motion Pictures*, one of whose aims is to ensure the preservation of our photographic past.[98] The folks from an outfit called EverColor Pigment Prints give me the rundown on their method for making permanent color prints that will endure "for centuries," which combines digital scanning with carbon pigment printing; the latter process dates back to the late 1800s. And, at the adjoining expo, Pierre-Yves Mahé, founding director of s.p.e.o.s., a new photo school in Paris, logs me onto a real-time transatlantic discussion with a colleague in France, via phone and computer-imaging system; this makes possible an intercontinental version of that ancient ritual, the portfolio critique. *Plus ça change, plus c'est le même chose.* Or at least, as Hemingway said on another matter, "Pretty to think so."

*

On the morning of July 25, just before my departure from Rochester, I have breakfast with Nathan Lyons. Looking healthier than he has in years, Lyons remains both an optimist and a pragmatist. Rochester is headquarters for

Eastman Kodak and Xerox, and the home of the International Museum of Photography, the Visual Studies Workshop (founded by Lyons), and R.I.T.; there's also a strong program in photography at the University of Rochester, chaired by photographer and scholar Carl Chiarenza. As previously mentioned, it's certainly a human-scale and hospitable city. Given those resources, there's no place in the country, perhaps in the world, better suited to serve as host for a gathering such as this.

Yet, Lyons notes in a non-accusatory fashion, the Rochester business community's support was slow in coming and the festival is therefore in debt. By this Sunday, the festival's halfway mark, the numbers are starting to roll in and the project has been vindicated on the bottom line: local press and media support has been considerable, Governor Mario Cuomo showed up to put his imprimatur on the event, attendance at the various institutional exhibits is breaking records, the downtown merchants – whose district is undergoing revitalization – are delighted, and the trade fair is such a success that exhibitors have already asked for a repeat.

Lyons, whose vision had inspired it all, and who'd served as the festival's president, is confident that all this will sway the local forces to retire the festival's debts, and to consider committing well in advance to a second Montage, perhaps three years down the pike. "This event had to happen somewhere," Lyons tells me. "We made it happen here. A few years from now it has to happen again – here or somewhere else – and it will. But we won't do it again without full backing. Rochester's choice is either to run with the ball that's in its hands or drop it. If this city lets it go, someplace else will pick it up – and five years from now the Chamber of Commerce will sit around saying, 'Gee, that was a great opportunity. Why did we let it pass?'"

*

The week after I come home, I go to Summerstage in Central Park one evening to hear a reading featuring William Gibson – considered to be the originator (if we leave out William Burroughs and Alfred Bester and quite a few other folks whose books I was devouring in my teens) of the new mode of fiction called *cyberpunk* – and Steve Erickson, whose dark, apoca-

lyptic brooding on the American psyche, *Arc d'X*,[99] I'd just finished reading. They're both fine readers of their own work. At the intermission I go over to get Erikkson's autograph on my copy of his book, and who's there hanging out with the two of them but – John Perry Barlow! I tell him I'd just seen him up in Rochester; he asks me how he went over.

The next night it's still hot and muggy, and I can't sleep, so I turn on Charlie Rose on PBS and his guest is – Jaron Lanier! To my surprise, I know what he's talking about and understand what he's saying – which I wouldn't have been able to do a month earlier.

That Sunday I open the funnies and the premise of one of my favorite strips (it involves journalists), *Shoe*, is – virtual reality! It's funny – and I get the joke, which two weeks before would have been lost on me.

Blink and this technology with its advocates is everywhere, so it seems. I'm expecting to bump into Brenda Laurel in SoHo any day now. And I'm wondering: Did we get adequate early warning on all this and I'd just stepped out for a beer when the alarms went off, or is it happening very suddenly and much too fast?

(January 1994)

The Final Image:
Some Not-so-terminal Thoughts

Last spring – on the morning of Monday, May 24, 1993, to be precise – I was headed toward the International Center of Photography Midtown for a press conference on Montage 93, the then-upcoming "international festival of the image" that took place in Rochester, New York last summer.

Anyhow, on the Staten Island Ferry that A.M. I picked up a *Daily News* that someone had left behind. (This is my John Cage-derived system for random newspaper reading, but that's another story.) Browsing that tabloid, I came across a feature on a just-opened "electronic imaging center" in Manhattan. "On the second day of business at Final Image on the upper West Side, a customer brought in some beautiful wedding photographs – marred by a gardener raking leaves who happened to wander into the pictures," it began. "Owner Oren Glick scanned the photos into a computer, and then, by manipulating the image using a mouse, removed the offending workman from the shot. The enthusiastic groom then asked Glick – as long as he was at it – to change the color of his bow tie and cummerbund from red to blue. No problem. In fact, he could even have replaced the bride. 'We can do anything,' enthuses [the 25-year-old] Glick. . . . 'It's magic!'"[100]

I sat there in the respectful silence one reserves for historic moments marking major cultural change. So much for all our agonizing debates over the ethics of electronic image alteration in photojournalism, our ponderous ruminations about whether the editors at *National Geographic* should have moved those damn pyramids closer together. *Vox pop* had spoken, and its answer was: *Go for it.*

In passing, I referred to this epiphany a few columns back. The heated letters-to-the-editor dispute over our recent issue [of *Camera & Darkroom*] on electronic imagery,[101] plus my own ongoing encounters with the new electronic forms of photography, led me to dig out the original news story and meditate on it awhile. And, as regular visitors to this column and my features might expect, I find myself of (at least) two minds on this complex subject. For I not only sympathize but empathize with those who find themselves unable to derive much pleasure or satisfaction from most of what's currently being held up to us as exemplary of state-of-the-art lens-derived imagery in various pixellated forms. Indeed, I'm perfectly willing (indeed, eager) to acknowledge that most of it is junk, and I have all kinds of reservations and questions concerning the technology by which it's generated, with which I'm still in many ways deeply uncomfortable. But the fact is that I have to disagree with those readers who claim that (a) this isn't photography, (b) it isn't even pertinent to photography, and (c) it certainly doesn't belong in this magazine.

Insofar as (a) is concerned, over the past decade I've talked to a great many photographers who've made the transition from traditional photographic processes to electronic imaging. Whether it's the venerable Todd Walker, who – with a solid grounding in silver-based and analine-dye photography, and with successful careers in advertising and creative photography under his belt – made the switch in his sixties or a comparatively young sprat like Katrin Eismann, whose presentations at Montage 93 last summer emphasized the value of her education in traditional photographic methods at the Rochester Institute of Technology, they invariably sing a common refrain: Once you understand the analogies, everything you learned about lens-derived imagery from your experience with traditional photography translates directly into electronic imaging methods. This suggests that, insofar as the actual production of imagery is concerned, there's a direct evolutionary link between these technologies for visual communication that simply can't be denied. We didn't get to electronic imaging from painting; we got there from the lens-based media – still photography, video and film.

In regard to (b), it's my belief that we do our minds the most service by casting our conceptual nets as widely as possible in looking for what might

nourish our understandings of photography. As a working critic specializing in photography, I consider my purview to include not only traditional darkroom-based imagery in monochrome and color but negativeless forms like Polaroid 20 x 24s and sx-70s, "disembodied" forms such as slide projections, and, beyond those, photocollage, process experiment in photolithography, photo-silk-screen, holography, even photo-realist painting – and, certainly, electronically generated and/or manipulated imagery that's in some way photographic. My premise is that an understanding of the specifics of photography – both the processes of production and our cultural relationship to the results – cannot help but prove useful in analyzing such work; and, conversely, that engaging with such work can only enrich my relationship to the specifics of the traditional photographic media.

Now, let me make it clear that I'm not speaking from the standpoint of an experienced performer within any of the visual media. I'm neither a working photographer nor a professional in electronic imaging. I can't claim to have immersed myself in what the computer environment has to offer to picture-makers. Aside from the glimpses one gets and the flirtations one engages in at trade shows, my total hands-on experience to date with electronic imaging consists of an afternoon in which I got to play with a Sony Mavica, the electronic camera whose "negatives," digitally encoded on 3-1/2-inch floppy diskettes, could be instantly called up on computer and incorporated into a newspaper's page layouts, and a one-day introduction to Photoshop, during the course of which I violated copyright law by "capturing" my son Edward's face from a photo I carry of him in my wallet and using it to replace the visage of the shaven-headed, shirtless, insect-covered beekeeper from Richard Avedon's *In the American West*.[102] (I gave it to Ed for his birthday; he loved it.) This hardly makes me a maven.

Nonetheless, the handwriting has been on the wall in this regard for a long time, and, if I may mix my metaphors, you haven't needed a weatherman to know which way the wind has been blowing. Even an untrained outside observer like me could stick a wet finger into the breeze. Which brings me to (c), the question of why that discussion belongs in these pages.

As early as 1976 I was writing cautionary prophecies about the imminent transformation of our visual communication systems via electronic imaging.

In 1980 my colleagues Douglas I. Sheer, Tricia Grantz and I published a resource book we'd worked on for several years, *The Photography A-V Program Directory*, listing over 3,300 programs on photography in all current media: slide-sound, audiotape, film, videotape . . . and, yes, even way back then, a handful of computer programs.[103] Now there are hundreds of such programs designed for photographers to use (a lot of them are freeware or shareware), even if they choose to work with the platinum print: programs for negative-file and print-file management, for all kinds of record-keeping, for exposure calculation, for control of enlargers during printing. More and more cameras, accessories and darkroom equipment incorporate electronic control systems. Every year, the volume of photographic images by all kinds of photographers, living and dead, that is encoded on CD-ROM disks increases exponentially. Growing numbers of picture researchers, picture editors, art directors, photo historians and others retrieve and utilize these electronically encoded images. By the year 2000, it's safe to say, only the most willfully stubborn and archaic among us will be eschewing on principle anything photographic that's got electronics in it – and that'll take some doing.

We don't have to like these facts, but we do have to face them. There is no future for a photography journal that avoids this complex of issues. Erecting a sign over the entrance to this magazine that reads "Nothing electronic permitted past this point" is a sure way to doom the publication to a not-so-slow death. The audience for a magazine devoted, on principle, exclusively to forms of photography that originated before 1950 – many of which are essentially nineteenth-century – is not only limited but shrinking. Ten years from now there will barely be enough of them to support a bi-monthly newsletter.

What's more, despite the fact that my favorite form of photography remains the finely crafted, interpretive silver print, I don't want to write for such an ostrich-minded readership; nor, I suspect, do most of my fellow contributors. Whatever our preferences and our anxieties, none of us can afford to close the door on the future. Electronic imaging is here to stay. Many of its variant systems are directly related to photography, and the troublesome nature of that relationship – the similarities, and the differences as well – demands our critical attention, our analytic awareness. I can think of no place better than the pages of this magazine, whose readers are extremely

knowledgeable concerning the preceding forms of lens-based imagery, to stage such a discussion. What better-informed or more critical audience could there be for that debate?

(This is the first of a two-part series.)

(June 1994)

The Digital Evolution

An Arranged Marriage:
My Life with the Computer

In my last column [see 'The Final Image: Some Not-so-terminal Thoughts'], I acknowledged my sympathies with those photographers who are less than thrilled with the accomplishments to date of those who produce electronic imagery, and who remain skeptical about the impact of these new technologies on the craft of photography. Now I want to indicate my empathy with those photographers who have an actual fear and loathing of these suddenly omnipresent tools and processes that seem to be rapidly taking over the medium. I understand what you're going through; it's exactly parallel to what I've experienced as a working writer, and I want to address the situation from that standpoint.

As a professional wordsmith, I hated the whole idea of writing on a computer from the beginning. Not that I was a Luddite, devoted to the literal manuscript, by any means. During the early 1950s my family had spent a couple of years in France, where they still taught kids to write by the Palmer Method; so I had a fine cursive hand, of which I was quite proud, by the age of eight. But my parents founded a small publishing enterprise that was run from our home in my childhood, so I grew up around typewriters: not just manual ones, but even more serious writing machines – those hulking, tank-like post-World War II I.B.M. electrics. They were the first pieces of machinery I ever came to love; I used to turn them on when no one was around, to listen to them hum, or to run a blank piece of paper all the way through by keeping my finger on the automatic carriage return...

When asked how to become a writer, Sinclair Lewis habitually answered, "Learn to type." I never did acquire touch-typing skills, though I had plenty

of opportunity; instead, I evolved an idiosyncratic, advanced hunt-and-peck technique that even today pretty much keeps pace with my thinking. Still, by my teens I understood what Lewis meant: Typing lets you see what your words would look like in print. While I made notes, and sometimes first drafts, by hand (and still do), by the time I got to college it had become second nature to sit down at the typewriter – a lovely dull-green Olivetti manual portable, finely designed and compact, the writer's equivalent of a 1950s rangefinder Leica, was the first I had as my very own – to work out an idea.

As an undergraduate at Hunter College in the Bronx, I wrote for the school's bi-campus paper (the largest in the City University system) and its literary magazine – my first experience in seeing my own work published. Both of these publications were produced in the same print shop, down on Manhattan's Lower East Side. In my senior year I edited the school news-paper. Altogether I spent weeks, maybe months of my life in that cramped little shop. My favorite part of it was watching the Linotype operator set something I'd written myself. If I stood at the side of the machine, I could observe out of one eye as his hands flew over his keyboard, entering in my text from the typescript before him; with the other eye, I could see the slugs of hot lead drop down a slot, my words in metal, fixed, permanent, in-eradicable.

When I graduated from college in 1964, with a B.A. in English, and headed off to do graduate work in literature and creative writing, my mother asked me what I wanted for a present. "An electric typewriter," I answered im-mediately, Smith-Corona having just produced its first electrified portable model. And that's what she gave me, over my father's strenuous objections: "No real writer writes on an electric typewriter," he sneered.[104] (It stung me. A sometime writer himself, he gave me a monogrammed leather brief-case, presumably a more essential tool of the trade. A few years later, in a profile of James Jones, I read that the celebrated author of *From Here to Eternity* always wrote standing up at the mantel, on an electric typewriter. I sent the clipping to my dad. So there. Not long thereafter I'd started earn-ing my living as a working writer, and that no longer mattered.)

So I got accustomed to turning my instrument on and off, and to its hum-ming quietly and vibrating slightly on my desk as I worked. For the next

The Digital Evolution

two decades I traded up every five years or so; like camera manufacturers, typewriter companies periodically added new bells and whistles. (There was the automatic carriage return, the typo correction cartridge, the changeable typeface ball . . .) Basically, however, the instrument remained the same; the user never had to rethink his or her fundamental relationship to the tool. In this sense, photography and writing were in pretty much the same boat from World War II through the decade after Vietnam.

Then, in the early 1980s, "word processing" began to be discussed, and various crude instruments came on the market. I could tell this was the future of my profession, and I found it hateful. I'd never been much for television, and this promised to be like watching myself writing on TV. Even the term "word processor" was repellent; it sounded like something you'd use to make verbal sausage. I committed myself to holding out.

One day in 1981 there came a knock on my door. I opened it to find a postman named Aaron Farr, who lived on Staten Island also and was, it turned out, something akin to my average reader (according to the demographics of some of the publications I was then writing for): a college-educated, serious amateur photographer, in his mid-30s. He'd recognized my name on the mail he was delivering, and decided he wanted to meet me, since he'd been reading me in *Camera 35* and elsewhere for years. A writer doesn't often get to meet his average reader, so I invited him in for coffee and we struck up a friendship.

Aaron was also seriously interested in computers. I don't know if he'd qualify as a hacker, but he was fooling around with a Texas Instruments model (nowadays a real dinosaur) and doing some elementary programming. He invited me over to his house one day and gave me a tutorial. It was my first direct encounter with word processing. I didn't exactly take to it, but it seemed – *intriguing*. In any case, I could no longer say I'd never tried it.

By mid-1987, editors were beginning to ask if I could make my texts available to them on floppy diskette or via modem. The inevitable moment had come. Through a strategy that's too bizarre to recount, I forced myself to address this new technology by ensuring that a large quantity of my work would be converted to text files on floppy diskettes for my own subsequent use, an act roughly equivalent to entering into an arranged marriage. I was

handed a dozen such diskettes – I'd literally never touched one before – by a woman who wished me good luck, and who neglected to inform me that she'd entered all the texts in an early Apple word-processing program already so outdated that copies of it had become scarcer than hen's teeth.

There ensued perhaps the most stressful period of my working life as a professional: three agonizing, extremely frustrating months in which every available minute of my time – often eight to twelve hours a day – was devoted to finding my way into this technology. I had to acquire a whole new vocabulary. There were system crashes. Sometimes an entire file would simply vanish into cyberspace (which, as I came to understand it, is the computer version of that parallel universe inhabited by all your missing socks). Occasionally, late at night in the computer lab at the university where I taught, I'd find myself weeping, or screaming, or pounding the desk in rage.

Then, quite suddenly, to my astonishment, I came out the other side, happily and confidently working away in WordPerfect, which continues to be my word processor of choice.[105] Somehow, I'd come to terms with the first radical transformation of my medium that had ever confronted me. Two months after that I had my first computer. Everything I've written since then (including everything you've read in these pages), even if it started out as a hand-written draft, has been put through the computer; I can hardly imagine working without it now, and cannot figure out why I waited so long to engage with it.

Mind you, I'm no computer maven, nor even a word-processing whiz. I haven't logged on to the Internet; the postman hasn't rung once yet insofar as E-mail is concerned.[106] As a working professional writer, I haven't once experimented with desktop publishing or mail-merge; I use my computer mainly as a fancy electric typewriter with built-in scissors and paste, Wite-out, and vast memory. I don't say this proudly; I know I'm ignoring some of what this technology could contribute to my productivity, and plan to attack this self-limitation soon.

At the same time, I'm more than willing to acknowledge that, even at this stage, I can't imagine getting along without the computer; it's changed my life as a working writer, and has even, in some ways that I sense but can't

The Digital Evolution

specify, changed my writing. And yes, I still consider myself a *writer*, and call what I produce *writing*, even though my former blank page has been replaced by a screen, and my prose has become plastic, malleable and provisional in a way it never was when, by hand or by typewriter, I used to imbed words physically in the fibers of paper.[107] (Am I obligated to give it some other name – "electronic wording," perhaps? Instead of telling people that I'm a professional writer, should I instead be saying something like "I'm in prose" or "I do words"?)

In any case, I can't really claim to have taste-tested the full range of the computer's potential improvement of my life. So when the beauteous and brilliant Brenda Laurel (who devised the home version of Pac-Man) announced to a packed house at the Eastman Theater in Rochester last July that "Computers are devices not just for computation but for representation – they allow us to re-present all kinds of things and issues to ourselves," I had to take that assertion on faith. Almost. But not entirely.

You see, back when I was in graduate school, circa 1965, I wrote a peculiar, pre-"cyberpunk" experimental fiction titled "postscript" that was intended as a cross between a lunatic's ravings and an account of a post-apocalyptic world. I meant it to be heard in the reader's mind as coming from a flat, affectless, virtually robotic voice; I used certain punctuation mannerisms to indicate this. But no one I ever showed it to heard it as I'd intended. By and by, I realized that it was a sound piece, meant for the ear and not the eye. But I couldn't figure out any way of getting it onto audiotape that wasn't unbearably laborious. So I shelved it as a failed experiment.

Then, a few years ago, a friend of mine in Cleveland, the photographer Masumi Hayashi, was describing to me some electronic imaging work she was doing on an Amiga system. In passing, she mentioned that the Amiga "Talker" program would allow the computer to recite an electronically encoded text, in a variety of voices: male, female, and "robotic." My ears perked up; I remembered my failed experiment. I dug out the text and had it scanned onto diskette, in ASCII. A few months later, I bought a cheap round-trip ticket to Cleveland, spent a weekend in Masumi's studio, and produced a computer-spoken version of my fiction, on audiotape. As soon as I heard the first few words come out of the computer's speaker, I knew that this was

the way the work was supposed to be experienced; this was what I'd heard in my own head when I was writing it twenty years before. It was a very young piece of writing, and far from perfect; but it had, at last, found its appropriate form.[108]

The simple fact is that, for any creative person who engages with it seriously, the computer makes feasible things that couldn't have been done before – either because they were impossible or because they were too labor-intensive to be worthwhile. Even a disgruntled creature of habit like myself, an old dog who's just crossed the half-century mark, can learn new tricks, can at least test this tool for its potential contribution to his or her working process. Some of my favorite older writers – Frank Herbert, best known for his consciousness-expanding *Dune* novels; the venerable Hugh Kenner, whose brilliant literary criticism I was reading in graduate school – have not only found value in this new tool as part of their own professional practice but have written at length about the significance of the computer as a new communications technology. I simply didn't feel I could afford to avoid the challenge they were embracing.

Changes in the tools, materials and processes of any medium are traumatic for some of its practitioners. The great British architectural photographer Frederick Evans stopped photographing when the commercial production of platinum paper was discontinued early in this century; he couldn't – or didn't care to – actualize his way of seeing in silver. The shift from manuscript to typescript, though rarely investigated or even discussed in terms of its impact on literature, was both a shocking and a shaping experience for several generations of writers a century ago; the transition from one-of-a-kind images to multiples, and from hand-drawn images to lens-derived ones, was equally transformative and has been much more widely analyzed. There's no question that the shift to word processors and electronic imaging systems will be such a watershed in our day, for writers and picture-makers alike.

Be there or be square, I say. Put your fear and loathing on hold; approach this set of options with an open mind. Take a look at the fascinating experiments that are being run by serious photographers like Pedro Meyer, Joan Fontcuberta and others (parallel investigations in creative writing are being

undertaken by such writers as William Gibson.) In particular, I'd advise you to reconsider, in the light of these new technologies, any photographic projects of your own that you've shelved as unfeasible; you may find, as I did, new options at your disposal. (For example, I'm convinced that there are extraordinary potentials here for new, inexpensive ways of structuring, encoding, transmitting and disseminating documentary and photojournalistic image-text works.)

There's no obligation to accept these new technologies into your own toolkit, and certainly one can and should adapt them to one's own process. (My father, who in his seventies resumed writing fiction and poetry full-time, still produces all of his first drafts by hand in an almost illegible scribble – which he then has transcribed and keyed in by a secretary, so he can make his revisions and corrections on a computer printout.) But it seems to me that those who reject this new way of working out of hand, untested, whether writers or picture-makers, are in the same league as the "moldy figs" of jazz criticism and performance in the 1940s, who refused to recognize the revolutionary importance of such innovators as Charlie Parker and Dizzy Gillespie, and insisted on listening to or playing nothing but Dixieland and swing. One can sympathize with their inability to shift paradigms while also realizing that, as a result, they ended up in the dustbin of history. Let's learn from their errors. The computer, in all its technical, conceptual and cultural complexity, seems to be here to stay. It's up to each of us to find out what we can make of it.

(August 1994)

"In the Nature of the Computer":
A. D. Coleman interviewed by Marc Silverman

... *Marc Silverman: We've now seen electronics making their way into photography over the past few years. Much of what I've seen is a slicker version of what's already been done. Do you think we are going to see a new type of work, or is this going to be similar to what the word processor did to writing? It made it faster and easier, but you don't see a whole new genre of writing coming out.*

A. D. Coleman: I'm not sure I agree with you in terms of the word processor. ... I may be over the cusp – in terms of age – as someone who's likely to make or be or find a major breakthrough stylistically as a result of the computer. But there are writers – "cyberpunk" writers like William Gibson, for example – who have done some very experimental pieces of writing based on the computer itself. Texts, for example, that come up on your computer screen and then disappear as you read them, never to be retrieved, at least not from that diskette – you get it once and that's all. I think that there are possibilities for writing built into the computer that are being explored and are being discovered, and I think there are possibilities for visual imagery built in there that are just beginning to be explored.

Marshall McLuhan was fond of saying that the first thing people do in a new medium is replicate the previous medium: radio replicated vaudeville, film replicated Broadway theater, and so forth and so on. In a certain sense, I as a writer am more or less just replicating, with certain fancier hardware, what I used to do with scissors and paste and Wite-out. I'm not really using this tool to its full advantage; and I think that's

true with a lot of electronic imaging. What people are doing is collage and montage without having to fuss around in the darkroom and use multiple enlargers and various kinds of masks on their prints. But I believe that, inevitably, out of all this hacking around and experimenting and reiterating the past, etcetera, some new and very medium-specific forms are going to emerge. I believe that eventually you're going to see some version of purism, some version of inquiry into what is it in the nature of the computer to do, in terms of electronic imaging, versus what is extraneous to electronic imaging. I think you'll see that emerge at some point. I think you'll see self-referential stuff emerge that will be very computer-specific. I just don't think we're seeing a lot of that yet. I think everyone is caught up in just mastering the technology and in staying abreast of the constant change in the technology – which is a big problem for an artist, because the ground is always shifting. . . .

So I think there are potentials within this technology that simply have not really been realized yet, certainly not fully. I don't think we even have yet a single body of work in electronic imagery that we would look at and say, "This is a definitive body of work, this is a standard, a marker, for decades to come people are going to refer to this." I think we *will*; I think it's just a matter of time. I may not like that stuff. I may not want to look at images on a screen. I may love the finely crafted silver print. But I have to look at this technology and say that this is going to be the direction for a lot of people, and certainly for information-based imagery, information-oriented imagery – photojournalism, etcetera. This is bound to be the direction it goes in.

Based on your earlier comments on the democracy of photography and the sheer number of photographers, do you think that we are going to see a have versus have-not problem, just simply because of the cost of the equipment to do computer imaging? This arose in your piece on Todd Walker and electronic imaging.[109] *At one point he says something like, "This is all a retired fellow on a fixed income can afford."*

The economic issue, I think, is only going to be a temporary issue. Todd is now working on a machine that is more powerful than the Univac computers that cost I don't know how much money – millions of dollars each,

whatever – that he photographed in the 1950s. I've been to Todd's studio; he's got a 486 – I've got a 386 – and he's got various peripherals, etcetera. So even this "retired guy on a fixed income" can afford a more powerful computer than the U.S. government could afford thirty-five years ago. Five years from now, assuming Todd lives and is in good health, which I don't see any reason to doubt, he's going to be able to afford something that's probably ten times as powerful, because that seems to be the rate of progression. So five years from now, if he can hang in there, he'll have that.[110]

Cost will be a problem for someone who doesn't have the time for some reason – because they're aging, or because what they are working on is too urgent to wait for the next development [to come down in price]. But the fact is that the stuff keeps getting better and faster and more powerful and cheaper. We have just seen it. I have a little laptop that basically is the second laptop that Tandy ever produced, the laptop I still work on; and it's a dinosaur compared to what I can now get: a laptop just as powerful as what I've now got on my desk for about the same amount of money, more or less, as what I paid for the Tandy five years ago.

No, I'm not worried about it from that end. I'm convinced that five years from now you're going to have a $25 home computer that's about as powerful as what I've got on my desk, that you will just plug in to a terminal wire through which your five hundred [cable TV] channels that you were just speaking about will feed also, and you will be able to hook into the Library of Congress. At least in this country you'll have that. You will go buy that computer at Computers 'R' Us or Toys 'R' Us or something like that for your kids, and *they'll* hook into the Library of Congress. I don't see costs as a major problem.

The most recent statistic I read said that in 1991 46 percent of U.S. schoolchildren were using computers at home or in school, kids between age three and seventeen. Okay, granted that the 54 percent that aren't are probably minority kids. But this stuff is going to open up; this stuff is going to get very, very cheap. There is not going to be a school without these computers within the next ten years. If these kids aren't getting them there, they're getting them at other places. I've been reading that

The Digital Evolution

Untitled, 1987 © Masumi Hayashi
Courtesy of the artist

crack dealers are using all kinds of sophisticated electronic equipment, including computers now, to log in sales – little pocket computers and laptops to log in sales, and for record-keeping. So this stuff goes everywhere in the culture; it's really pervasive. I just don't think that's going to be the issue.

I think the real issue is going to be that the computer has become the quintessential "black box." That is, people use them without understanding how they work. Teaching people genuine computer literacy isn't just showing them how to use a particular program that's so self-explanatory you don't have to understand how it works. I think the problem is going to be getting people to understand how computers are *programmed*. That's true with any technology: the problem is getting people to understand the cultural bias of the technology itself. That's going to be an educational challenge, and I don't see that challenge being met.

(January 1994)

Connoisseurship in the Digital Era

At the 1995 Whitney Biennial, amidst the usual array of trendy attitudes, one-liners, and disposable ephemera, I find myself stopped in my tracks by a work whose maker has never before had that effect on me: Richard Serra. The piece on view, made of his trademark rusted steel plate, is (as I recall) uncharacteristically diminutive, about chin height. I can best describe it as two square, hollow L-shaped metal columns standing upside down, braced on each other to form an arch or inverted U.

My senses inform me immediately that, comparatively small (for Serra) as these two objects are, the weight of either could crush me, and it would take superhuman strength to keep either one standing. Inspecting the plane on which their two shorter sides touch reveals slight gaps, confirming that they are not joined there but merely propped against each other. Their proportions make it clear that to upset the delicate balance by moving either would topple both. Which is why, when I read the work's title and date – "For Primo Levi," 1992 – I am stunned and devastated by the resonances those three words and one number (and this sculpture's power depends much on them) set off: this stark metaphor evokes the awkward, unbearable weight of Holocaust survival; the painstaking shoring up of a riven, traumatized self; the constant, inevitable risk of disruption and fatal imbalance; the immanence of a devastating crash.

But these words of mine, through (I hope) no fault of their own, cannot convey the experience of standing within touching distance of this simple, eloquent, passionate work – its patina of never-sleeping rust, its solidity and bulk, its physical embodiment of the simultaneously ponderous and pre-

carious. Nor could a photograph, or a film or video – or even a hologram – transmit its sensory impact and the intellectual/emotional consequences thereof. You have to plant yourself in its presence to know what it's about.

If it sounds as if I'm taking the unfashionable stance of advocating something suspiciously like connoisseurship, that's because I think we need to recall and recover the term's original meaning and its significance – especially now, at the dawn of the digital evolution. Connoisseurship has gotten a bad rap in recent years, due to its ostensible dependence on wealth and privilege; but, originally, it simply distinguished between those who had actually laid eyes on particular works of art, thereby truly "becoming acquainted with" them (the original definition of the term's Latinate root, *cognoscere*) and those who knew them only second-hand, through written descriptions or etched and engraved renditions thereof.

With the invention of what the late theorist and Metropolitan Museum of Art curator William M. Ivins called "the exactly repeatable pictorial statement"[111] – images printed in multiples, first via woodblock and then in the additional forms of etchings, engravings, and lithographs – pictures of all kinds began to reach audiences previously undreamed of by any artist. Photography (especially after the invention of the half-tone process and off-set lithography) disseminated them even further. Among the types of images broadcast in these ways were representations of works of art in other media – pictures of, or based on, paintings and sculptures, for example. People who could never get to Athens, or Rome, or Cairo, were thus enabled to contemplate detailed visual descriptions of the artworks located there.

In the same fashion, the new pixellated media will enlarge the reach of imagery as never before. As one predictable consequence of digital technology, electronic reproductions – that is, digitally imaged versions – of an ever-increasing volume of works of art from around the world will circulate to an ever-widening global audience. More and more people, consequently, will be in a position to acquaint themselves with certain aspects of those artworks. That's a good thing, in my opinion. But among the foreseeable problems that will result is this: many of those people will believe that, since they've encountered a digital translation of the work, they've somehow experienced the thing itself, when they haven't.

Like most people who teach and lecture on art, I do a fair amount of what one colleague calls "art in the dark," employing slides to introduce students and public-lecture attendees to a wide variety of work. The projected slide inarguably functions as a cheap, portable, versatile, replaceable, eminently convenient means for representing artworks. It also has severe limitations as a gateway to knowledge about works of visual art. Slides homogenize everything: all works become the same size on the screen, reduced to two-dimensionality, with their distinctive hues and tonalities filtered through the color palette of the particular film used, and anything notable about their surface qualities muted if not eliminated entirely. They're reports about the work, but not the work itself. I feel always obligated to caution my classes and audiences, repeatedly, that at the end of any of these sessions they haven't actually seen any of the works I've illustrated in this fashion, and that if they wish to discuss them with any authority they're obligated to seek out the originals and spend time with them "in the flesh," so to speak.

I don't say this because I'm inclined toward precious-object fetishism, or am drawn nostalgically to what Walter Benjamin called the *aura* of handmade works of art. I'd use the same ground rules in considering inexpensive, mechanically reproduced images or objects – a Weegee *Daily News* front-page crime photo, a '50s formica dinette set. Rather, I insist on it because, like a good detective in the Sherlock Holmes/Sgt. Joe Friday mold, I'm intent on taking into account all the available facts about any work before I begin to interpret or evaluate it. And there's much for us to learn from the physical-object aspect of any work of art. "No ideas but in things," as William Carlos Williams wrote.

The tools, materials and processes employed in its production shape any work in many ways. And the choice of those methods tell us something about the artist as well as about the work; they not only reveal the labor involved but give us decision made visible, creativity made tangible. Think, for example, of the differences among the photographic prints of Edward Weston, Weegee and Joel-Peter Witkin, and the ways in which encountering their works "in the flesh" informs us about their relationship to the medium. A form made of wood or marble conveys different information than the same

form rendered in (as in the case of Joseph Beuys, for example) felt and animal fat. Even painted a similar rusty red, the Serra piece described above, if made from blocks of styrofoam, would have a vastly different feel to it, would in fact be a different work altogether.

With the exception of films, videotapes, slide projections, certain kinds of conceptual-art activity and, now, digital imagery, almost all works of visual art exist not only as images but also as objects; they come to us in some tangible, physical form. Even if randomly made (using some aleatory or chance process, *à la* John Cage), the materials and methods employed in generating a work become integral to the work upon its completion, and affect our responses to it. So a part of the task of our critical engagement with works of art, as members of an active audience, is careful attention to and scrutiny of the physical nature of these objects. What we're looking for are what I call the *strategies of facture* that underlie the work's construction: the determining aspects of the technology used, plus the decisions, conscious or not, of the artist, the cumulative consequences of which make the image/object look the way it does and persuade us to pay attention to it in comparatively specific ways.

Don't mistake this concern for a reverence for the touch of the artist's hand. Even sending something out to be produced by others through mechanical means, or farming out production to hired artisans – as Andy Warhol, Mark Kostabi, Robert Longo and others have done in our time, and as others before them had done for centuries – does not eliminate these questions of choice of materials and production method from our consideration; they merely propose alternatives to what were once standard approaches. Without knowing how a thing was made, we are forced to deal with it as a prototypical "black box" – a mysterious, closed system. Awareness of those decisions – to the extent that they're left visible in the work – does not undermine the power of substantial art; instead, it lets us in on the very process of creative communication.

So digital technology will likely prove itself a two-edged sword in our relation to non-digital works of art. On the one hand, it can make instantly accessible to us an unprecedented range of contextualizing information about any given work of art. The kinds of interactive CD-ROMs we're beginning

to see on art-related subjects provide a wealth of informative data: critical commentaries, biographical information, the artist's own comments (sometimes in the artist's own voice!),[112] film or video clips of the artist at work in his or her studio, images of the work from various vantage points, close-up details, pictures of dozens/hundreds/thousands of related works by the same artist or others – all available either by slipping a CD-ROM into one's computer or accessing it online and clicking a mouse. Going beyond that, within the next year or so I predict we'll begin to see real-time online Internet chats – both audio and video – with artists in various media while actually in the process of production: electronic studio visits and cyberspace encounters with works-in-progress. By the time you read this, such may already have started.

These innovations, extant and imminent, are a teacher's dream. And a student's. And a scholar's. And a connoisseur's – in fact, a wish come true for anyone who not only enjoys looking at art but goes a step further by seeking to learn more about it. But what they will not, cannot do is put you, literally and metaphorically, directly in touch with the art. Translated into pixels, restricted in size to the screen dimensions of whatever computer monitor they're viewed on, works of art necessarily change. Some will look better this way, some worse; but all will look *different*. No matter how persuasive the digital representation may feel, it cannot replace laying eyes on the actual object, the first-hand encounter with the thing itself: its scale in relation to your own body, its surface texture, its smell, its complex physicality.

I'm reminded of René Magritte's famous painting of a pipe, underneath which he wrote, "*Ceçi n'est pas un pipe*" – this is not a pipe. By the same token, the digital replications of artworks you'll be seeing more and more of from now on – including those on this very CD-ROM – could each bear the cautionary caption, "This is not a work of art." If I had my way, I would have that message displayed beneath every digital representation of a work of art. And I would engrave it in the consciousness of everyone – including you who are reading this now – who uses this complex new technology as a tool for inquiry into art.

(Spring 1996)

The Digital Evolution

What Hath Bill Gates Wrought?
The Future of Image Archives

Reporters have called repeatedly to solicit my opinion on Bill Gates's very own "October surprise" – Corbis Corporation's fall 1995 acquisition of the sixteen-million-image Bettmann Archive – and don't seem to understand my response: You're not seeing the forest for the tree.

There are an incalculable number of extensive image archives in the world: public and private, corporate and individual. Discriminately or haphazardly, suddenly or over centuries, countless libraries, museums, schools, corporations, government agencies, private citizens and other repositories have generated, found, stolen, purchased, traded for, salvaged, inherited and otherwise come to possess mountains of imagery. Taken cumulatively, they constitute a bucket in which the Bettmann collection is a mere drop.

Some of these – like Bettmann, the Library of Congress, and Time/Life – have made their holdings accessible for years in one way or another; others have never yet considered doing so. But the nascent electronic culture demonstrates an insatiable appetite for imagery, so everyone who owns or controls such an archive, no matter how obscure, specialized or geographically isolated, has begun to rethink their collection's premises and potentials.

Let's call the management of such collections *image librarianship*. The problems faced in that field break down as follows: preservation, storage, retrieval, dissemination. Until the advent of digital imaging, images had physical form, mostly as fragile works on paper; exposing them to researchers, or the general public, inevitably deteriorated them. So they needed protection. As objects, they occupy space; storing them in protective ways while keeping them accessible to potential users has proven difficult at best. Creating filing

Computer Revelation, 10/22/74 © 1981 Barbara Crane
Courtesy of the artist

systems that enable those users to identify and locate the specific images they need, without subjecting the images to constant wear and tear, is far from easy; even trained picture researchers often don't know what they want until they see it. Finally, getting usable copies of selected images into the hands of users rapidly and at minimal cost is an ongoing logistical challenge.

CD-ROM (or whatever variants thereof evolve) solves virtually all those problems in one fell swoop. For a minimal cost (the last quote I read was 37 cents per image, and falling), images in quantity can be copied onto CD-ROM. Since few researchers, even specialists, need physical access to the large majority of the actual original objects themselves, these can then be put into the deep-freeze semi-permanently. The same technology that makes the encoding of these images possible permits the simultaneous organization of such material in numerous ways: once annotated, imagery can be retrieved in-

The Digital Evolution

stantly by subject, by region, by chronology, and so on. It can be left as raw data or contextualized in complex, interactive ways. Lastly, once the imagery's encoded and organized digitally, distribution can be achieved inexpensively and rapidly by putting it online and/or purveying it in CD-ROM form.

A few predictions. The Microsoft/Bettmann deal already has everyone with half a brain in charge of a sizeable and/or significant image archive asking themselves, "What could we do with this to make money?" (The truly savvy have already been working on that problem – and finding solutions to it – for several years now.) By the same token, the entrepreneurial purchase and/or optioning of rights to image archives has just become big-league tulip fever. The next quarter-century will see an unprecedented increase in the traffic in images, as thousands upon thousands of archives disgorge their holdings in some electronically accessible form. This will prove both a nightmare and a dream come true for serious researchers, since they – like the rest of us – will find the sheer volume of available material overwhelming, but will have the nigh-impossible task of coping with it.

The profession of image librarianship, heretofore a minor offshoot of print librarianship, will be radically redefined and foregrounded, as will picture researching; anyone with those skills, and especially those with a background in photography, will be able to write their own ticket for the next several decades. New businesses, indeed whole new industries – image-archive digitizing, image-archive design and consultancy, image search-and-retrieval software development, image-archive marketing – will emerge. International protocols, standards and legislation will require lengthy consideration, endless wrangling and continual redrafting at global conferences. Copyright-related litigation over archived-image usage will provide employment for generations of lawyers to come.

And that's just for starters. There's the trickle-down effect to consider: Eventually, your Aunt Sally – the enterprising one who sold Tupperware and Avon and all that stuff, the one who has every picture ever made of anyone remotely related to your family – will get wise to this and open her own home page on the 'Net, licensing rights to those cute pictures of you fleeing an angry goose with your diapers falling down...

(March/April 1996)

What Hath Bill Gates Wrought?

Fear of Surfing in the Art World

As the proprietor and director of a multi-disciplinary Website, The B.Y.O. Café [now The Nearby Café], I often find myself in the unanticipated position of offering Internet tutorials to people – some of them from other walks of life, but the majority of them from what we might broadly call "the art world." Frequently, these introductions to the 'Net, and the World Wide Web, happen spontaneously in a one-on-one context: someone at an opening asks what I'm up to, I tell them, and we're off. Recently, however, my project associate Nina Sederholm and I had occasion to walk roughly a hundred interested parties (attendees at the biennial Houston FotoFest this March) through the making of our site, in a series of presentations.[113]

Several patterns have begun to emerge from these varied experiences. For example, I can report that the two questions most frequently asked by my colleagues do not concern themselves with philosophical, social or aesthetic issues. Those questions, in order: "What about copyright?" and "How do you make money with this?"

There are many answers to both questions, of course. My responses (short versions): to the first, you do not surrender or void your copyright on anything by presenting it in cyberspace; to the second, any way you can – and such ways are identifiable – if that's your main concern.

Though hardly irrelevant, such questions seem marginal as opening inquiries in anyone's relationship to a new medium of mass communication. They suggest a short-sightedness, if not an actual blindness, in regard to the potential of a radically innovative technology. And I'd trace this failure of vision to the remarkable fact that, although they certainly fit the demographic

The Digital Evolution

profile of Internet users, few of the art-world folks I speak with have ever explored the Internet, victims of a condition I've come to call (with apologies to Erica Jong) "fear of surfing."

This attitude has no parallel in my experience. When commercial television was introduced to this culture, in my childhood, many on the left and in intellectual circles – including my parents' bohemian/socialist/artsy crowd – disdained and suspected it. If they hadn't read Adorno's critique, they'd certainly found Dwight MacDonald's. But that didn't stop them from turning "the boob tube" on to watch the Army-McCarthy hearings, or "Requiem for a Heavyweight," or the ballgame. Within two to three years of the mass-marketing of television sets, everyone I and my parents knew had watched something or other on a television set – at a friend's house or in a bar, if not in their own homes.

The comparison, though not exact, isn't odious. Exploring the Internet doesn't involve anything more than using a computer mouse to point and click, a procedure far less complicated than running the remote control for your stereo. Even if, like myself, they're technophrenic, most of those who've avoided the 'Net have long since learned to work on a computer and to use such programs as WordPerfect, Photoshop, PageMaker and various data-base/spreadsheet applications – all of them requiring mastery of more complex skills than surfing. Indeed, constructing and posting an elementary home page is simpler than learning to use any word-processing program.

Just about everybody in the urban environment in this country knows somebody who's spending time out on the 'Net – family member, friend, co-worker. Many if not most art-world types labor in workplaces that are – or will shortly become, of necessity – connected to the 'Net. Yet (forgive me if you're an exception) odds are that you who are reading this have not spent even an hour investigating this transformative technology. And, with so-called "cyber-cafés" – not virtual Websites like ours, but actual places where you can buy a *mocha latté*, rent an hour on the 'Net, and surf away to your heart's content – springing up everywhere, the only remaining excuse for total Internet abstinence is neurotic anxiety.

As one who felt the same way no too long ago, I empathize. I steered clear of computers till 1987, when editors started asking for texts on floppy disks;

and I'd never logged in to a discussion group – didn't even have an E-mail address – until the spring of '95. Now, to my considerable surprise, I'm the organizer of a large-scale, content-heavy cyberspace environment. Nonetheless, I remain skeptical about the ultimate impact of this technology on our culture, and on creative activity in all media, and certainly hope to maintain my critical distance from it (while also developing a critical position grounded in hands-on experience with it from the production end).

In part, my engagement with the 'Net resulted from receiving an increasing stream of press releases concerning artists, photographers, critical journals, institutions and other sources announcing their presence on the 'Net (and, usually, on the Web, which permits the dissemination of images as well as text). Many of the announced projects were Internet-specific. As a working critic and journalist, I simply couldn't afford to remain ignorant of this development. Additionally, it's becoming clear that this communication system may well become the locus of our ongoing debate over freedom of speech, an issue with which I'm greatly concerned. I could hardly speak convincingly to that issue without a knowledgeable relation to the underlying technology.

I am not urging you to create your own Website. I am urging you – as a member of the art world, and as an engaged citizen – to acquaint yourself with the Web, and the 'Net. Just as odds are (though they're changing rapidly) that you haven't spent any time on the Internet, I'd wager that neither have many of those most vociferously opinionating in public about the Internet, including the nitwits in Congress and the Senate who recently passed nonsensical, unenforceable, unconstitutional laws in a desperate attempt to control what they've never experienced and don't comprehend.[114] All of which makes the clamorous discourse on the subject resemble the attempts to debate productively with people who never attended a screening of *The Last Temptation of Christ* or saw a photograph by Andres Serrano.

One expects such terrified, knee-jerk reaction from the small-minded and uneducated, but not from the presumably educated and sophisticated, especially those who pride themselves on maintaining some proximity to the cutting edge of culture. Set aside your fear of surfing and at least test these waters; after all, they're lapping at your front door.

(June 1996)

Tending the Fire, Making Stone Soup:
Community in Cyberspace

To the question posed as the premise for this dialogue – "What is virtual community and what's at stake in its many contradictory formulations?"[115] – I have to reply, simply, that I don't know. Perhaps that's because I'm no longer sure I could answer that query in regard to real community. Yet I've become involved in a project whose motive could probably be described as "community-minded," and whose ambition is to further something that might at least resemble what we imagine (or remember) community to look and feel like.

Simply put, that venture is essentially a multi-subject, content-heavy electronic magazine of which I'm the editor. It offers an international mix of material – images and texts – about art, photography, music and other subjects, provided by a consortium of people and organizations active in those fields. Formerly called The B.Y.O. Café, it will shortly re-emerge under a new rubric, The Nearby Café.

In her recent book, *Approaching Eye Level*, Vivian Gornick writes, "I have endured the loss of three salvation romances – the idea of love, the idea of community, the idea of work."[116] I would not go so far as to say that I've entirely "lost" any of those ideas, but I do agree that they are romances; and, in a sense, I've consciously opted to behave as a romantic. One can go about one's life blindly, as what we call an "incurable" or "hopeless" romantic; or one can choose, quixotically, to live as a romantic, knowing full well that the windmills are nothing more than windmills yet tilting at them nonetheless, in the belief that symbolic action and extravagance of gesture have value, if only to oneself.

I cannot say, at this juncture in my life, that I feel myself truly part of any community, either in my personal or my public life. Yet, paradoxically (or, at least, seemingly so), my work as a writer and teacher assumes various commonalities among constituencies: shared language, shared symbol systems, shared interests, shared (or negotiable) values. Asked awhile back to define the public function of criticism, I heard myself explain, "It's the activity of responsible citizenship within a given community."[117] If I did not think that my professional activities mattered to others – to specific living others, to some generalized Other in my own time, to those who may come after us and find some value to the existence of an historical record of our time – I'd do something else entirely.

But affecting others, even positively, does not of course necessarily define or produce community. Nor does wishing for community, or acting as if it existed and one were a member of it, necessarily actualize that "salvation romance" and make it real. The various microcosms in which I function professionally – the art/photo/publishing/higher-education environments – seem more like sprawling dysfunctional families than communities to me. Authentic community emerges and develops organically; it may very well depend on co-existence in a particular physical place, and is unquestionably enhanced by such proximity. Certainly it's not something you can create overnight, simply by throwing a bunch of people together either in one geographic location or out there in cyberspace, or else by bringing together temporarily those who have one or another area of common interest.

Our capacity for community in this culture has been under serious, concerted attack from many sources – real-estate developers who physically uproot and disperse us, Mad Ave. hucksters who fragment us into target markets, mass-media entrepreneurs who commercialize and thus trivialize the very imagery of community, so many more – for a long time. The blame does not automatically fall to technology – the telephone (especially the party line) enhanced community life in many ways; but human beings, and not their tools, generate community. Or fail to. It takes long-term commitment to a specific cluster of others to make a village.

I haven't felt myself part of a functioning community – in either my private or my professional life – since sometime back in the early 1970s. And

I seem to encounter less and less genuine communitarian energy in my travels than I used to. Yet I refuse to succumb to the tempting assumption that this has vanished for good, at least for others in my own day and in the future, though I no longer expect to regain that sense of belonging for myself in this lifetime. Which is perhaps a way of saying that while I'm not sure that "community" now exists in our culture here in the U.S., if it ever did, I believe that maintaining the idea of community, and trying to exemplify some of its possibilities, remains a useful project. So I choose to act as if I were a responsible member of a community I could identify and describe, though I have not a single shred of evidence that, if my house burned down, anyone in, say, the art/photo world would send me a can of peas, much less join in a barn-raising party.

The Internet project of which I'm the organizer and (still) primary sponsor began as a simple act of self-publishing. In mid-1995, finding my writing opportunities diminishing due to the protracted economic recession, I decided to establish at long last one dependable outlet for my work that was entirely under my control. The then-recent emergence of the World Wide Web as a technology and communications system allowed me to begin producing what I thought of as a newsletter – "C: The Speed of Light" – in the form of a personal home page, at a cost so low (under $500 per year, aside from a modest initial investment in equipment) that it proved irresistible. This went online in mid-1995, and was an enormously self-empowering step to take.

Soon after, enough other individuals and organizations with whom I was in contact had become interested in this new medium that I decided to enlarge the site considerably, adding approximately a dozen more content providers whose material would be organized and made Web-viable by myself and several part-time assistants. I thought a certain synergy might result that would benefit all of us, by attracting a wider mix of visitors. Dubbed "The B.Y.O. Café" (for "bring your own"), that project went online in October of 1995. (A year later, it's temporarily offline, in the shop for retooling; by December 1, we will go back online at a new ISP, with a new URL and a new name: The Nearby Café. The "we" to which I refer includes our current site designer, Ralph Mastrangelo, and our assistant manager, Nina Sederholm.)

The ultimate aim, on my part, is to create a cyberplace that has the ambiance of the classic international café with an Internet spin, a venue in which those who (like myself) think of themselves as citizens of the world can feel comfortable, meet kindred spirits, and engage in provocative dialogue. Others seem to share my vision. We get lots of E-mail from folks who tell us they've spent hours browsing through our site. It comes from people and places around the world that none of us – neither we who run the site nor our various content providers – have previously reached with our activities.

Does this constitute the creation of community? I'm not sure it does, but that doesn't impeach it or render it meaningless. The image that comes to mind for me is that of the "pen pal." I remember, from back in grade school, how we were offered the chance to correspond with someone from another country – someone we'd probably never meet, from a different culture, who we'd know only from what could be transmitted through the postal system. That didn't breed community, but it engendered an increased openness to the reality of cultural difference and the experience of communication across national borders. If that proved to be all the Internet achieved, I'd still consider it a major force for good.

Separately and collectively, we at the Café haven't yet figured out how to make this venture economically self-sufficient, but it's getting there. I sell copies of my books through my newsletter at the site, and have been commissioned to give one lecture (at Cybeteria, Prague's first cyber-café) and write three essays (for payment) based on the know-how I've developed as a site director; Prague House of Photography drew 35 percent of its student body for its 1996 summer workshop from those who discovered its existence through this site. And so on. Thus, at least for now, it may be more realistic to think of such ventures less as for-profit ventures than as a kind of loss-leader or – perhaps – a give-back to one's community, something akin to the religious practice of tithing.

I have always tithed to my constituencies, in various ways: visiting colleagues' classes and even giving public lectures in return for travel expenses, offering essays to "little" journals that pay a pittance if anything, providing free consultancy services and serving on the boards of non-profit ventures. Tithing – which, broadly construed, represents the return of a portion of one's

income to the common pot, a version of the Kwakiutl custom of *potlatch* – strikes me as one of the fundamental acts underpinning the idea of community.[119] At present, this Website is my primary form of tithe.

Yet if something we'd agree to call community results from my activities in general, or from this Café, or from the Internet and the Web and their evolution, I don't expect it to be a tribal form of community – people bonded for life, living side by side, intimately involved, standing back to back permanently against their enemies. I predict it'll be more like the looser connectedness that the *agora* encourages, a varied mix of people coming from all over, a context for the barter and exchange of goods, ideas, skills, energies. And, somewhere in the middle of that marketplace, a few spots with a kettle kept boiling for the making and sharing of stone soup. For the foreseeable future, you'll find me tending one of those fires, at The Nearby Café.

(December 1996)

Define/Defy the Frame © 1990 Esther Parada
Courtesy of the artist

The Digital Evolution

Toggling the Mind: Toward a Digital Pedagogy for the Transitional Generations

Born in 1943, I represent a transitional generation in the cultural history of the computer. By the time I left graduate school in 1967, the advent of the "personal computer" was still more than a decade away; it didn't enter my own life until I'd reached the age of 44. I consider myself, therefore, effectively Jurassic in my relation to this technology: a person primarily shaped by a pre-computer environment who now lives in a pervasively and increasingly computerized world.

Those of my generation in the "first world" have effectively served as guinea pigs for the extraordinary social experiment that the computerization of culture represents. Yet I know of nothing addressing the adaptation of mature adults to this phenomenon. Now and henceforth, for those not born into poverty, the computer will function as a birthright (even if a problematic one). But the computerizing of the world, though relentless, is presently and will remain gradual for decades at least. That situation will, for many years to come, require vast numbers of people to commence grappling with the computer not during the flexible, conceptually open phases of childhood but at much later stages of their lives. So I thought that I would conclude this book by considering those issues of transition.

Toward that end, I spoke at some length with two very different visual artists, Joyce Neimanas and Esther Parada, who have moved from analog photography to digital ways of working and who are approximately my age, so we share numerous reference points in photography, in art, and in broader cultural experience. This essay, thus, is informed by my sense of their experience, as well as my own.[120]

Confronted with these new digital technologies, the mind – at least the mind of one not raised with them and taking them for granted – often freezes, crashes, boggles. Why, then, to use a term common in software design, does it sometimes toggle, turning on rather than off?

Few of the people I know in my own cohort came to the computer early on, or out of an active interest in the tool itself as a novel and potent artifact. When first introduced into the life of anyone over the age of thirty, the computer appears to epitomize a psychological boundary between the understood and the unknown, evoking a deep-seated mechanophobia. I have no theory to explain this, just the raw data, my observation of this force operative in myself and others.

Which brings me to my conversations with Neimanas and Parada. My interest in speaking with them on this subject started with my respect for their work as visual artists. Though their art is dissimilar on many levels, both of them work in ways that merge autobiographical inquiry with cultural analysis, creating visually rich, intellectually provocative palimpsests that reveal their complexities most readily to those willing to take the time to subject them to careful, patient readings and rereadings.

How did their involvement with the computer come about, and what did the computer contribute to the evolution of their work?

Parada engaged with the computer well before many, starting back in 1986, exhibiting her first computer-generated work[121] a year later. Though she'd had a traditional education in analog photography, by the mid-'80s she'd also experimented with Kodalith transparencies, copy art, posterization, and offset printing; hence altering the black & white image and finding new forms of image display and distribution were anything but alien to her. A former Peace Corps volunteer engaged in various approaches to political discourse and community activism, she also was accustomed to considering her work and her methodology in relation to the cultural impact of media vis-à-vis her choice of audience(s).

As she puts it, she'd long been involved with "strategies of fragmenting the image and layering information"; and, as she once wrote, "these strate-

The Digital Evolution

gies transcend, although they may also be facilitated by, particular technologies."[122] She'd already begun to move toward installation-based pieces in which images and texts (some her own, others excavated during research) interwove; the possibility of rescaling and/or redesigning such pieces for a given venue opened up with the computer. Yet, contrary to received opinion, Parada discovered that using the computer intensified her relationship to craft by allowing her a range of choices that she hadn't previously enjoyed; she fine-tunes her work much more carefully now than ever before.[123]

Parada credits "the enormous technical and psychological support over the years of my friend and computer guru Robert Check" as a major factor in her development. Check urged her to explore new hardware and software regularly, even though, as Parada says, "I'm not technically or mechanically inclined – I've never been particularly interested in equipment." Parada recognizes this technology's dangerous seductiveness. "Sometimes people get involved [with computers] and lose their vision as artists," she acknowledges. Yet the converse of that effect, she points out from experience, is that the tool and the new media predicated on it push their user into unexpected new areas and insights. Working on her World Wide Web and CD-ROM projects,[124] for instance, initially left her "feeling unmoored" by making her conscious of "a certain methodical way of laying out a page and organizing information" toward which she tends but that she'd never been forced to question – a challenge that provoked her into rethinking some fundamental assumptions.

Finding the term "political artist" too constricting, especially in the minds of audiences, Parada identifies herself as a "cultural worker";[125] her projects take an analytical (and self-analytical) direction, regularly addressing issues of imperialism – military, economic, and cultural. Digital technology, she's discovered, encourages an open-ended, provisional, work-in-progress mentality that she finds harmonious with her own anti-authoritarian principles.[126] As she put it wryly, concerning "Transplant: A Tale of Three Continents," her World Wide Web project, "the neat thing (harrowing thing?) about websites [is] the possibility of continuous revision and updating . . . "[127]

By contrast, Joyce Neimanas comes out of a background in painting and drawing, and positions herself as a neo-Dadaist, extending the tradi-

Total Chaos © 1995 Joyce Neimanas
Published by the University of Iowa Center for the Book, 1995

tions of photocollage and photomontage. Her current work combines family-album material from her own personal history, snapshots and other kinds of found or vernacular photographs, and pop-culture iconography taken from postcards, comic books, instruction manuals and other sources. These she selects from and scans in, one at a time, assembling the results into satiric, explosive, sometimes cryptic, self-contained mini-dramas – intricate composite images that take permanent physical form.

The Digital Evolution

Neimanas had a computer and peripherals given to her by Macintosh in 1992, as part of a program to involve recognized artists and photographers with the technology. Intimidated by it initially, she let it sit untouched for six months, until a hands-on workshop sponsored by Macintosh demystified it somewhat. Then a month of study with Los Angeles teacher Jonathan Reff gave her the confidence to begin: "He knew that I wanted to know just enough about the computer to be able to make some art," she recalls.[128]

In conversation, Neimanas asks, "You know what I like about the computer? I can work on more than one thing at the same time, without having to complete any of them. Also, oftentimes the way I work is to start arbitrarily with something interesting, something I may want to include; but it may not end up in the final piece. That reminds me of when I was a painter, being able to say, 'I want to take that out.'"

However, though it results in occasional duplication of her efforts, she maintains no image bank; not only does she not scan anything that's not being considered for a specific piece, but she discards all scanned elements – even the unused and rejected ones – after a piece is completed.[129] "I try to make every picture different from any other picture I've made before," she explains. "I need to be spontaneous about the way that things enter a piece. That's very much about being a photographer. I really like that aspect of it, and don't want to lose it. If I had to define the benefit of working this way, it's that I don't feel I ever put these images together simply because I had them. . . . I need to see it as a new experience. I want to make something new that I haven't thought about before."

This work has taken final form as an offset-printed artist's book[130] and, for exhibition, Iris ink-jet prints made for her by Nash Editions.[131] This represents the first time in her practice that she's been distanced from the actual printmaking process, but she has adapted to this method. "When I first started out I couldn't imagine them, couldn't visualize what they were going to look like. Now I can," she states.

Like many with whom I've talked, Neimanas has worked out an idiosyncratic set of procedures. "I know the things that I have to do by hand, and I know the things the computer can do. Sometimes the scanner will just take over. I like that – because I don't have any control over it, I don't know

what's going to happen. And I'm not interested in the technical aspects of it. So I figure out other ways to do it, to get around things."

And what was the hardest part of the transition for her? "How to keep it loose and let things come into the work."

<p style="text-align:center">*</p>

As is true of most of the people I know who work with computers, Parada and Neimanas did not first acquire a range of digital skills and then look for ways to apply them; instead, they conceptualized projects and found ways of actualizing them through the computer, learning only what they needed to know towards those ends.

Which leads me to the conclusion that, at least until the day that a computer can understand voice commands, interpret correctly any spoken instruction, and explain its own actions comprehensibly, what will induce adults to engage with this technology for the first time will probably include one or more of the following factors:

 * the involvement will have a mandatory professional or occupational component (*i.e.*, as a job requirement on some level);

 * its use will solve identifiable problems in their working lives that had proven intractable, or eliminate tasks that had turned onerous, or propose enticing new options that were previously unthinkable;

 * there will be demonstrable, immediate benefits to using it, substantial enough that those gains will outweigh the unpleasantness of the sometimes steep learning curve associated with acquiring them;

 * and the introduction to the tool will occur in an unembarrassing, user-friendly way – preferably under the guidance and encouragement of someone the novice knows and trusts, who can analyze the individual's needs and show him or her how to apply this tool to filling them efficiently.

In short, the motivation will be utilitarian and task-oriented, not hypothetical; people will not learn to use computers because they feel they should know something in the abstract about this force that's reshaping our culture or, on principle, should acquire the ability to operate one in case they ever

The Digital Evolution

have to do so, but instead because they have something specific and urgent that they want or need to do with it.

This is, perhaps, nothing more than stating the obvious; yet the obvious often doesn't make itself available for critical analysis until it's stated. I'm far from comfortable with those conclusions, because I'm wary of what Lewis Mumford long ago dubbed "techno-bribery" (the enticements and immediate rewards a technology offers that blind us to its other consequences) and less than enthusiastic about prioritizing those benefits at the outset. Furthermore, I believe in establishing a critical relationship to tools early on.

However, just as there is only so much that driver education can achieve before putting the learner behind the wheel, there's only so much that theory-oriented or technoskeptical computer education can accomplish before the prospective user sits down in front of the keyboard and monitor. I am not – at least not yet – a believer in the existence of what's called "artificial intelligence." I don't think that these machines think. I believe, therefore, that we need to think for them, as well as about them. But I also believe that thought process must be informed by hands-on experience, because, in the healthiest dynamic, theory informs praxis while praxis tests theory.

For older users, I believe, empowerment in relation to the computer – as both a presence in everyday life and the "defining technology" of a stage of cultural evolution – will necessitate the dissipation of a deep anxiety over computer use that the young do not seem to experience. That acclimatization, which I hope will be anything but uncritical, will prove a fundamental teaching strategy for the foreseeable future – because, in combination with the profound complexity of the tool, that anxiety can be effectively paralytic, freezing not only the ability to acquire computer-related skills but also the ability to think lucidly about this technology's extraordinary social and political significance.

So yes, confronting the computer and its implications, facing a binary logic that the mature psyche may well find incompatible with the nuanced sense of inconclusive options that life experience breeds, the mind often boggles.

Then again, given the right conditions, sometimes it toggles.

(August 1998)

Notes

Specific bibliographic information about the original publication of these essays appears in the Publication Credits section. In some instances I've placed brief parenthetical comments about the production of these essays before their endnotes. – A. D. C.

Acknowledgments

1. In the interim, I've started to write a regular column on matters digital and electronic, first for *PhotoWork*, a new monthly magazine that died aborning, and then for *Photo Metro*; that column derives its rubric from this book's title. I've also organized a substantial multi-subject site on the World Wide Web, The Nearby Café (http://www.nearbycafe.com); initiated a bi-monthly newsletter of my own therein, *C: The Speed of Light*; and given Internet tutorials in Houston, New York City, and Prague. For a brief account of those experiences, and some reflections thereon, see "Fear of Surfing in the Art World" and "Tending the Fire, Making Stone Soup," elsewhere in this volume.

2. Peter designed the first several versions of the site (formerly called The B.Y.O. Café), before going on to greater glory as the designer of sites for *People* and *Paper* magazines, the 1996 Superbowl, and other major Web projects.

3. For more on this encounter, see "An Arranged Marriage," elsewhere in this volume.

4. Kenner, Hugh, *The Counterfeiters: An Historical Comedy* (Bloomington: Indiana University Press, 1968).

5. See, for example, his essay on the cultural implications of the CD-ROM, "Learning Not to Forget," in *The World & I*, Vol. 7, no. 10 (October 1992), pp. 256-63.

Author's Foreword

6. In a special issue of *Time* magazine concerned with the "cyberrevolution," a report on controversy over computer-generated art concludes, "It is not for the first time. In 1902, Alfred Stieglitz, Edward Steichen and other now venerated American photographers formed a group devoted to convincing doubters that photography was a worthy form of artistic expression. That goal took decades to achieve." See Bellafante, Ginia, "Strange Sounds and Sights," *Time*, Vol. 145, no. 12 (Spring 1995), p. 16.

7. "A defining technology develops links, metaphorical or otherwise, with a culture's science, philosophy, or literature; it is always available to serve as a metaphor, example, model, or symbol. A defining technology resembles a magnifying glass, which collects and focuses seemingly disparate ideas in a culture into one bright, sometimes piercing ray. Technology does not call forth major cultural changes by itself, but it does bring ideas into a new focus by explaining or exemplifying them in new ways to larger audiences." Bolter, J. David, *Turing's Man: Western Culture in the Computer Age* (Chapel Hill: University of North Carolina Press, 1984), p. 11.

8. See "Two Extremes," elsewhere in this volume.

9. See "Of Snapshots and Mechanizations," elsewhere in this volume.

10. See "Begging the Issue," elsewhere in this volume.

11. "No Future for You? Speculations on the Next Decade in Photography Education," in *Light Readings: A Photography Critic's Writings, 1968-1978* (Oxford University Press, 1979; second edition, University of New Mexico Press, 1998). The pertinent sections are excerpted elsewhere in this volume.

12. *Light Readings*. The portrait in question can be found on p. 12 of the present volume.

13. See "An Arranged Marriage," elsewhere in this volume.

14. A new version of this now appears, under entirely different management, as *American Photo On Campus*; and the issue I'm looking at – Vol. 1, no. 2 (March 1997) – is headlined "Digital Special."

15. From the text of an unpublished lecture titled "Expecting the Barbarians: Photography Education Awaits the Millenium," delivered at Syracuse University on May 2, 1988.

16. Aside from a few relevant passages in interviews with me, the only substantial and pertinent texts of mine on this subject not included in this collection are "The Vanishing Borderline: Sketch for a Manifesto on the 'Democratization' of Art," from 1986, which appears in another published collection of my essays, *Depth of Field: Essays on Photography, Mass Media and Lens Culture* (University of New Mexico Press, 1998), and a summer 1997 lecture, "Analogizing the Digital: Issues for a Medium in Transition." That lecture, and those interviews, will be included in a forthcoming book of mine, *Speaking of Photography*. The interested reader may also want to factor in another essay from *Depth of Field*, "Mutant Media: Photo/Montage/Collage," which considers at length the analog precursors to much digital activity in photography.

* * *

Prologue:

Flowering Paradox: McLuhan/Newark (September 1967)

(Some comments on the genesis of this essay can be found in the Acknowledgments and Author's Foreword to this volume. It's the only piece I published professionally under the byline Allan D. Coleman.)

17. Marshall McLuhan and Quentin Fiore, *The Medium is the Massage* (New York: Bantam Books, 1967). The cover describes it as "Coordinated by Jerome Agel."

18. *The Medium is the Massage*. Written by Marshall McLuhan, Quentin Fiore, and

Jerome Agel. Columbia Records, 1967: stereo CS 9501, mono CL 2701. Subsequently I reviewed another project by the same team of McLuhan, Fiore, and Agel, *War and Peace in the Global Village* (New York: Bantam Books, 1968). My commentary appeared in "Eye on Books," *Eye*, Vol. 1, no. 10 (December 1968), p. 21.

Two Extremes (April 1973)

(The title of this piece isn't mine; it was probably penned by the late Bernard Gladstone of the *Times*, my line editor there.)

Of Snapshots and Mechanizations (July 1974)

(Again, the title of this piece isn't mine; but it represents one of Gladstone's better efforts.)

19. Peter Schjeldahl, "The Sheridan-Smith Show: A Misalliance of Art and Technology," *New York Times*, Section D, June 23, 1974, p. 23.

20. I'd met Sheridan the previous summer, when we were both briefly in residence at the Visual Studies Workshop in Rochester, New York, as part of a book-making conference sponsored by the National Endowment for the Arts and the Noble Foundation and organized by Joan Lyons. John Wood and Hollis Frampton completed our invited group; and Keith Smith, permanently in residence at the v.s.w., took part also. Sheridan taught me how to work on the Haloid Xerox machine, a prototype of the common office model; and I produced my first bookwork, a body-scan self-portrait, *Carbon Copy* (1973) during my stay.

Begging the Issue (February 1976)

(At the time I wrote these words, I had not yet joined the s.p.e., but maintained the position of an outside observer and journalist in relation to that organization. Subsequently, I joined it, served on its Board, founded and chaired one of its committees – and then resigned from it, early in 1986. My open letter of resignation went both unanswered and unpublished by the organization. The title under

which this piece was originally published [and then republished] was not of my devising.)

21. Hilton Kramer, "Holography – a Technical Stunt," *New York Times*, Sec. 2, July 20, 1975, p. 1. For my own contrary view, see "Holography: A Prophecy" in *Light Readings*. Because holography is not (yet) a digital technology, it's not addressed in this volume.

22. For Shipman's summary of her position on this matter, Krauss's outline of his own comments, and position papers pro and con from two other S.P.E. members, see *Exposure*, Vol. 14, no. 1 (February 1976).

23. Shipman would subsequently come to exemplify, almost exactly, the statistics of her M.F.A. cohort, 95 percent of whom abandon photography five years out of graduate school. In her dramatic farewell address to the S.P.E. a few years after this panel, Shipman announced that she'd decided to give it all up in order to become . . . a travel agent.

24. And, as such, I may have helped to spark it with an essay of mine that appeared in the *New York Times* in 1971 under the title "Along with the Three R's – Photography?" Thus, although I was not involved in either of the projects just named, I may be implicated in them. Under its original title, "A Manifesto for Photography Education," this essay is reprinted in *Light Readings*.

* * *

Remember: The Seduction of Narcissus Was Visual (November 1976)

(This essay was commissioned as the lead story for a special *Village Voice* supplement [November 1976] devoted to the subject of photojournalism, where it appeared in somewhat shorter form. This is its full, original version.)

25. *Sœur Sourire: The Singing Nun*, Philips Records, 1963. A 1966 biopic based on her life starred Debbie Reynolds and Greer

Garson. Subsequent to her brief moment of fame, The Singing Nun – whose real name was Jeanine Deckers, and who left the Dominican cloister in 1966 to join a lay order – sinned mortally by committing suicide along with her long-time companion, according to her obituary. See "Belgium's Singing Nun Is Reported a Suicide," *New York Times*, Sec. 2, April 2, 1985, p. 6.

26. Paul Daniel Alphandéry, "Albigenses," *The Encyclopaedia Brittanica*, Vol. 1 (New York: Encyclopaedia Brittanica, Inc., 1926, thirteenth edition), p. 506.

27. Lewis Grossberger, "Peking Sauce That's Not on Menu," *New York Post*, Vol. 173, no. 281 (October 24, 1974). p. 3.

28. It seems worth noting that while the "boy" in Rouson's cartoon certainly caught the bigger fish, the "girl" clearly demonstrates a superior visual sophistication.

29. These are from a group of four anonymous postcards in my own collection, possibly by or from the archive of Ernesto Casasola.

30. I recall this terse locution from one of several speeches I heard Carmichael (now known as Kwamé Turé) deliver in the middle 1960s, but can find no specific published source for it. The closest I've come are these passages from *Black Power: the Politics of Liberation in America*, by Stokely Carmichael and Charles V. Hamilton (New York: Random House, 1967): "We shall have to struggle for the right to create our own terms through which to define ourselves and our relationship to the society, and to have those terms recognized. This is the first necessity of a free people, and the first right that any oppressor must suspend." (p. 34) "Today, the American educational system continues to reinforce the entrenched values of the society through the use of words." (p. 37)

31. The reader can perhaps understand why, in this connection, I consider the first ten or so minutes of Woody Allen's brilliantly mordant comedy *Zelig* (1983) – in which the

main character, played by Allen himself, is inserted seamlessly into snippets of historical film footage – one of the most terrifying passages in cinematic history. Now, of course, it's been trumped by *Forrest Gump* (1994).

No Future For You? Speculations on the Next Decade in Photography Education (March 1978)

(Excerpted from the keynote address to the National Conference of the Society for Photographic Education, held at the Asilomar Conference Center, Pacific Grove, California on March 22, 1978. For the complete text, see *Light Readings*.)

Lies Like Truth: Photographs as Evidence (October 1978)

32. For more on this, see "'From Today, Painting Is Dead': A Requiem" in *Light Readings*.
33. For more on this, see "Photography and Conceptual Art" in *Light Readings*.
34. *Hitler Moves East: A Graphic Chronicle, 1941–43*, by David Levinthal and Garry Trudeau (Mission, Kansas: Sheed Andrews & McMeel, Inc., 1977). A second edition – a virtually exact facsimile reprint – was published in 1991 by the Laurence Miller Gallery in New York. For my reconsideration of Levinthal's project on that occasion, see "*Hitler Moves East* Turns Fourteen," *Camera & Darkroom*, Vol. 14, no. 1 (January 1992), pp. 54-56.
35. DeLappa's sequence was published in *Creative Camera*, No. 160 (October 1977).
36. *Evidence*, by Mike Mandel and Larry Sultan (Greenbrae, CA: Clatworthy Colorvues, 1977).
37. Indeed, at least one reviewer of the 1991 edition, photographer-editor-publisher Charles Rotkin, bought the illusion lock, stock, and barrel, producing an unintentionally hilarious essay in which he poured out his feelings about World War II without paying serious attention to the photos on which he was premising his divagations. Even when the directorial nature of the imagery, and the artificiality of its literal subject matter, were brought to his attention by this writer, he refused to relinquish his belief that the book nonetheless "has value as a document, however technically flawed." See *The Rotkin Review*, Issue No. 8 (Winter 1990).

Some Thoughts on Hairless Apes, Limited Time, and Generative Systems (November 1979)

(A somewhat different version of this text was published as "Hairless Apes, Limited Time, and Generative Systems" in *Camera 35*, Vol. 25, no. 2 [February 1980].)
38. Kenner, Hugh, *The Pound Era* (Berkeley and Los Angeles: University of California Press, 1971), p. 415.
39. This is the complete text of a lecture delivered on November 10, 1979, at the symposium held at the International Museum of Photography at the George Eastman House in Rochester, New York, marking the debut of the museum's traveling survey exhibit "Electroworks," curated by Marilyn McCray.
40. An illustrated catalogue of the exhibit was produced by the International Museum of Photography at the George Eastman House: Marilyn McCray, *Electroworks* (Rochester: IMP/GEH, 1979).
41. I produced the color Xerox collage series, "Desecrations," in the late 1970s. Samples were exhibited in "Eros and Photography," San Francisco Camerawork, 1977, curated by Lew Thomas and Donna-Lee Phillips, and "X-Static: 12 Directions in Electrostatic Art," City Without Walls, Newark, NJ, 1984, curated by Colleen Thornton. Two of them are reproduced in Lew Thomas and Donna-Lee Phillips, eds., *Eros and Photography* (San Francisco: NFS Press, 1977). *Carbon Copy* (New York: ADCO Enterprises, 1973), a body-scan self-portrait sequence based on Haloid Xerox images, was published in an edition of 50. (See note 20 for details on its production.)

42. See "Of Snapshots and Mechanizations," elsewhere in this volume.

43. McCray, *op. cit.*, p. 7.

44. Ibid., p. 8.

45. In one of the most blatant and absolute acts of discrimination I've ever both witnessed and been subjected to, the artists in attendance at the gala opening reception were directed to separate tents from those where the other invited guests – mostly industry execs and wealthy Rochesterians – were seated for dinner; they were served different food and wine (very nice, as I recall, but less fancy, as we later learned), and were in every other way put in what that sponsorial system determined was their place. For a very different account of this remarkable socio-economic event, from the standpoint of a dedicated teaching artist, see Peter Thompson's splendid essay, "Counting on the Odds," in *Exposure*, Vol. 21, no. 1 (Spring 1983), pp. 26-29.

46. McCray, *op. cit.*, p. 9.

Fiche and Chips: Technological Premonitions (October 1981)

(This is the partial text of an address delivered in Vienna, Austria, on October 25, 1981, at the 6. Internationales Symposion der Sammlung Fotografis Länderbank, "Kritik und Fotografie, 2. Teil." Other symposiasts included Martha Rosler, Victor Burgin, John Baldessari, Rosalind Krauss, and Benjamin Buchloh. The full text of that presentation incorporated passages from the earlier essay, "Some Thoughts on Hairless Apes, Limited Time, and Generative Systems," elsewhere in this volume. This version of the text appeared in an issue of *Camera Austria* that served as a proceedings for the symposium, and in *European Photography*, in both cases accompanied by a German translation.)

47. Garboden, Clif, "Computer Graphics," *Polaroid Close-Up*, Vol. 10, no. 2 (Summer 1979), p. 3.

48. In conversation with the author, winter 1980.

49. See "Some Thoughts on Hairless Apes," elsewhere in this volume.

50. I've grouped together here several quotes from and statements by Sheridan. The first comes from an exhibition catalogue, *The Inner Landscape and the Machine: A Visual Studies Traveling Exhibition of the Work of Sonia Landy Sheridan* (Rochester, NY: Visual Studies Workshop), unpaginated. The rest come from sources I can no longer identify.

Digital Imaging and Photography Education: A. D. Coleman interviewed by Thomas Gartside (March 1983)

(This interview was recorded by Thomas Gartside on March 16, 1983, during the course of the National Conference of the Society for Photographic Education in Philadelphia. At the time, I was on the faculty of New York University, and was also serving as an elected member of the Board of Directors of the S.P.E.)

Lens, Culture, Art: A. D. Coleman interviewed by Daniel Kazimierski (February 1984)

(This conversation with me was initiated and recorded in February 1984 by photographer/film-maker Daniel Kazimierski, who was at the time a colleague of mine on the faculty of the Tisch School of the Arts at New York University, and also a member of the faculty of the International Center of Photography. Extracts from that interview were published subsequently, in newsletters from both institutions.)

Information, Please (March 1984)

(The original version of this text was first presented in lecture form during a symposium at Hampshire College, Amherst, Massachusetts, on March 3, 1984. Subsequently, it was converted into essay form and published in *Lens' On Campus* (February 1985), and evolved into a series of columns for that publication which, in turn, became the essay

"Documentary, Photojournalism and Press Photography Now: Notes and Questions," in *Depth of Field*.)

51. The variation of this set of tropes freshest in my mind at that moment was one I'd heard delivered by Abigail Solomon-Godeau at the San Francisco Art Institute a few years earlier, but I also recalled an eerily parallel one offered up by Martha Rosler at the 1981 Vienna symposium described in my notes for "Fiche and Chips," above.

52. These passages created something of a tempest in a teapot. For more on this matter, see my notes to "Documentary, Photojournalism and Press Photography Now" in *Depth of Field*.

53. Not to say that they couldn't; quickie books – such as the instant paperbacks on the 1997 mass suicide of the Heaven's Gate group, and other such ephemera – appear all the time.

54. McLuhan said this in many ways and many places, but nowhere more eloquently – while at the same time vividly illustrating his point – than in *Counterblast* (New York: Harcourt, Brace & World, Inc., 1969), pp. 99-104.

Photography: Today/Tomorrow (October-December 1985)

(This brief statement provides answers to the questions "How do you assess the current state of photography? And: Which developments, trends, perspectives do you see for the future?" – posed as the premises for a correspondence symposium in the journal *European Photography*.)

55. From my notebooks; source unknown.

The Future of Photography: A New World (November 1987)

(These are my comments [plus a few connective statements by others] made during the course of a panel discussion bearing this same title, hosted by the American Society of Magazine Photographers. It took place at the Jacob Javits Center in New York City on the evening of November 20, 1987, as part of Photo Expo, an annual trade fair. The panel was organized and moderated by photographer Helen Marcus, then the ASMP's president. My co-panelists included photographers Harvey Lloyd, Ron Scott, and Michael O'Connor; *Time*'s Arnold Drapkin; Raphaele of Raphaele/Digital Transparencies, Inc.; Alistair Gillett of Young & Rubicam; Henry Scanlon of the Comstock Agency; and Sam Yanes of Polaroid. Some brief extracts from the transcribed dialogue, including some excerpts from portions of my comments, were published in the Spring 1988 issue of the magazine *Photo Design*.)

The Hand With Five Fingers; or, Photography Made Uneasy (January-February 1988)

56. Howard Smith, "Camera Karma," *Village Voice*, Vol. 27, no. 20 (May 18, 1982), p. 24.

57. This served as the slogan for a wonderfully macabre Nikon campaign, modelled on vintage Hollywood horror movies like *The Mummy's Curse*, that ran from 1986–87. The art director for this campaign was Simon Bowden, then a partner in Scali, McCabe & Sloves.

58. According to Jason Schneider of *Popular Photography* magazine, "decision-free photography" originated with Kodak as the slogan for its disk-camera system; variants on this idea soon emerged in ads for other fully automated systems aimed at the amateur market. (In conversation with the author, September 2, 1998.) The term used in private around the industry for these cameras was less high-flown: "idiot-proof." The basic premise updates George Eastman's 1889 promise, "You push the button, we do the rest."

Historianship and the New Technologies (September 1989)

(These comments are excerpted from my keynote address to the international symposium "The Histories of Photography: Evaluating the first 150 years of the medium's historiography; anticipating the histories to come,"

co-sponsored by the European Society for the History of Photography [ESHPh] and the Erna and Victor Hasselblad Foundation's Center for Photography, Göteborg, Sweden, September 29, 1989. The full text of that speech remains unpublished. Portions of it – including these passages – were published as "[Re:] Making History: The Social Construction of Photography" in *Camera & Darkroom* [October 1990].)

Back to the Future: Photography in the '80s and '90s (October-December 1989)

(This brief diagnosis/prognosis was a response to a poll of its contributors, on the subject of its title, conducted by the magazine *European Photography* in celebration of its tenth anniversary. A slightly shortened version of it was published in that journal. The precipitating questions: "What are the important characteristics of and developments in the photographs of the '80s?" and "What do you foresee for the '90s?")

Who Owns the Facts? (August 1991)

59. "The 'Privatizing' of Information: Who Can Own What America Knows?" *The Nation*, Vol. 234, no. 15 (April 17, 1982), pp. 461-63. This essay began its life as a letter to the editor in response to the Schillers's commentary, was revised at the editor's request for possible publication, and when unpublished in that forum, expanded into its present form for presentation in a different venue. As often happened, one thing led to another, and it became the first in a series of columns for *Camera & Darkroom*.
60. Coleman, Douglas I. Sheer and Patricia Grantz, *The Photography A-V Program Directory* (New York: Photography Media Institute, 1981).
61. As a charter member of the National Writers Union, in a May 1990 letter to the editor of the union's journal of record I proposed the creation of an online syndication service under the union's auspices, with two components. "The first would be the crea-

tion of a database, to be made available via CompuServe or some such system, in which I and other members could briefly describe our columns, selected features, subject area(s) of interest, and give our addresses to facilitate further inquiry. The second would be the periodic (perhaps twice-yearly) conversion of this database into a simple, inexpensive, desktop-published catalogue that would be mailed to a list of periodicals here and abroad." See "A Writers' Syndicate?" *American Writer*, Vol. 9, no. 1 (Summer 1990), p. 2.
62. For assorted accounts of these activities, see Steven Levy, *Hackers: Heroes of the Computer Revolution* (New York: Doubleday & Co., 1984), and Kathie Hafner and John Markoff, *Cyberpunk: Outlaws and Hackers on the Computer Frontier* (New York: Simon & Schuster, 1991), among other chronicles.
63. Recall, in this regard, the behavior of the character played by Melanie Griffith in the 1988 film *Working Girl* – and the delighted approval it evoked from office workers around the country.

Copyright – or Wrong? Intellectual Property in the Electronic Age (September 1991)

64. Derek Bennett, "Une spéculation" ("A Speculation)," *Clichés* 45 (April 1988), p. 3. His text appears in French only, and though I doubt that he wrote it in that language I know of no published English version of this text.
65. As such, it would be covered by property law, and its disclosure without permission would be actionable. But, should someone else coincidentally duplicate that discovery and begin to market it, those who'd first created it would have no recourse under law.
66. Umberto Eco, *The Name of the Rose* (New York: Harcourt Brace Jovanovitch, 1983).
67. Popper, Karl, *Objective Knowledge: An Evolutionary Approach* (Oxford: Oxford University Press, 1972).

68. My source for this quote is the main branch of the Amalgamated Bank of New York, on Union Square West, in whose interior it's engraved in marble. Beyond that, I cannot vouch for its accuracy.

Marginalizing the Maker: The Status of Authorship in the Digital Epoch (November 1991)

69. Walter Benjamin, "Author as Producer," in Victor Burgin, ed., *Thinking Photography* (London: The MacMillan Press, Ltd.), pp. 15-31.
70. For a thoughtful summary of the *Art Rogers v. Jeff Koons and Sonnabend Gallery, Inc.* trial and decision, and the legal issues underlying same, see Barbara Hoffman, "Legal Update: Whose Image is It?" *CAA News*, Vol. 15, no. 5 (September-October 1990), pp. 5-6, and the same author's follow-up story, "Legal Update: . . . and the Winner Is," *CAA News*, Vol. 16, no. 3 (May-June 1991), p. 6. Hoffman – not a participant in the case – served at that time as Honorary Counsel for the College Art Association (C.A.A.).
71. For a report on the opening salvo in the battle for the *droit de regard*, see my account of the 1989 Rencontres Internationales de la Photographie, "Letter From: Arles, No. 6," *Photo Metro*, Vol. 8, no. 72 (September 1989), pp. 24–25.
72. Hoffman, "Legal Update: . . . and the Winner Is," *loc. cit.*

Todd Walker: Representation and Transformation (Fall 1992)

73. Todd Walker, untitled artist's statement in the entry "Walker, (Harold) Todd," in George Walsh, Colin Naylor and Michael Held, eds., *Contemporary Photographers* (New York: St. Martin's Press, 1982), p. 795.
74. Letter to the author, July 2, 1992.
75. Walker, *Contemporary Photographers*.
76. Ibid.
77. See "The Quest of Form" in Newhall, *The History of Photography: from 1839 to* *the present day* (New York: Museum of Modern Art, 1964, revised and enlarged edition), p. 162.
78. Kostelanetz, Richard, "An ABC of Contemporary Reading," *Precisely: One* (November 1977), p. 32. Reprinted in Kostelanetz, ed., *Esthetics Contemporary* (Buffalo, NY: Prometheus Books, 1978).
79. Letter to the author, July 2, 1992.
80. *Leaf*, 1971. It's reproduced in Julia K. Nelson, *Todd Walker: Photographs, Untitled 38* (Carmel, CA: The Friends of Photography, 1985), p. 15.
81. Rosenblum, Naomi, *A World History of Photography* (New York: Abbeville Press, 1984), pp. 578-79.
82. Nelson, *op. cit.*, p. 8.
83. Letter to the author, July 2, 1992.
84. Nelson, *op. cit.*
85. Letter to the author, July 2, 1992.
86. In telephone conversation with the author, July 9, 1992, clarifying and expanding on the last sentence of this quoted passage, which is from a letter to the author, July 2, 1992.
87. Letter to the author, July 2, 1992.
88. Papert, Seymour, *Mindstorms: Children, Computers, and Powerful Ideas* (New York: Basic Books, 1980).
89. Walker, *Contemporary Photographers*.

Fotofutures: Ten Possibilities in No Particular Order (July 1993)

90. Bernard Edelman, *Ownership of the Image: Elements for a Marxist Theory of Law* (Boston: Routledge & Kegan Paul Ltd., 1979).
91. Hoo boy, did I have the wrong vampire! In early 1997 a nation-wide Adobe Photoshop ad campaign in photography and computer magazines, headlined "Au Natural," featured Joel Meyerowitz, "one of America's most renowned photographers and a pioneer in color photography as an art form," saying things like "Photoshop . . . eliminates the anxiety and frustration of the darkroom. It's actually fun. . . . Photoshop lets me explore options in a natural and in-

tuitive fashion with exciting results." (See, for example, *Pix*, Vol. 3, no. 2 [April 1997], p. 31.)

"Everything you know is about to be wrong": A Report on Montage 93 (January 1994)

(This is the first appearance in print of the full, uncut version of my report on this festival, which was [due to space considerations] trimmed considerably before submission to *Camera & Darkroom*, and trimmed further prior to publication.)

92. William J. Mitchell, *The Reconfigured Eye: Visual Truth in the Post-Photographic Era* (Cambridge: The MIT Press, 1994).

93. Actually, the first phone conversation took place in Boston in 1876.

94. By this I took him to mean the advent of photography, though Rochester can't really claim to be the town in which that started.

95. *Arcana* (Nykarleby, Finland: Nykarleby School of Arts, 1993).

96. Portions of this essay were subsequently recomposed into a review of "Iterations" when it came to the International Center of Photography in New York; see "It's Interactive! Get in Line for Your Turn at the Show," *New York Observer*, Vol.7, no. 40 (November 15, 1993), p. 28. A catalogue of this show eventually appeared: Timothy Druckrey, ed., *Iterations: The New Image* (Cambridge: The MIT Press, 1994).

97. From my notebooks; source unknown. Marshall's statement seems to paraphrase Susan Sontag's observation that "[Photography] is the prototype of the characteristic direction taken in our time by both the modernist high arts and the commercial arts: the transformation of arts into meta-arts or media." See Sontag, *On Photography* (New York: Farrar, Straus & Giroux, 1977), p. 149.

98. Henry Wilhelm, with Carol Brower, *The Permanence and Care of Color Photographs: Photographic and Digital Color Prints, Color Negatives, Slides, and Motion Pictures* (Grinnell, Iowa: Preservation Publishing Co., 1993).

99. Steve Erickson, *Arc d'X* (New York: Poseidon Press/Simon & Schuster, 1993).

The Final Image: Some Not-so-terminal Thoughts (June 1994)

100. Jon Kalish, "Improve Your Image: Special photo effects are a snap at high-tech store," in the "Urban Gazette" section, *New York Daily News*, May 24, 1993, p. 24.

101. The January 1994 issue of *Camera & Darkroom* that included the essay of mine found elsewhere in this volume, "Everything you know is about to be wrong," devoted itself to matters digital, and controversy over that editorial decision raged on the "Letters" page for at least the next four issues.

102. Forgive the hyperbole. Technically speaking, as I did this strictly for my own satisfaction, and did not market or publish the results, copyright law was not breached.

103. Coleman *et al*, *The Photography A-V Program Directory*.

An Arranged Marriage: My Life with the Computer (August 1994)

(This is the full version of the essay originally published in *Camera & Darkroom* under this title as a continuation of "The Final Image: Some Not-so-terminal Thoughts," elsewhere in this volume.)

104. In point of fact, this wasn't that much of a change in working method, roughly comparable to a photographer's first experience of using a built-in metering system rather than a hand-held one.

105. Nowadays I switch between Microsoft Word and ClarisWorks.

106. My first experiences with the 'Net, and with E-mail, came in the spring of 1995.

107. Several years after I published this piece, I was struck to find a number of similar percepts regarding the relationship of writing on an electric typewriter to writing on a computer in an essay by Ron Rosenbaum, a colleague at the *New York*

Observer. In his column, "The Edgy Enthusiast," for April 21, 1997, he offered an over-the-top paean to his wordsmithing instrument of choice (the Olympia Report deLuxe Electric), waxing delirious about how, with it, "you inscribe, carve – virtually brand – a thickly pigmented carbonized sign on the incarnate physicality of a tabula rasa." In addition to its value as a comparatively rare discussion by a writer of the physical tools of the trade, and its charms as a love song from a boy to his vehicle for flights of fancy, the piece speaks lucidly and provocatively to some of the changes for the worse Rosenbaum suspects computers to have generated in the work of at least some writers: a tendency to tinker rather than "rewriting from the top," a consequent erosion of internal coherence, and the loss of the complex relationship one used to have to failed but preserved earlier drafts, which he speaks of in much the same way certain photographers talk about their negative files. (Vol. 11, no. 16, p. 39.)

108. The piece is titled "postscript," and I still haven't done anything with the results; but it provokes me, and I suspect it'll turn into something one of these days.

"In the Nature of the Computer": A. D. Coleman interviewed by Marc Silverman (January 1994)

(This interview, conducted over the telephone by Marc Silverman of the journal *PHOTOPaper* on January 17, 1994, ranged widely over many subjects; I've excerpted the section pertinent to this volume.)

109. See "Todd Walker," elsewhere in this volume.

110. When I last visited Walker, in February of 1997, he'd upgraded considerably, thanks to a small grant he'd received.

Connoisseurship in the Digital Era (Spring 1996)

(This essay was commissioned for the premier issue of *ArtLook*, a periodical published solely on CD-ROM, with no print version – a first for me in my engagement with matters digital.)

111. William M. Ivins, Jr., *Prints and Visual Communication* (London, Routledge & Kegan Ltd., 1953; reprinted by Da Capo Press, New York, 1969).

112. A year later, I'd have the opportunity to experience that first-hand, when I recorded myself reading my catalogue essay for *The Luminous Image*, a survey show curated by Franc Palaia at The Alternative Museum in New York City – a catalogue that took the form of an interactive CD-ROM, and included my essay as both a text file and an audio file. Having the option, for anyone using that catalogue, of hearing me speak my own text as well as reading it on the screen, struck me as extraordinary, especially as I've always written for the ear as well as for the eye.

What Hath Bill Gates Wrought? (March/April 1996)

(This essay was commissioned for a special issue of *American Photo* devoted to the Internet, digital imaging, and related matters.)

Fear of Surfing in the ArtWorld (June 1996)

(This essay was commissioned by Eric Gibson, editor of *ARTnews*, as the kick-off piece for a new feature in the magazine, a column on Internet matters featuring opinions from many quarters, under the rubric "Web-Sight." I structured it specifically to serve as the introductory piece in that series.)

113. Since then I've conducted such tutorials at Cybeteria, Prague's first cyber-café, under the auspices of the Prague House of Photography, and at the Rotunda Gallery in Brooklyn, under the auspices of Artists Talk On Art.

114. Fortunately, so far even the conservative-dominated U.S. Supreme Court has refused to separate the Internet and the Web from the other media in which free speech remains privileged.

Tending the Fire, Making Stone Soup: Community in Cyberspace (December 1996)

(This essay was commissioned by Robert Atkins, editor of *TalkBack!*, an Internet periodical (http://math.lehman.cuny.edu/tb/), for a special issue on the subject of "community in cyberspace.")

115. Contributors were asked to respond in some fashion to one or more of a set of questions; I folded my answers to these into this essay.

116. Vivian Gornick, *Approaching Eye Level* (Boston: Beacon Press, 1996), p. 69.

117. For more on this, see the essay "The Destruction Business" in *Depth of Field*.

118. Approximately on schedule, this happened as planned. You can find The Nearby Café at http://www.nearbycafe.com.

119. For a luminous meditation on potlatch, the gift economy, and the creative spirit's struggle for survival in a market economy, see Lewis Hyde, *The Gift: Imagination and the Erotic Life of Property* (New York: Vintage Books, 1983).

Toggling the Mind: Toward a Digital Pedagogy for the Transitional Generations (August 1998)

120. Both discussions took place in their Chicago studios, the one with Parada on October 17, 1996, that with Neimanas a few days later, on October 21. Unless otherwise indicated, all quotations from and paraphrases of them in this essay come from those conversations. I thank them for their patience with my questions. Their opinions are either quoted or paraphrased herein, and clearly indicated as such. My conclusions are mine alone. The emphasis here on technological concerns reflects my priority for this essay, not theirs.

121. *The Monroe Doctrine, Part One: Theme and Variations, 1987.*

122. Parada, Esther, "Taking Liberties: Digital Revision as Cultural Dialogue," *Leonardo*, Vol. 26, no. 5 (1993), p. 445.

123. In fact, she has reconsidered at least one piece created in her pre-digital period – *Whose News? Whose Image? Whose Truth?* – in order to generate a digital version thereof.

124. The Web piece, *Transplant: A Tale of Three Continents*, can be found at http://omnibus-eye.rtvf.nwu.edu/Homestead/eparada/ep-1.html. The CD-ROM's title is *3 Works* (Riverside, CA: University of California, Riverside/California Museum of Photography, 1996); Parada's piece therein is titled . . . *To Make All Mankind Acquaintances*. A print version thereof can be found in the exhibition catalogue *Iterations: The New Image*, edited by Timothy Druckrey (Cambridge: The MIT Press, 1994), pp. 108-113.

125. Parada, "Taking Liberties," *loc. cit.*

126. "I consider this – my first venture into multi-media – to be a work-in-progress, both technically and conceptually; and I will welcome feedback on all aspects of the endeavor. . . . I am excited about this opportunity to link and layer diverse images and ideas, and – with your participation – to generate a multivocal network of commentary and response." Quoted from "Parada ReadMeFirst," *3 Works*.

127. Letter to the author, September 16, 1996.

128. Interview with Hisaka Kojima, in Hisaka Kojima, ed., *Digital Image Creation: Insights into the New Photography* (Berkeley: Peachpit Press, 1996), p. 210.

129. She also does not work with layers, a Photoshop feature designed specifically to facilitate the kind of imagery she's generating.

130. *Total Chaos: The Truth . . . Revealed!* (Iowa City: University of Iowa Center for the Book, 1995).

131. The Iris company is trying now to get people to call these *giclée* prints, to the great amusement of the French, in whose language that fancy-sounding term suggests spritzed or squirted, not unlike cat spray.

"Flowering Paradox: McLuhan/Newark" first appeared in the *Village Voice*, Vol. 12, no. 50 (September 28, 1967).

"Two Extremes" first appeared in the Arts and Leisure Section, *New York Times*, April 22, 1973.

"Of Snapshots and Mechanizations" first appeared in the Arts and Leisure Section, *New York Times*, July 14, 1974.

"Begging the Issue" first appeared in *Camera 35*, Vol. 20, No. 1 (February/March 1976), under the title "Society of Photographic Egos?" Subsequently it was reprinted in *Exposure*, Vol. 14, no. 1 (February 1976).

"Remember: The Seduction of Narcissus Was Visual" first appeared in "The New Photojournalism," a special section of the *Village Voice*, Vol. 21, no. 4 (November 29, 1976), in somewhat shorter form. This full version is previously unpublished.

"No Future For You?" first appeared in *Exposure*, Vol. 16, no. 2 (Summer 1978); reprinted in full in Coleman, *Light Readings: A Photography Critic's Writings, 1968–1978* (New York: Oxford University Press, 1979; second edition, revised and expanded, University of New Mexico Press, 1998).

"Lies Like Truth: Photographs as Evidence" first appeared in *Camera 35*, Vol. 23, no. 9 (October 1978), under the title "Is It Time To Stop Believing Photographs?"

"Some Thoughts on Hairless Apes, Limited Time, And Generative Systems" first appeared as "Hairless Apes, Limited Time, And Generative Systems" in *Camera 35*, Vol. 25, no. 2 (February 1980).

"Fiche and Chips: Technological Premonitions" first appeared in *Camera 35*, Vol. 27, no. 1 (January 1982). Subsequently published as "Fiche and Chips: Technol-

ogische Vorzeiche," *Camera Austria* 10 (October 1982), an issue serving as the conference's official proceedings. Also published in *European Photography*, Vol. 3, no. 3 (July-September 1982), in both English and German.

"Digital Imaging and Photography Education" was first published under the title "Conversations with A. D. Coleman: An Evolving Point of View," which appeared in the *Philadelphia Photo Review*, Vol. 7, no. 3 (Fall 1983).

"Lens, Culture, Art" was first published in *Cinema Studies: A Newsletter of the Department of Cinema Studies, Tisch School of the Arts, New York University*, Vol. 1, no. 3 (Summer 1984). It was subsequently reprinted in *Contact: The Education Newsletter, International Center of Photography*, Vol. 6, no. 1 (Winter 1984).

"Information, Please!" first appeared in *Lens' On Campus*, Vol. 7, no. 1 (February 1985).

"Photography: Today/Tomorrow" first appeared as part of a correspondence symposium, "Photography: Today/Tomorrow (III): An inquiry into the present and future of photography," in *European Photography*, Vol. 6, no. 4 (October-December 1985).

With the exception of a few passages that appeared in *PhotoDesign*, Spring 1988, the transcribed excerpts from the 1987 ASMP panel "The Future of Photography" are previously unpublished.

In considerably different form, an early version of "The Hand with Five Fingers: Photography Made Uneasy" first appeared in *Lens' On Campus*, Vol. 7, no. 4 (September 1985) under the title "Photography Made Uneasy." This version was published, under the bollixed title

"The Five Fingers: Photography Made Easy," in *A Critique of America*, January/February 1988.

Portions of the 1989 lecture from which "Historianship and the New Technologies" is excerpted, including these passages, were published as "(Re:) Making History: The Social Construction of Photography" in *Darkroom Photography*, Vol. 12, no. 10 (October 1990).

"Back to the Future: Photography in the '80s and '90s" first appeared, in both English and German, as part of a correspondence symposium, "Forum: Back to the Future: Photography in the 80s and 90s"/"Zurück in die Zukunft: Fotografie in den 80er und 90er Jahren," in *European Photography*, Vol. 10, no. 4 (October-December 1989).

"Who Owns the Facts?" first appeared in *Camera & Darkroom Photography*, Vol. 13, no. 8 (August 1991).

"Copyright – Or Wrong?" first appeared in *Camera & Darkroom Photography*, Vol. 13, no. 9 (September 1991). This somewhat revised and expanded version is previously unpublished.

"Marginalizing the Maker" first appeared in *Camera & Darkroom Photography*, Vol. 13, no. 11 (November 1991).

"Todd Walker: Representation and Transformation" first appeared in *Photo-Education*, Vol. 8, no. 2 (Fall 1992). This slightly revised version subsequently appeared in *Camera & Darkroom Photography*, Vol. 15, no. 9 (September 1993).

"Fotofutures: Ten Possibilities in No Particular Order" first appeared in *Camera & Darkroom*, Vol. 15, no. 7 (July 1993). A slightly revised version subsequently appeared as "Photo Futures: Electromagnetic Terrorism?" in the *New York Observer*, Vol. 8, no. 2 (Jan. 17, 1994). Both versions are combined here.

"Everything you know is about to be wrong: A report on Montage 93" first appeared, in shortened form, in *Camera & Darkroom*, Vol. 16, no. 1 (January 1994). This full version is previously unpublished.

"The Final Image: Some Thoughts On Electronic Imaging" first appeared in *Camera & Darkroom*, Vol. 16, no. 6 (June 1994).

"An Arranged Marriage: My Life With The Computer" first appeared, in shortened form, in *Camera & Darkroom*, Vol. 16, no. 8 (August 1994). This full version is previously unpublished.

"In the Nature of the Computer" has been excerpted from "An Interview with Photography Critic A.D. Coleman," which first appeared, in shortened form, in *PHOTOpaper* (no volume or issue no., n.d., Winter 1995). This interview by Marc Silverman was subsequently reprinted in full in two parts in *The Photo Review*, Vol. 18, no. 3 (Summer 1995) and Vol. 18, no. 4 (Fall 1995).

"Connoisseurship in the Digital Era" first appeared in *ArtLook: The CD-ROM Showcase of Contemporary Fine Art*, Vol. 1 (Spring 1996).

"What Hath Bill Gates Wrought? The Future of Image Archives" first appeared in *American Photo*, Vol. 7, no. 2 (March-April 1996), in somewhat shortened form. This full version is previously unpublished.

"Fear of Surfing in the Art World" first appeared in *ARTnews*, Vol. 95, no. 6 (June 1996), under the title "Fear of Surfing."

"Tending the Fire, Making Stone Soup: Community in Cyberspace" first appeared in the electronic online journal *TalkBack!*, Issue 3 (December 1996), (http://math.lehman.cuny.edu/tb/), under the title "How Self-Publishing Evolved into an Online 'Café.'" It remains otherwise unpublished.

"Toggling the Mind: Toward a Digital Pedagogy for the Transitional Generations" is previously unpublished.

About the Author

Recently named one of "the 100 most important people in photography" by *American Photo* magazine, media commentator and educator A.D. Coleman lectures, teaches, and publishes widely both here and abroad. Joel Eisinger, in *Trace & Transformation: American Criticism of Photography in the Modernist Period*, proposed that "Coleman ... might be considered either as a transitional figure between modernism and postmodernism or as the first postmodernist critic." *Library Journal* called him "a rigorous critic with a deep, insightful knowledge of the method, theory and history of photography."

Since 1967, Coleman's "controversial, pungent, and influential" essays have provoked and delighted an increasingly international readership. With more than 170 columns in the *Village Voice*; 120 articles in the *New York Times*; almost 300 pieces in the *New York Observer*; features in such diverse publications as *ARTnews*, *Art in America*, *Collections*, *Dance Pages*, *France*, *New York*, and *ArtLook*; introductions to several dozen books; and appearances on NPR, PBS, NPR's "Night Watch," and the BBC, he has demonstrated an ability to engage the attention of the general public. His widely read Internet newsletter, *C: The Speed of Light*, appears bi-monthly on the World Wide Web in The Nearby Café, a multi-subject electronic magazine of which he is Executive Director (at http://www.nearbycafe.com).

At the same time, the regular presentation of Coleman's articles in specialized journals – *Artforum*, *Impact of Science on Society*, and *The Journal of Mass Media Ethics* among them – attests to the scholarly community's regard for his work. A member of PEN, The Authors Guild, the

National Writers Union and the American Society of Journalists and Authors, Coleman served for years as Executive Vice-President of AICA USA, the international association of critics of art. He received the first Art Critic's Fellowship ever awarded in photography by the National Endowment for the Arts in 1976, a Logan Grant in Support of New Writing on Photography in 1990, and a major Hasselblad Foundation Grant in 1991. He was a J. Paul Getty Museum Guest Scholar in 1993 and a Fulbright Senior Scholar in Sweden in 1994. In the winter of 1996-97 Coleman was honored as the Ansel and Virginia Adams Distinguished Scholar-in-Residence at the Center for Creative Photography in Tucson, Arizona, where a 27-year bibliography of his writings on photography is currently in production.

Coleman's published books include *The Grotesque in Photography*, *Light Readings: A Photography Critic's Writings*, *Critical Focus: Photography in the International Image Community*, *Tarnished Silver: After the Photo Boom*, *Depth of Field: Essays on Photography, Mass Media and Lens Culture*, and *Looking at Photographs: Animals*, a work for children. *Critical Focus* received the International Center of Photography's Infinity Award for Writing on Photography in 1995; both that volume and *Tarnished Silver* were singled out for Honorable Mention in the 1996 Kraszna-Krausz Book Awards.

From 1988 through 1997, Coleman served as the photography critic for the weekly *New York Observer*; his syndicated columns appear regularly in *Photo Metro*, *Photography in New York*, *European Photography* (Germany), *Foto* (Hungary), *Foto* (Holland), *Fotografie* (Czech Republic), *La Fotografia* (Spain), and *Juliet Art Magazine* (Italy). In addition to photography, art, mass media, and new communication technologies, Coleman's subjects have included a wide range – from music, books, theater, and education to politics and cooking. Under his full name, Allan Douglass Coleman, he publishes poetry, fiction, and creative nonfiction. His work, which has been translated into nineteen languages and published in 26 countries, is represented by Image/World Syndication Services, POB 040078, Staten Island, NY 10304-0002 USA; Tel/Fax (718) 447-3091, imageworld@nearbycafe.com.

A.D. Coleman, Houston, TX
Photograph copyright © 1996 by Nina Sederholm